D1267050

The Art of
Pencil Drawing

Discover all the techniques you need to know to create beautiful drawings in pencil

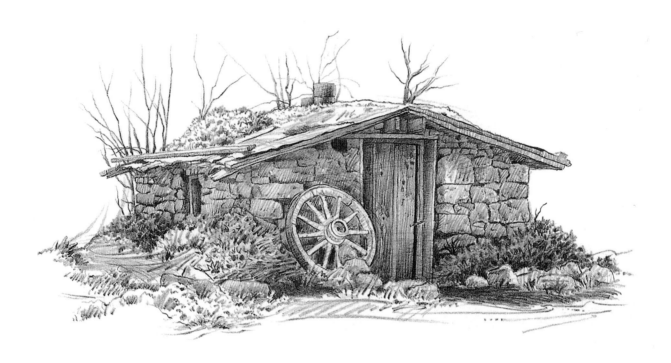

By Gene Franks

Walter Foster Publishing, Inc.
3 Wrigley, Suite A
Irvine, CA 92618
www.walterfoster.com

This library edition published in 2012 by Walter Foster Publishing, Inc.
Distributed by Black Rabbit Books.
P.O. Box 3263 Mankato, Minnesota 56002

Printed in Mankato, Minnesota, USA by CG Book Printers, a division of Corporate Graphics

First Library Edition

Library of Congress Cataloging-in-Publication Data

Franks, Gene.
 The art of pencil drawing / by Gene Franks. -- 1st library ed.
 p. cm. -- (Collector's series ; CS01L)
 Includes bibliographical references and index.
 ISBN 978-1-936309-47-4 (hardcover : alk. paper)
 1. Pencil drawing--Technique. I. Title.
 NC890.F68 2011b
 741.2'4--dc22

 2010052437

042011
17320

9 8 7 6 5 4 3 2 1

The Art of
Pencil Drawing

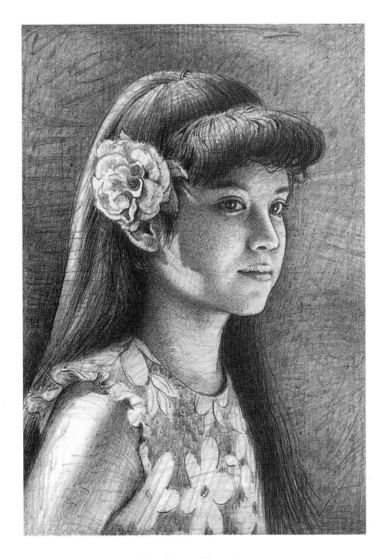

By Gene Franks

Contents

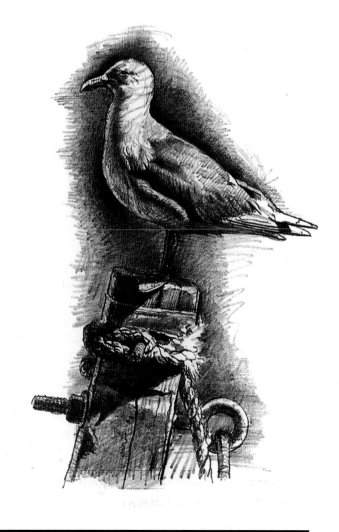

About the Artist

Recognized by many as a master of expressive pencil drawing, Gene Franks began exercising his talents for drawing and painting at the age of ten. His early years in rural Arkansas made a profound impact on his work. As a boy he traveled in horse drawn wagons and this slow way of life offered a time for thought and dreaming—it allowed him to see and study the beauty of nature, and caused him to think deeply about life. These feelings invariably come through in his artwork.

For many years, during his military duty and while doing other jobs to put food on the table, he would snatch precious moments to hone his talents—always practicing, practicing, practicing.

Those hungry, "learning" years paid off. Not only has Gene come to share his artwork with collectors and art lovers everywhere (he is the recipient of many awards and his works can be found in private collections nationwide), but for over a decade he has inspired literally hundreds of students with his unique teaching style. His instructional books have generated enthusiastic responses from students throughout the world. And, many of his students have become professional artists in their own right. He has discovered that almost anyone, when shown how to handle the pencil correctly, can do quite well. Gene says, "Learning to draw teaches people to see."

Gene has taught young and old—those with little talent and those with a lot. He is able to handle a diverse group of people in one class, each working on his or her own project at his or her own pace. He especially enjoys helping talented young people. He believes it is his responsibility to pass on whatever he can about painting and drawing to the next generation.

"If young people don't pick up the baton and become serious about traditional fine art, who will?" he asks.

Gene received his formal art training at Jefferson Mackhammer School of Art in Santa Monica, California and acquired additional skills through classes at the Art Center School in Los Angeles.

Gene and his wife, Jane, who is a partner with him in his work, live in the San Bernardino Mountains of Southern California.

Introduction

Welcome to the world of pencil! We believe that you will not find a finer collection of pencil drawings anywhere. A wide range of subjects, from still life and landscapes to animals and people can be found in this book. These drawings cover the gamut from rough, bold sketches to fine detail with subtle contrast of texture and shading.

Artist/author Gene Franks has worked diligently for many years to take pencil as far as he possibly can. This book is the culmination of that endeavor. He has allowed great demands on himself to choose just the right subject and to light it properly, or to find the perfect outdoor lighting situation in which to photograph it. He has experimented with dozens of kinds of paper and many types of pencils to arrive at the ideal system for his work. He has developed a variety of strokes and point "modes" to yield various subtle tones and textures. This process—a slow progress in one direction—has developed the discipline and determination that are so important to success in life. It has taught him that worthwhile pursuits take time—another important lesson for our "instant" society. Gene feels strongly that it is a special calling to be an artist, and that it is his responsibility to develop his God-given talent. He also feels that it is his job to share his impressions of the world in pencil with those who will accept them.

Gene believes that pencil drawing is a type of "basic training" and fundamental to all other visual art. Whether sketching an idea for a sculpture or painting, or carrying a pencil drawing to a completed piece that can be matted and framed, pencil is the first medium that a serious artist attempts. Therefore, it is important that every artistic person learns to draw. When an artist thinks in black and white, he is thinking of shapes in their most elementary and, perhaps, most poetic form. While basic and simple, pencil drawings can be finished works of art. Masterpieces appear in galleries and museums everywhere. Black and white has a beauty and importance of its own.

There are three kinds of people who, we hope, will read this book. The student will be inspired and taught to enter a step-by-step selfdevelopment program of pencil drawing. This book can help the student to improve his or her pencil ability over time. The professional artist will be challenged to take his or her own drawing technique and "run with it"—to carry it to a deeper and more personal level, and to produce a level of work he or she has never before achieved. The art lover will be educated to appreciate pencil as a major, legitimate art form in itself. In the end, we trust each reader will see pencil in a new light. We hope you will enjoy this book—wander through these pencil drawings and let them excite and motivate you. We want to see you, as a serious student, take pencil in hand and carry this lovely form of art to a higher plane. Show the world how beautiful pencil can be! We wish you much success!

Jane W. Franks

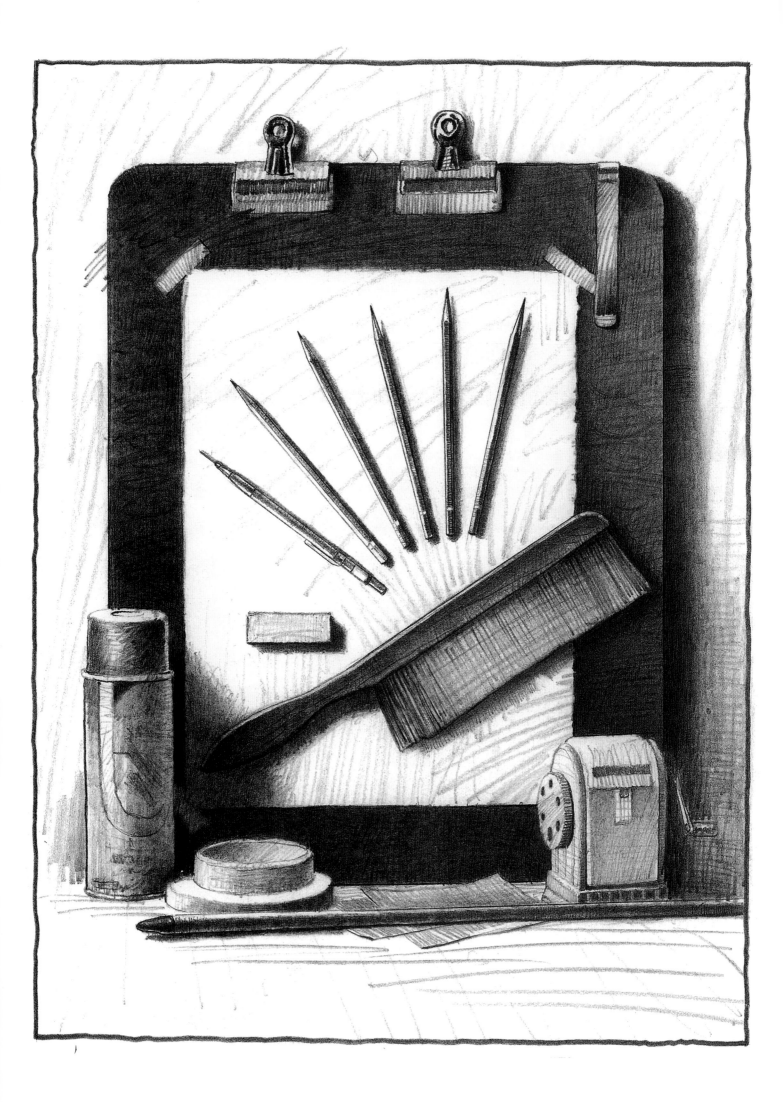

Tools and Techniques

SUPPLIES

PENCILS

I use both wooden pencils and metal drafting pencils in this book. The ones I recommend to begin with are:

Wooden Pencils
Hard F HB B 3B 5B Soft

Drafting Pencil
Metal holder and H lead, for roughing in.

PAPER

I prefer a smooth, textureless paper because I can avoid grain and build my own texture. I use 50% cotton, Italian, 140 pound, neutral PH, hot-pressed paper available in 22" x 30" sheets. Plate finish papers sold in pads are also acceptable.

ACCESSORIES

A smooth **drawing board** of 1/4" tempered masonite or plexiglass, size 16" x 20"; **masking tape or clips** for attaching paper to your board; a **vinyl eraser** (I use vinyl exclusively to avoid damaging the paper); **maulstick;** sheet of **plain bond paper** to slip under the hand while working to avoid smudging; **desk broom,** to brush off debris; **pencil sharpener; #220 and #600 sandpaper** for forming lead points; **workable fixative,** available in a spray can. Several light coats are sprayed on the finished drawing to prevent smudging.

PENCIL PROCEDURE

INTRODUCTION

Once you are acquainted with the tools and how to prepare and maintain them, and have practiced the value scale, the pencil strokes, and the shading samples on the following pages, then you are ready to begin the four steps that lead to accomplished pencil drawings. You will need to spend considerable time practicing each step. This faithful practice will bring great results in your final drawings. So plant your feet firmly and dig in for a determined effort in mastering this self-development program of pencil drawing.

STEP ONE - ROUGHING IN

Rough in the subject with an "H" lead and metal holder; the holder laid flat and held under your hand. Allow lots of freedom in your strokes, moving your entire arm. At this point think only about general shapes. You will add definition and detail later. Practice this step again and again.

STEP TWO - LINE DRAWING

You will need to invest time and practice to develop an expressive line drawing. Use the point of an "H" or "F" lead or wooden pencil.

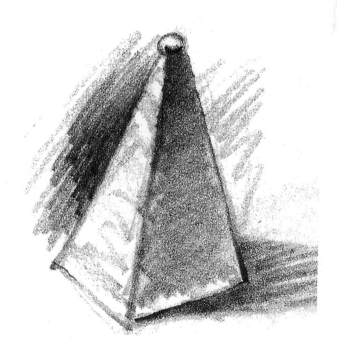

SECTION 1

Experiment with holding the instrument in both writing and underhand positions. In the underhand position, you can vary the thickness of your line by rolling the lead or pencil on its side for thick lines or up on the point for thin. Train yourself to show roundness and depth with expressive lines.

STEP THREE - PRELIMINARY SHADING

To achieve successful shading you must establish the structural pattern smoothly and under careful control. Gently "lay in" the darks and shadows in medium tones Don't commit yourself too darkly, too soon. Once you are sure, darken these areas by pressing harder or switching to a softer pencil. Allow the point to become slick and smooth for even tones.

STEP FOUR - FINISH

For final shading, use a some what darker pencil, drawing on a smooth point for even tonal control. Repeat the shading process over and over with softer pencils until you achieve your desired density. Reinforce the lines and accents as you go. Add final action strokes for the ultimate artistic effect.

Focus your attention on each finished drawing in this book, observing the detail, and use the other steps only for reference. Afterward, concentrate on your own personal handling of the pencil.

To avoid smudging, spray the completed drawing with several light coats of workable fixative. (If you immediately frame the drawing under glass, you do not need to spray.)

Sometimes you may want to create a complete drawing using only one hardness of pencil. "HB" is a good average pencil for this purpose. You may want to start with three HB pencils, one at each degree of sharpness. By varying the pressure on the pencil points and changing hand positions, you can accomplish several values and a wide variety of strokes.

Note: Throughout the book, "lead" means a metal drafting holder with removable lead; "pencil" refers to a wooden pencil.

SHARPENING

Wooden Pencils

You may use either an electric or manual sharpener for wooden pencils. After sharpening, rub the point on a paper towel to clean and smooth. The ball and blunt points are produced by brief use. While working I keep several pencils with each type of point close at hand.

Metal Holder With Removable Leads

With 1/2" of lead extended, I form the point on #240 sandpaper, then finish and polish it with #600 sandpaper to a long point as shown above.

PENCIL POINTS

•SHARP POINT

Use for
- Fine Lines
- Sharp Accents
- Hatching
- Thick & Thin

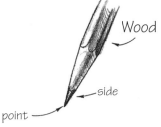

•ROUND POINT

Use for
- Normal Strokes
- General Shading

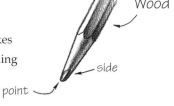

•BLUNT POINT

Use for
- Blunt Strokes
- Soft Shading
- Glazing

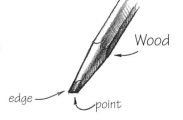

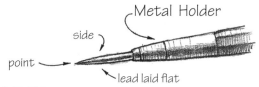

•LONG POINT

Use for
- Mass Shading
- Broad Strokes
- Glazing
- Thick & Thin

PENCIL STROKES

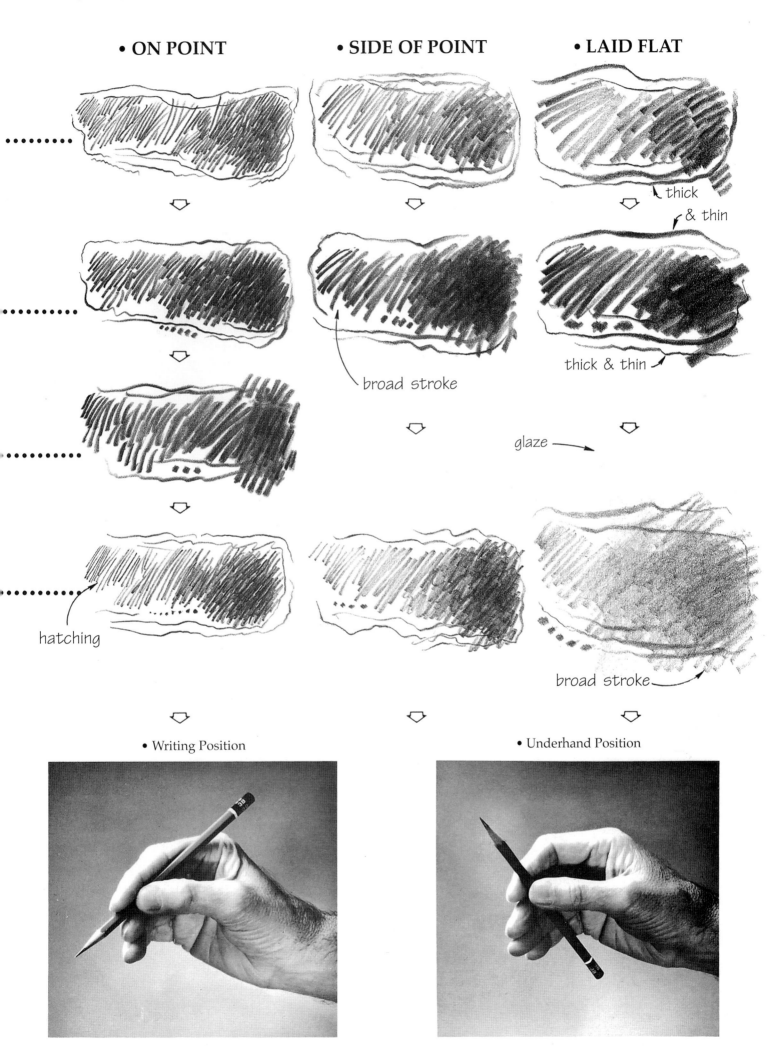

• ON POINT

• SIDE OF POINT

• LAID FLAT

thick

& thin

broad stroke

thick & thin

glaze

hatching

broad stroke

• Writing Position

• Underhand Position

Value Scale

TONES

1.

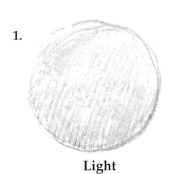

Light

2.

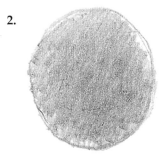

Medium Light

3.

Medium

4.

Medium Dark

5.

Dark

TRANSITION OF TONE

H F HB B 3B 5B

Graduation of tones is accomplished by overlapping strokes with each hardness of lead.

Shown here are five of the nine tones in the value scale. These five are all you will really need, even for advanced drawing. Practice these five tones as a musician might practice the musical scale—over and over. When the tones are firmly planted in your mind, you will be able to achieve the most refined shading effects. When you know instinctively how to hold and handle each pencil, you will be able to execute each tone with assurance.

As you gradually master the value scale, you will increasingly possess the ability to turn ordinary drawings into works of great substance and depth.

Shading Samples

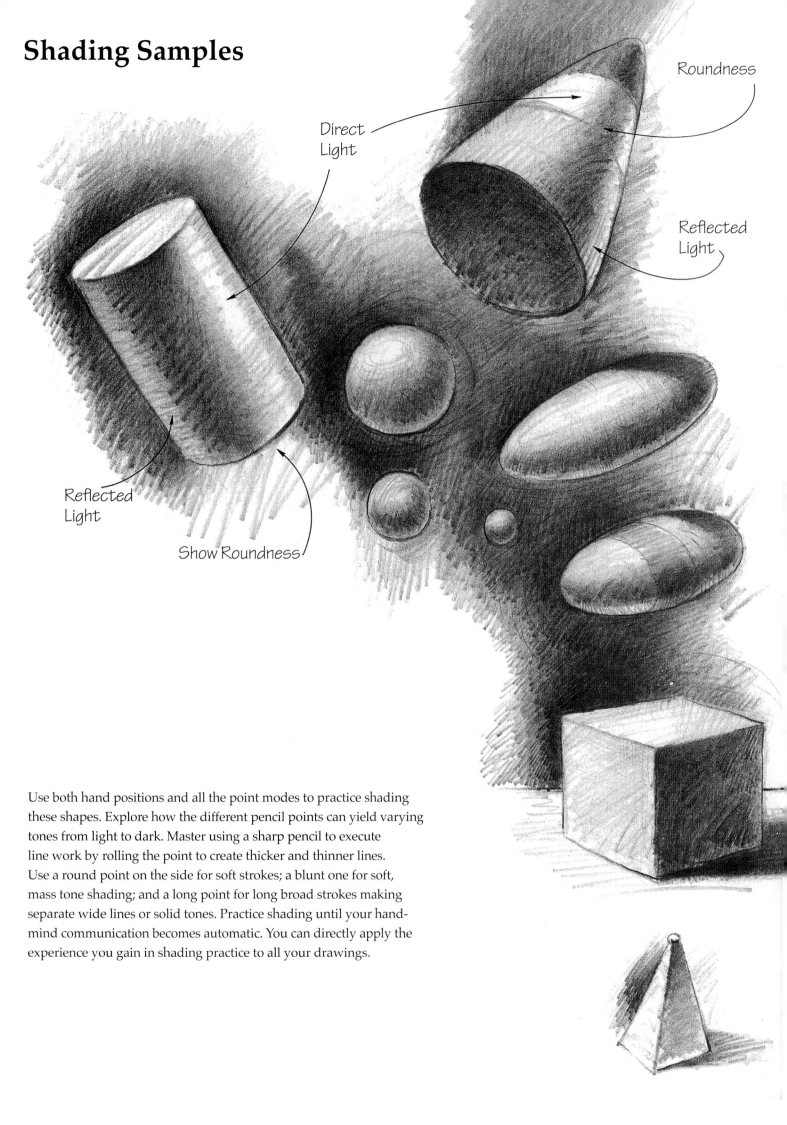

Direct Light

Roundness

Reflected Light

Reflected Light

Show Roundness

Use both hand positions and all the point modes to practice shading these shapes. Explore how the different pencil points can yield varying tones from light to dark. Master using a sharp pencil to execute line work by rolling the point to create thicker and thinner lines. Use a round point on the side for soft strokes; a blunt one for soft, mass tone shading; and a long point for long broad strokes making separate wide lines or solid tones. Practice shading until your hand-mind communication becomes automatic. You can directly apply the experience you gain in shading practice to all your drawings.

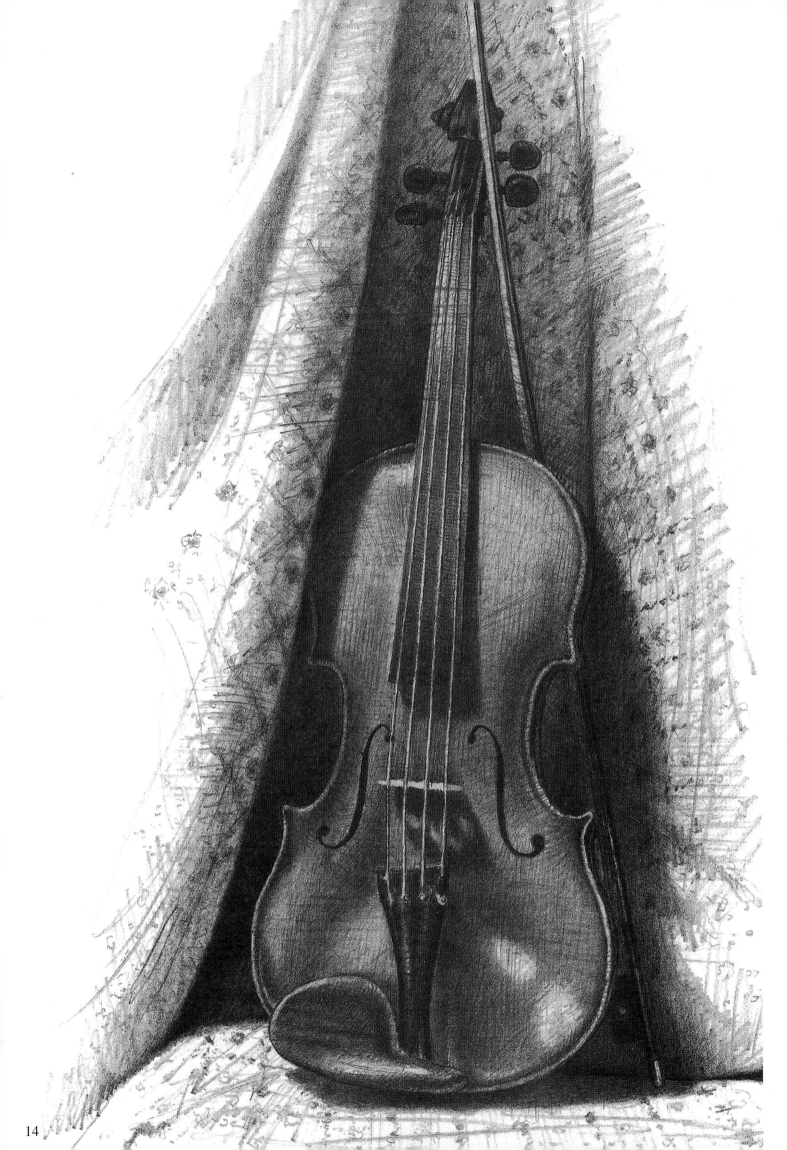

Still Life

Still life objects are good subject matter to begin with when learning to draw. You have complete control over the arrangement and lighting of your items because still life articles are usually photographed or drawn indoors.

CHOOSING THE SUBJECT

Become observant when searching for your subject. Keeping an open mind and relying on your sensitive, creative nature will help you to discover some unusual items. Look around your house or borrow items from friends and relatives—they are usually honored to have you draw their possessions. A child's wooden toys and a pair of worn tennis shoes made good subjects for this book. Gather shells and sea objects while at the beach, or browse through antique shops for interesting items. Museums and libraries are also great sources for pictures to copy.

THE SETUP

You may want to draw your subjects from sight, or you may decide to take photos and slides from which to work. Whatever method you choose, the setup is very important. Experiment with the placement of the objects; arrange them in different groupings until you arrive at just the right combination. For example, it is fun to use toys with antiques such as a teddy bear on an old quilt. When using fabrics, drape the material in soft folds to pick up light and provide shadowed areas.

Following are a few tips that will ensure success:

- Choose a subject with meaning and appeal to you. Then you will be willing to spend time on it.
- Select something with a variety of texture and design. This provides good contrast for the black and white of pencil.
- Light your subject with spotlights or floodlights to reveal its character, texture, and detail. There should be cast shadows on one side and highlights on the other.
- Adjust your technique to suit the subject. For example, loose, bold strokes are used for bulky objects, while tight, controlled lines best portray delicate items.

If you are persistent, you will delight yourself and excite the viewer with your still life drawings.

SECTION 2

Sketching

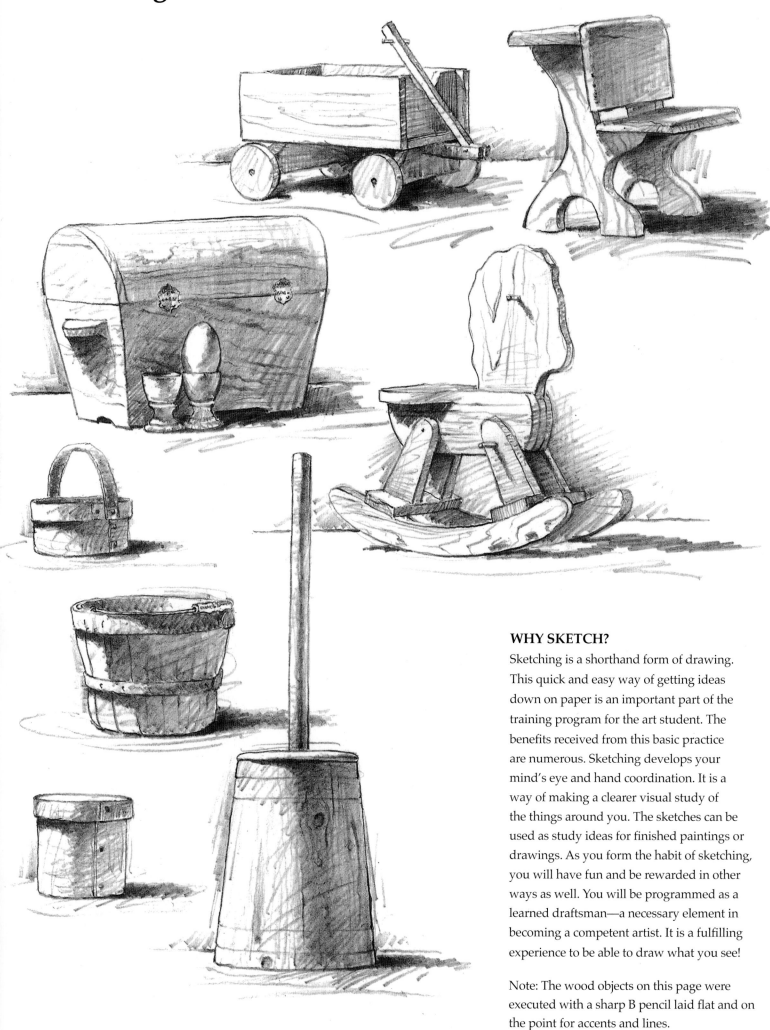

WHY SKETCH?

Sketching is a shorthand form of drawing. This quick and easy way of getting ideas down on paper is an important part of the training program for the art student. The benefits received from this basic practice are numerous. Sketching develops your mind's eye and hand coordination. It is a way of making a clearer visual study of the things around you. The sketches can be used as study ideas for finished paintings or drawings. As you form the habit of sketching, you will have fun and be rewarded in other ways as well. You will be programmed as a learned draftsman—a necessary element in becoming a competent artist. It is a fulfilling experience to be able to draw what you see!

Note: The wood objects on this page were executed with a sharp B pencil laid flat and on the point for accents and lines.

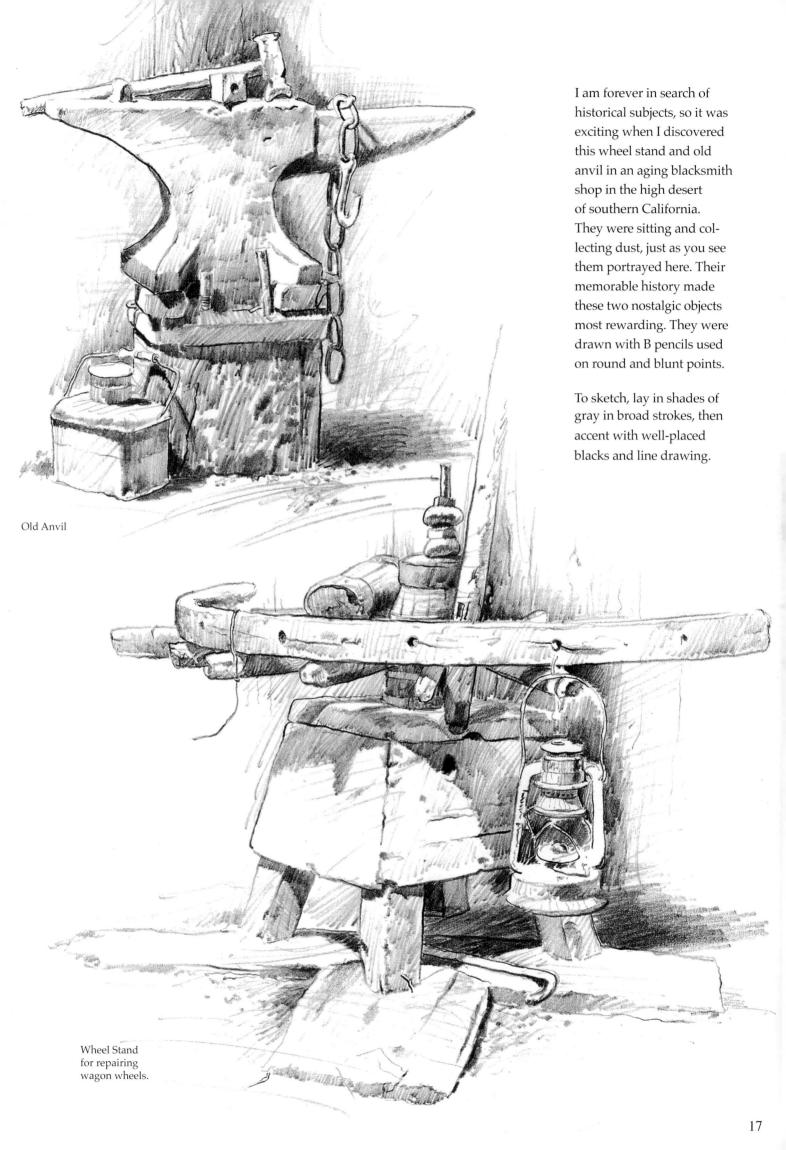

I am forever in search of historical subjects, so it was exciting when I discovered this wheel stand and old anvil in an aging blacksmith shop in the high desert of southern California. They were sitting and collecting dust, just as you see them portrayed here. Their memorable history made these two nostalgic objects most rewarding. They were drawn with B pencils used on round and blunt points.

To sketch, lay in shades of gray in broad strokes, then accent with well-placed blacks and line drawing.

Old Anvil

Wheel Stand
for repairing
wagon wheels.

Grapefruit

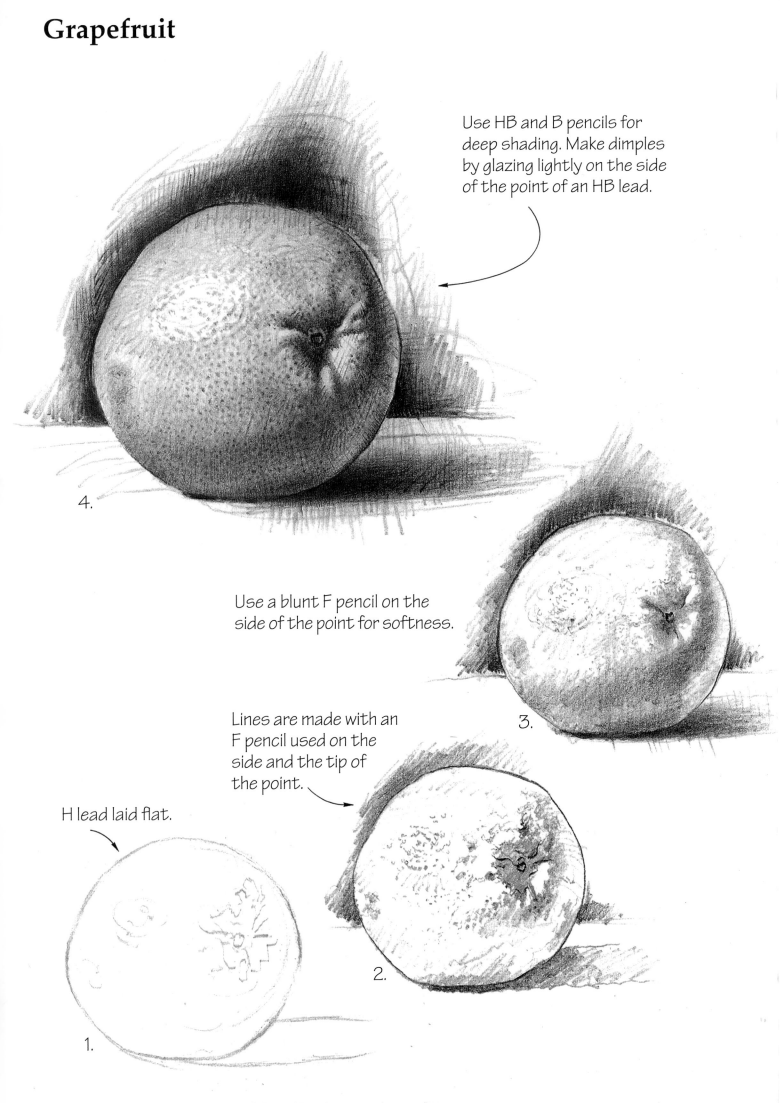

Use HB and B pencils for deep shading. Make dimples by glazing lightly on the side of the point of an HB lead.

4.

Use a blunt F pencil on the side of the point for softness.

3.

Lines are made with an F pencil used on the side and the tip of the point.

H lead laid flat.

2.

1.

Cabbage

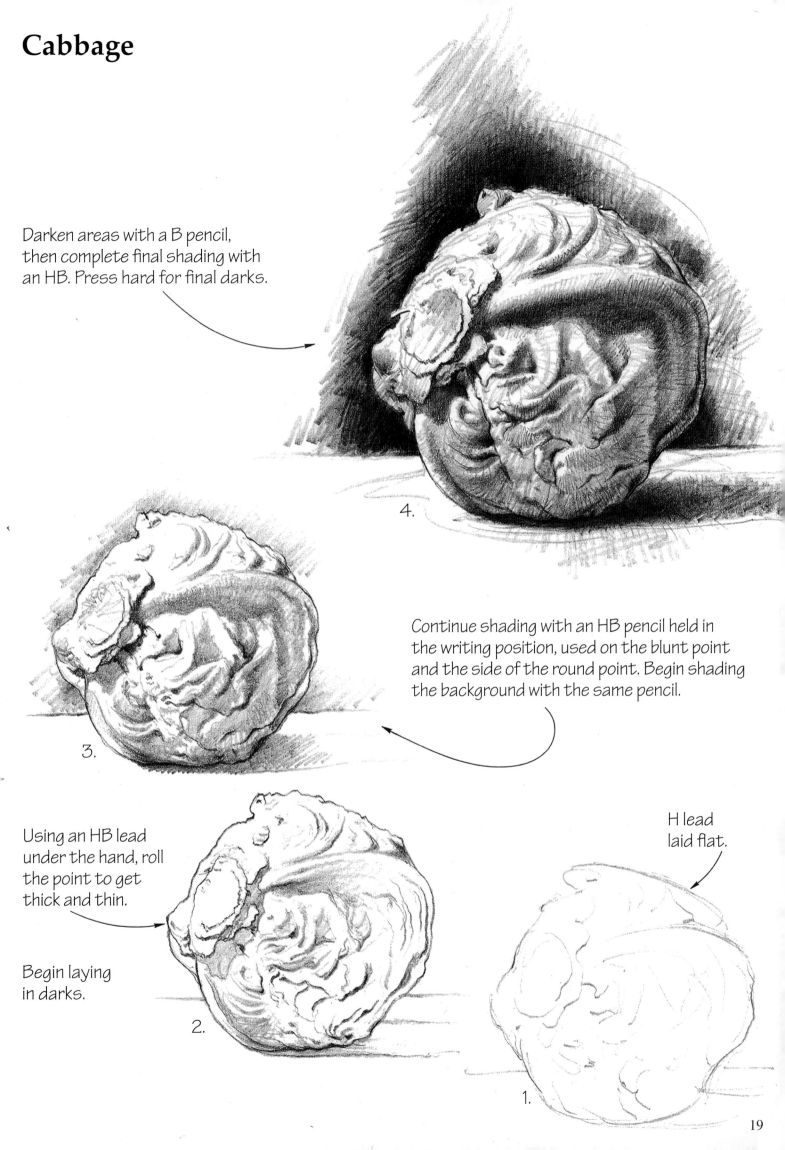

Darken areas with a B pencil, then complete final shading with an HB. Press hard for final darks.

4.

Continue shading with an HB pencil held in the writing position, used on the blunt point and the side of the round point. Begin shading the background with the same pencil.

3.

Using an HB lead under the hand, roll the point to get thick and thin.

Begin laying in darks.

2.

H lead laid flat.

1.

Glass Bottles

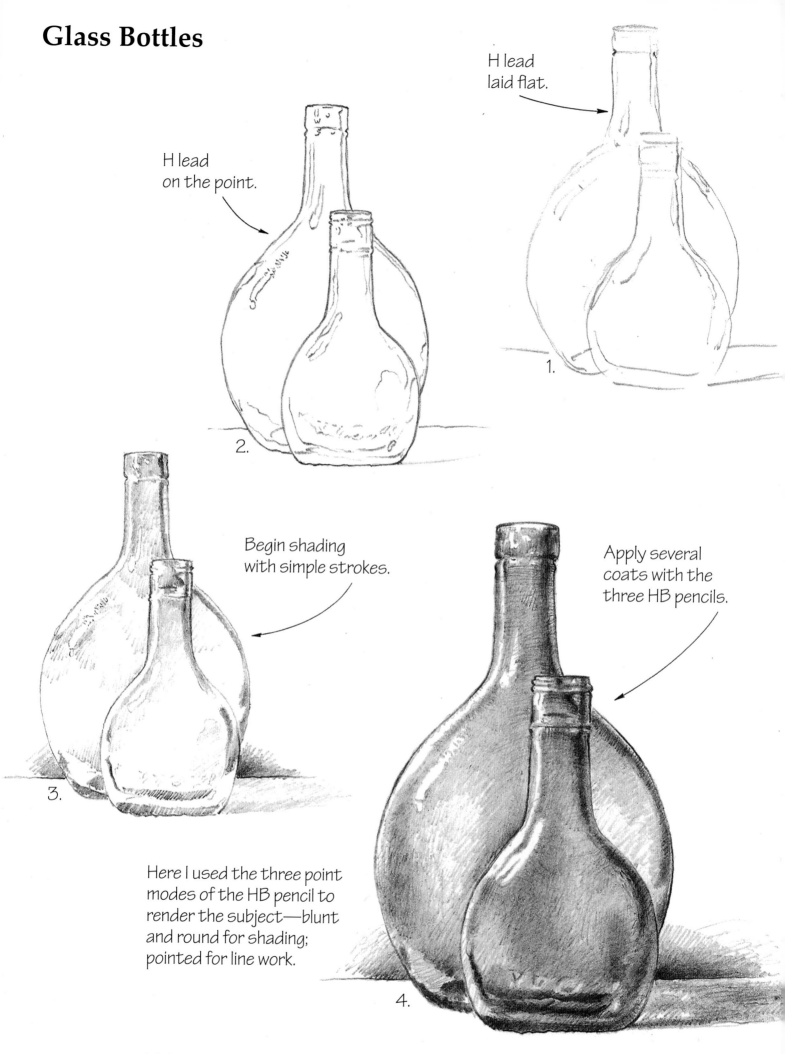

H lead
laid flat.

H lead
on the point.

1.

2.

Begin shading
with simple strokes.

Apply several
coats with the
three HB pencils.

3.

Here I used the three point
modes of the HB pencil to
render the subject—blunt
and round for shading;
pointed for line work.

4.

Multiple coats of soft strokes and glazing were used to simulate glass.

Coffee Pot

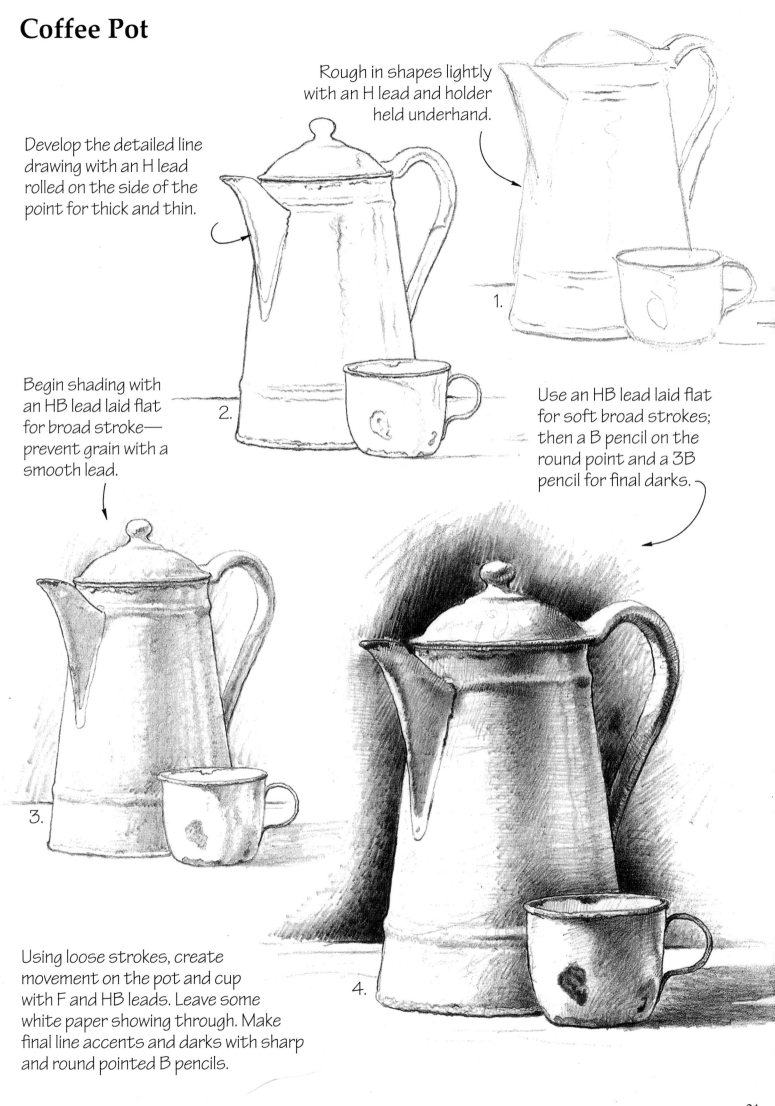

Rough in shapes lightly with an H lead and holder held underhand.

Develop the detailed line drawing with an H lead rolled on the side of the point for thick and thin.

1.

Begin shading with an HB lead laid flat for broad stroke—prevent grain with a smooth lead.

2.

Use an HB lead laid flat for soft broad strokes; then a B pencil on the round point and a 3B pencil for final darks.

3.

Using loose strokes, create movement on the pot and cup with F and HB leads. Leave some white paper showing through. Make final line accents and darks with sharp and round pointed B pencils.

4.

Ancient Treasures

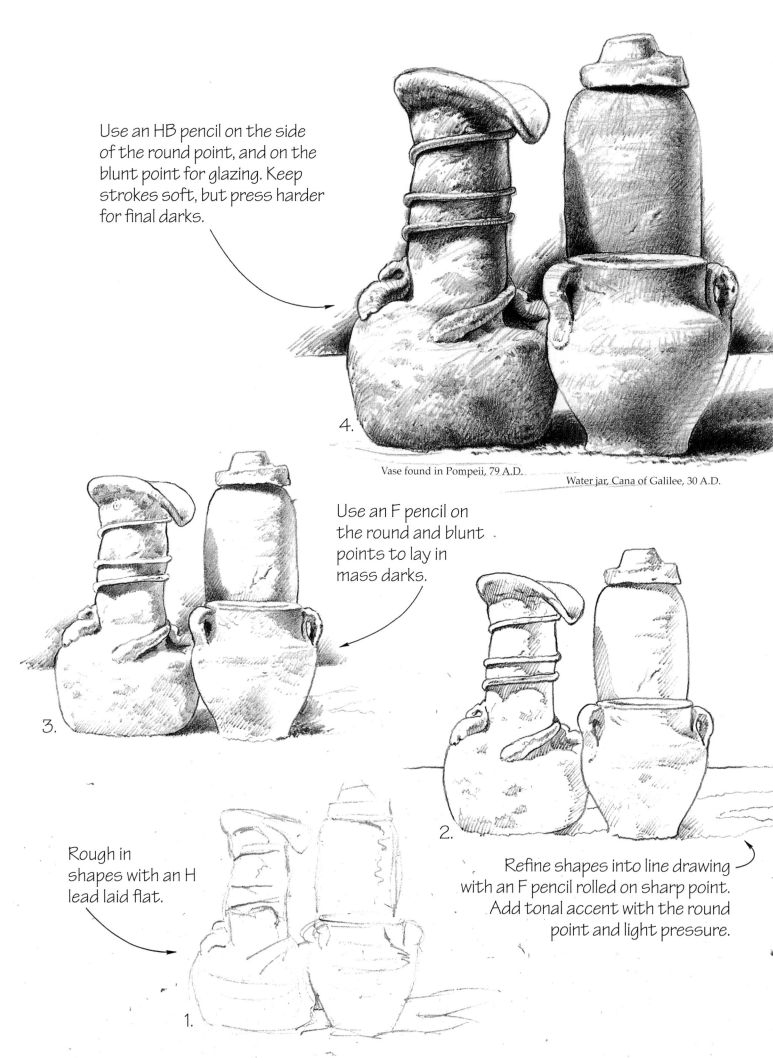

Use an HB pencil on the side of the round point, and on the blunt point for glazing. Keep strokes soft, but press harder for final darks.

4.

Vase found in Pompeii, 79 A.D.

Water jar, Cana of Galilee, 30 A.D.

Use an F pencil on the round and blunt points to lay in mass darks.

3.

Rough in shapes with an H lead laid flat.

Refine shapes into line drawing with an F pencil rolled on sharp point. Add tonal accent with the round point and light pressure.

2.

1.

22

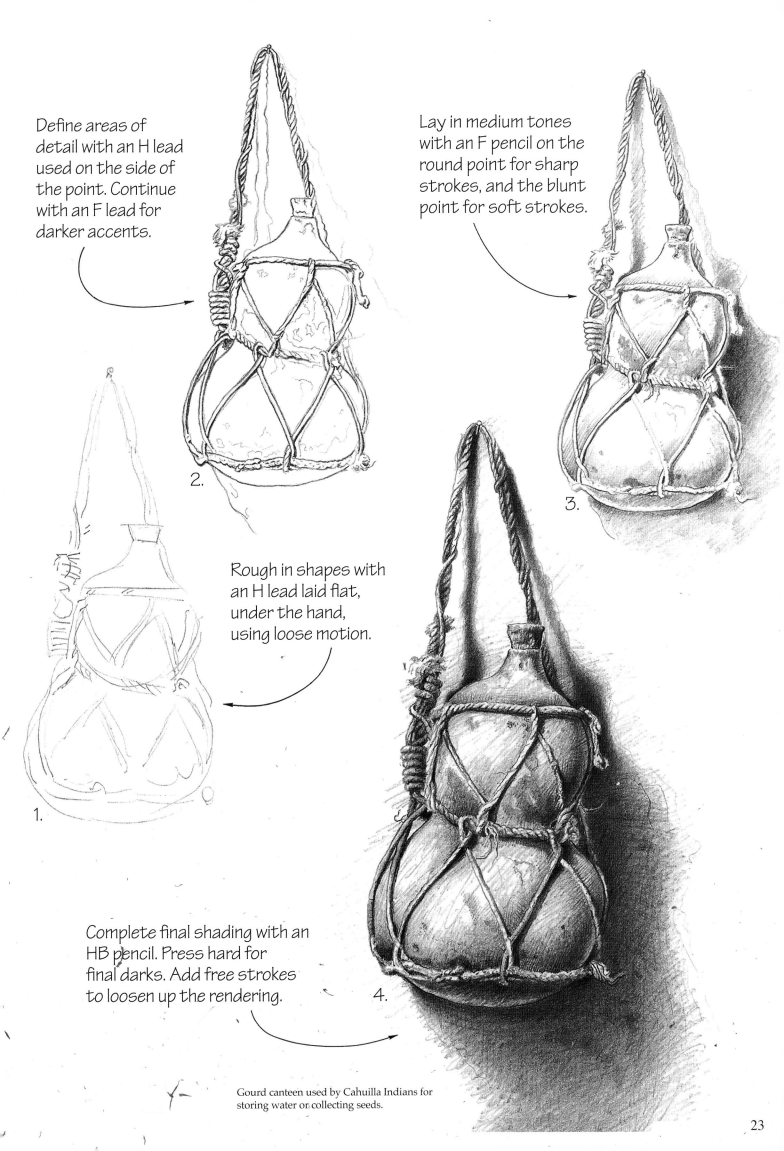

Define areas of detail with an H lead used on the side of the point. Continue with an F lead for darker accents.

2.

Lay in medium tones with an F pencil on the round point for sharp strokes, and the blunt point for soft strokes.

3.

Rough in shapes with an H lead laid flat, under the hand, using loose motion.

1.

Complete final shading with an HB pencil. Press hard for final darks. Add free strokes to loosen up the rendering.

4.

Gourd canteen used by Cahuilla Indians for storing water or collecting seeds.

Conch

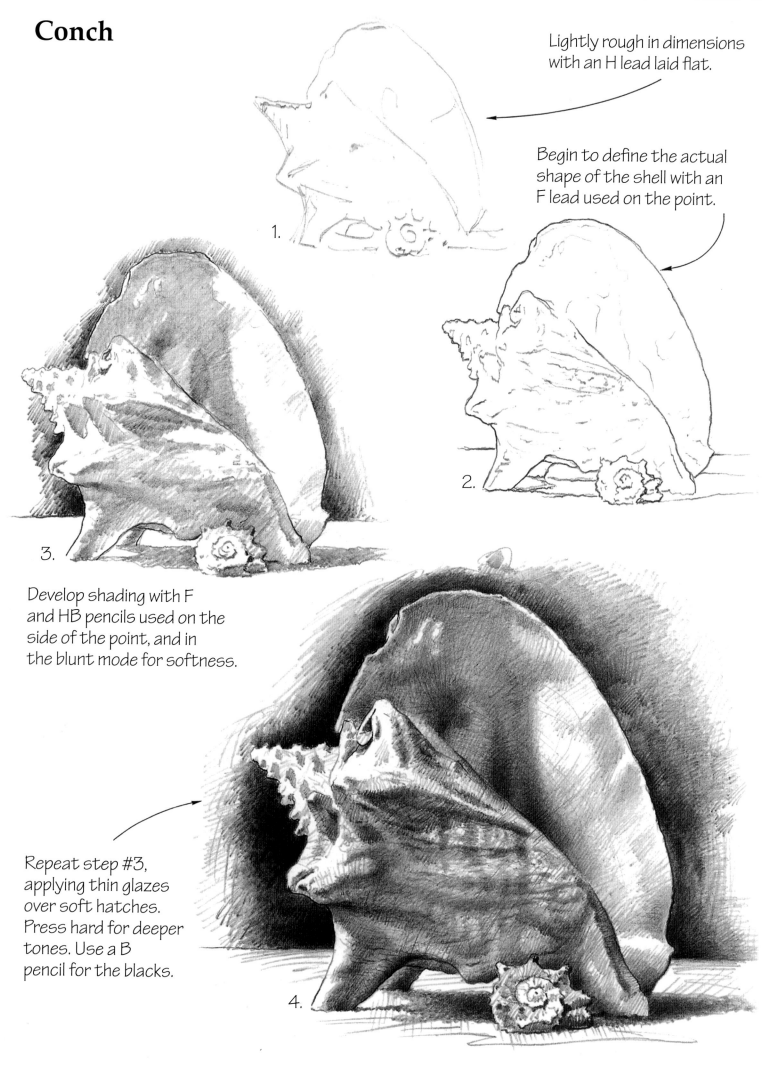

Lightly rough in dimensions with an H lead laid flat.

Begin to define the actual shape of the shell with an F lead used on the point.

1.

2.

3.

Develop shading with F and HB pencils used on the side of the point, and in the blunt mode for softness.

Repeat step #3, applying thin glazes over soft hatches. Press hard for deeper tones. Use a B pencil for the blacks.

4.

The porcelain-like luster of the conch is created with multi-layers of shading.

Starfish

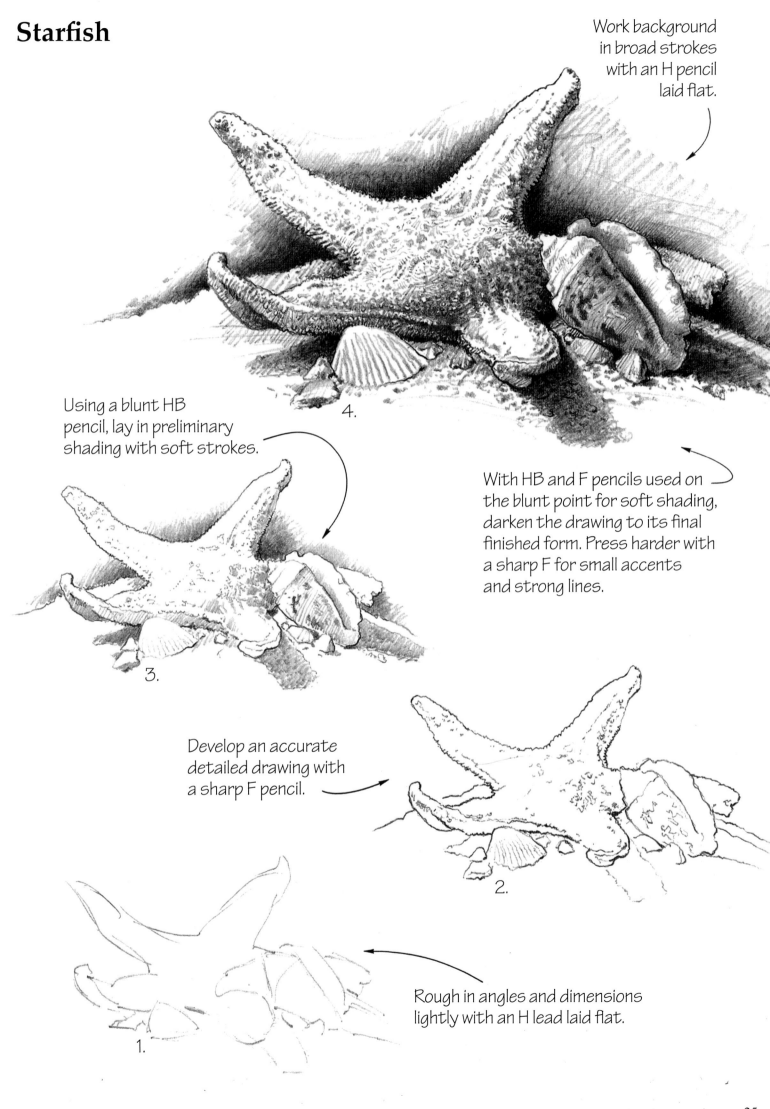

Work background in broad strokes with an H pencil laid flat.

Using a blunt HB pencil, lay in preliminary shading with soft strokes.

With HB and F pencils used on the blunt point for soft shading, darken the drawing to its final finished form. Press harder with a sharp F for small accents and strong lines.

4.

3.

Develop an accurate detailed drawing with a sharp F pencil.

2.

Rough in angles and dimensions lightly with an H lead laid flat.

1.

Ball and Glove

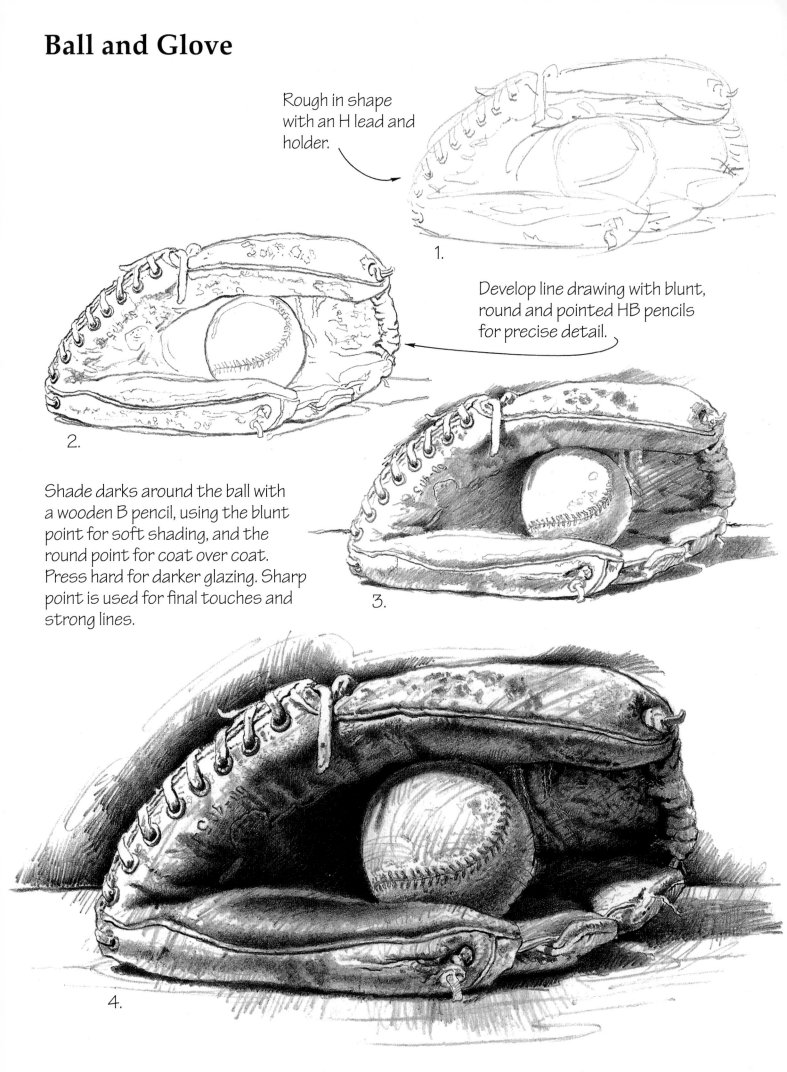

Rough in shape with an H lead and holder.

1.

Develop line drawing with blunt, round and pointed HB pencils for precise detail.

2.

Shade darks around the ball with a wooden B pencil, using the blunt point for soft shading, and the round point for coat over coat. Press hard for darker glazing. Sharp point is used for final touches and strong lines.

3.

4.

Repeat steps 1-3 with a 3B pencil—alternating the blunt, round, and sharp points. Change pencils and point modes freely.

Tennis Shoes

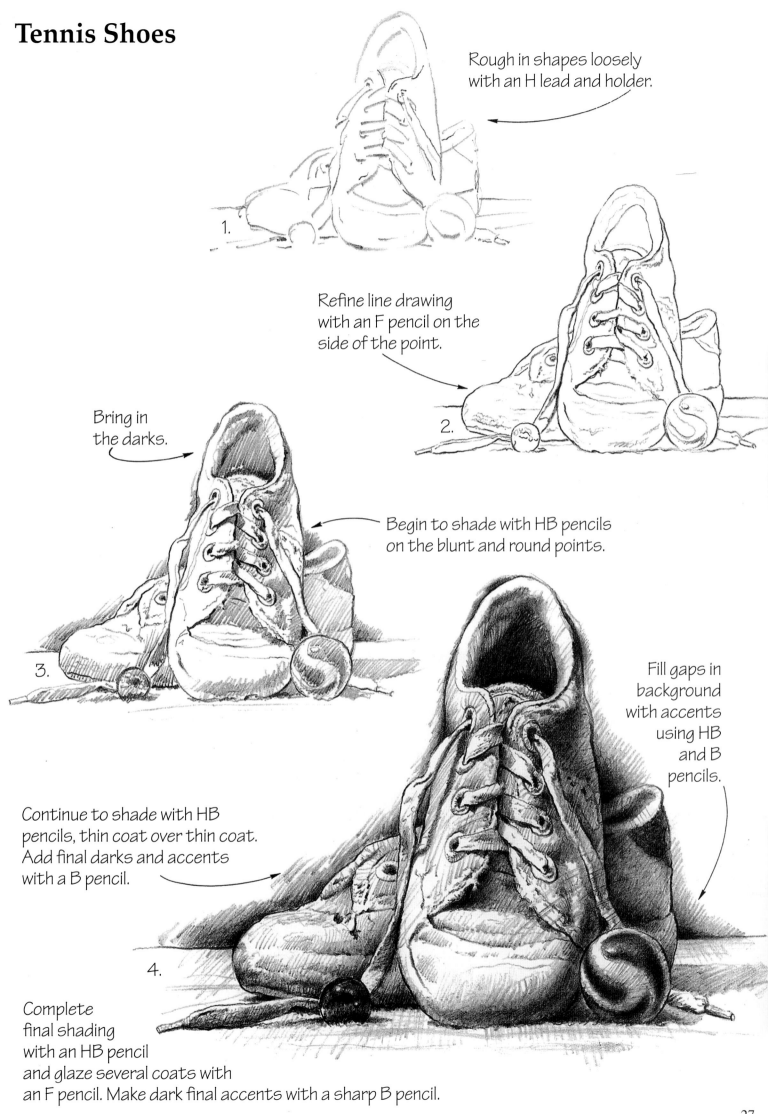

Rough in shapes loosely with an H lead and holder.

1.

Refine line drawing with an F pencil on the side of the point.

2.

Bring in the darks.

Begin to shade with HB pencils on the blunt and round points.

3.

Continue to shade with HB pencils, thin coat over thin coat. Add final darks and accents with a B pencil.

Fill gaps in background with accents using HB and B pencils.

4.

Complete final shading with an HB pencil and glaze several coats with an F pencil. Make dark final accents with a sharp B pencil.

Toy Car

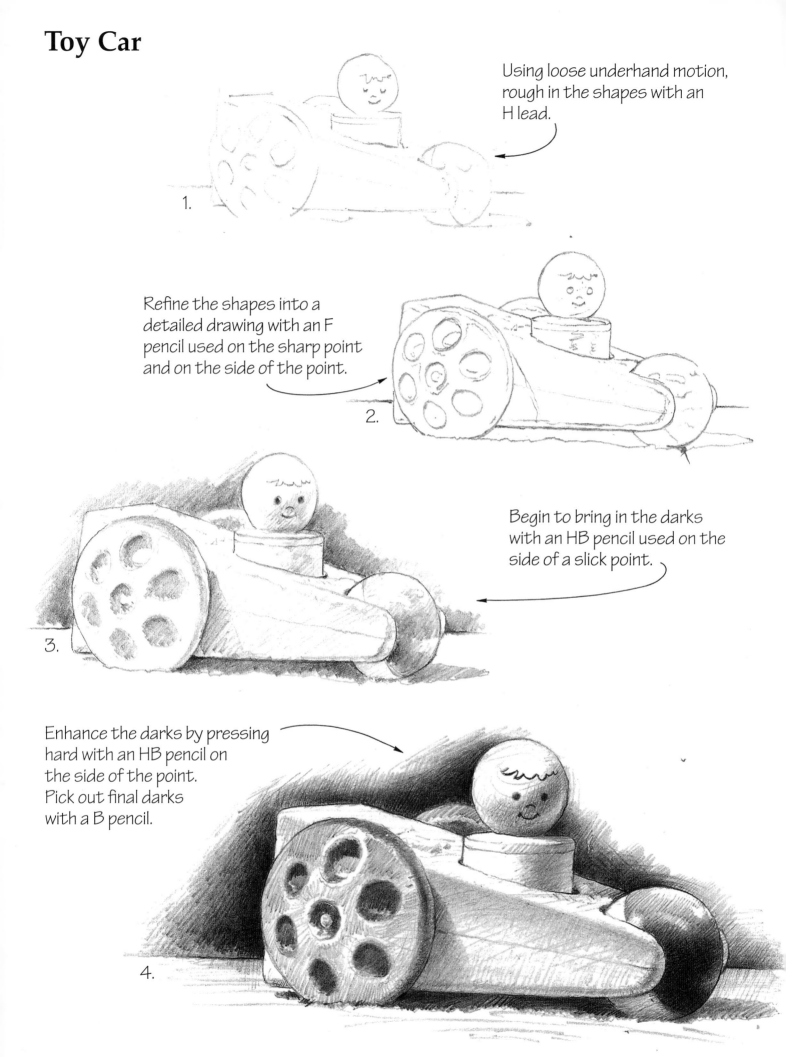

Using loose underhand motion, rough in the shapes with an H lead.

1.

Refine the shapes into a detailed drawing with an F pencil used on the sharp point and on the side of the point.

2.

Begin to bring in the darks with an HB pencil used on the side of a slick point.

3.

Enhance the darks by pressing hard with an HB pencil on the side of the point. Pick out final darks with a B pencil.

4.

Round, cylindrical, and triangular shapes, and indented ovals show variety of design.

Blocks and Marbles

Rough in the drawing holding an H lead under the hand.

1.

Use an F pencil for fine line drawing. Keep the point nice and sharp.

2.

Develop the shading softly with an HB pencil on the blunt point. Turn the sharp edge for accent lines.

3.

With HB and F pencils on the blunt and round points, darken the drawing. Press firmly with a B pencil for final darks.

4.

These fun objects show round and square shapes in perspective.

Monkey Business

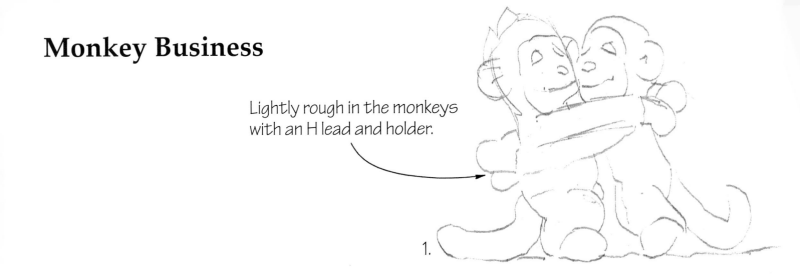

Lightly rough in the monkeys with an H lead and holder.

1.

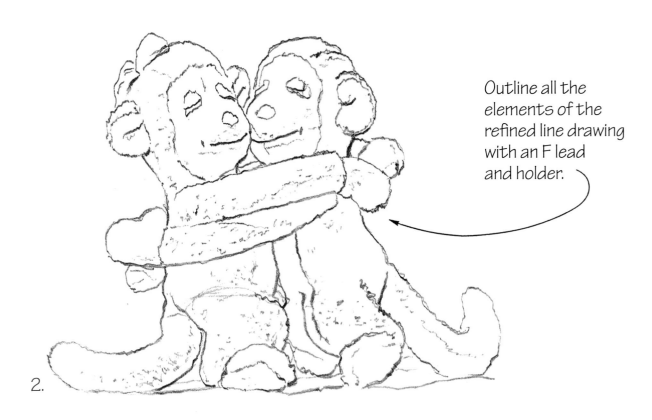

Outline all the elements of the refined line drawing with an F lead and holder.

2.

Use blunt B pencils for darks.

Begin shading with HB and B pencils. Pick out the darks in medium tones, and accent lines.

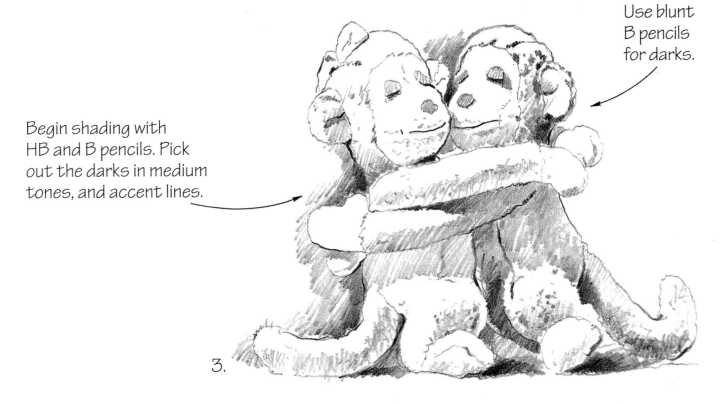

3.

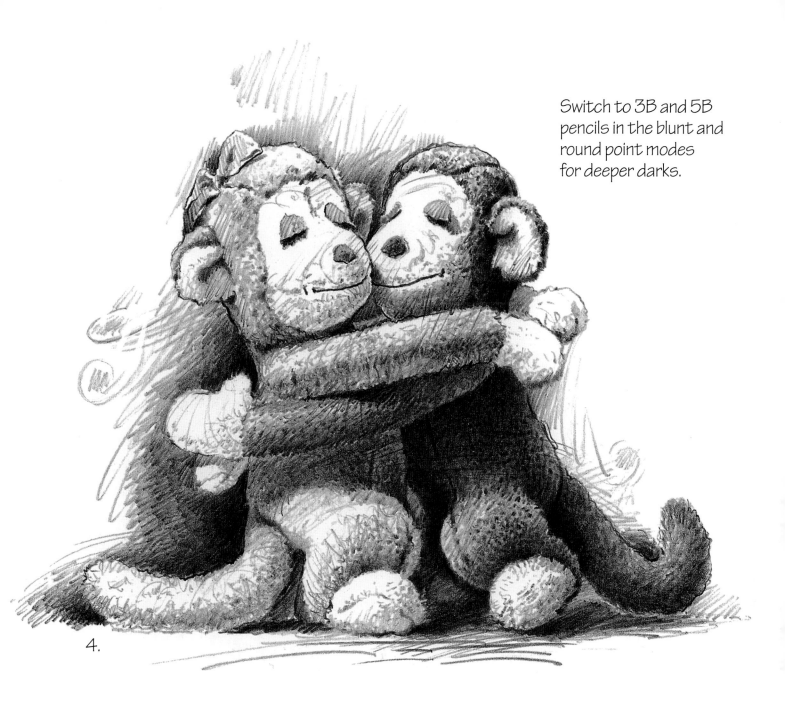

4.

Switch to 3B and 5B pencils in the blunt and round point modes for deeper darks.

This fun drawing was done in a carefree method. I enjoyed making the bold strokes and innovative shading. The direct approach used with this subject helps to portray love and humorous affection.

Please understand that you can get more out of a pencil than you may expect. If you will practice the sharp, round, and blunt point modes, then you will execute the magical strokes that are demonstrated here.

I am often surprised with the immediate results from my pencils. At first, the HB seemed to be doing well, but as I progressed, I realized that the softer grades were more effective for the bolder and darker tones. I was delighted to see, as I worked through the B and 3Bs, that I could

glaze and stroke with the 5B pencil worn smooth for final darks. The principle of needing to change pencils midstream is true with the development of many drawings.

The factors determining which tools are to be utilized on a given project are paper, size of the subject, character of style, and coarseness of strokes desired.

So, consider your projects carefully. Realize that the success of your pencil drawings in your hands. Dedicated practice of the basic steps, wise selection of your subject, proper lighting of the subject, thoughtful control of the materials, and a personal handling of the pencil will yield fantastic results.

Antique Doll

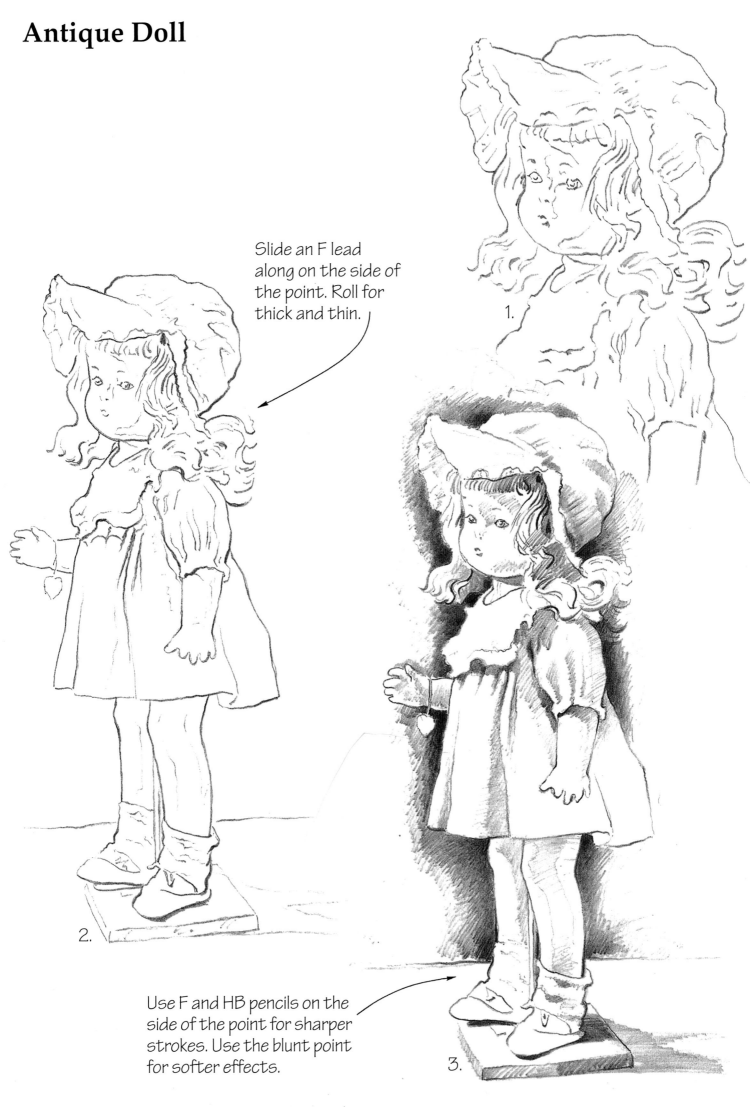

Slide an F lead along on the side of the point. Roll for thick and thin.

1.

2.

Use F and HB pencils on the side of the point for sharper strokes. Use the blunt point for softer effects.

3.

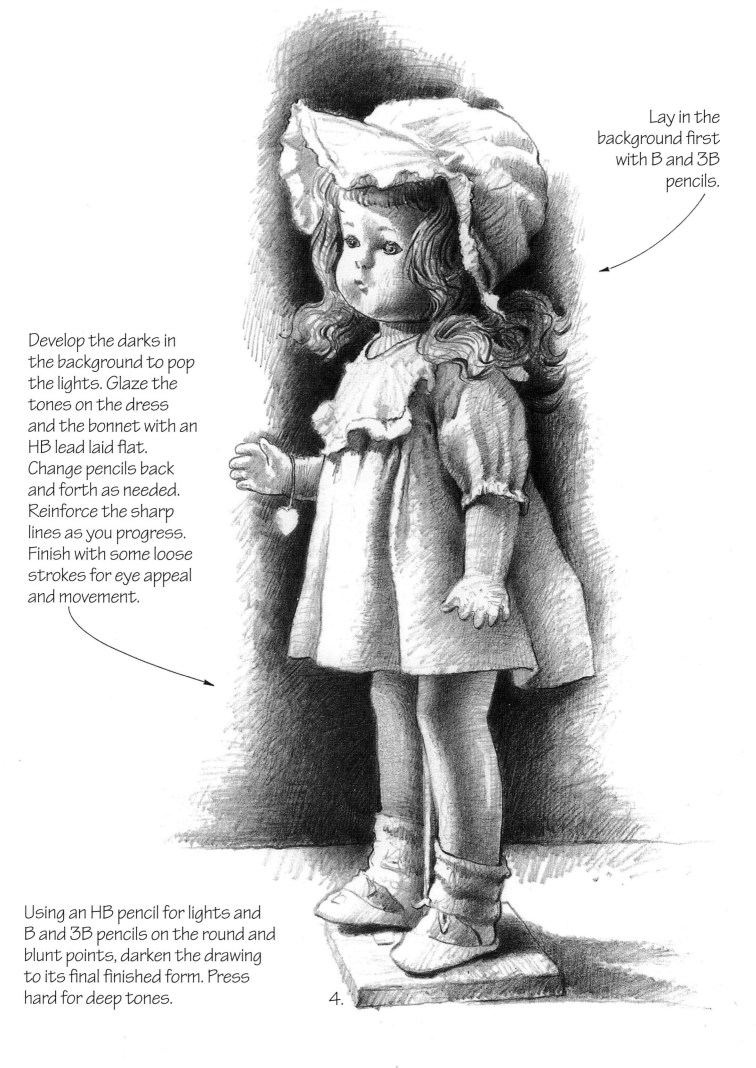

Lay in the background first with B and 3B pencils.

Develop the darks in the background to pop the lights. Glaze the tones on the dress and the bonnet with an HB lead laid flat. Change pencils back and forth as needed. Reinforce the sharp lines as you progress. Finish with some loose strokes for eye appeal and movement.

Using an HB pencil for lights and B and 3B pencils on the round and blunt points, darken the drawing to its final finished form. Press hard for deep tones.

4.

Many will remember this nostalgic doll from the 1930s.

Railroad Lantern

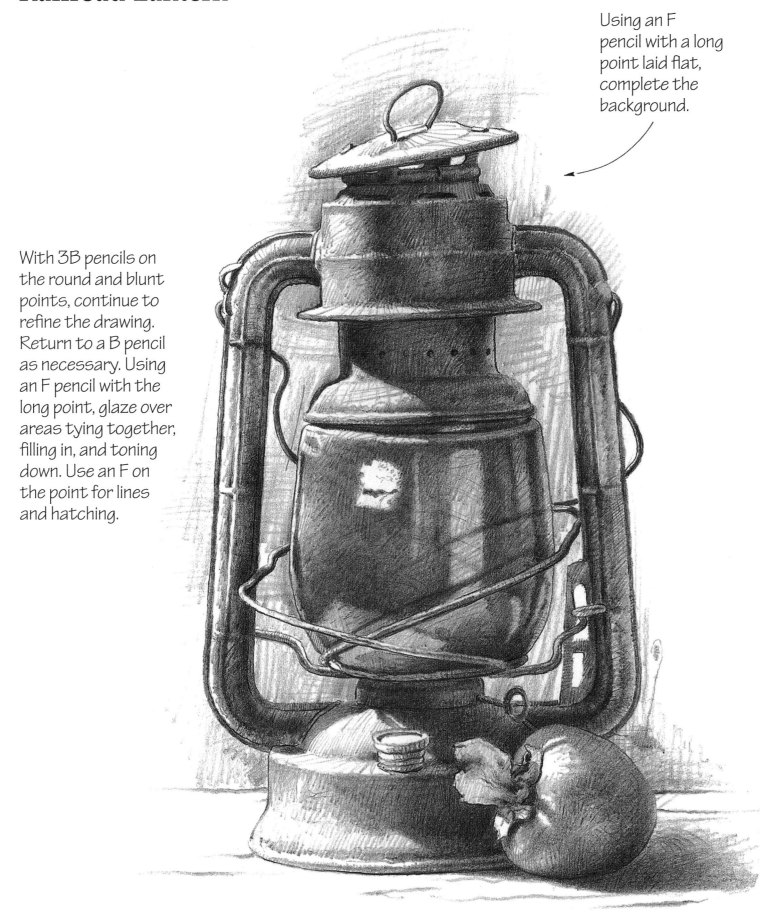

Using an F pencil with a long point laid flat, complete the background.

With 3B pencils on the round and blunt points, continue to refine the drawing. Return to a B pencil as necessary. Using an F pencil with the long point, glaze over areas tying together, filling in, and toning down. Use an F on the point for lines and hatching.

This old railroad lantern was found at an antique barn nearby. Its ruby globe brings back memories of swaying lights and mournful whistles on midnight freights that rumbled through town years ago.

Hand Pump

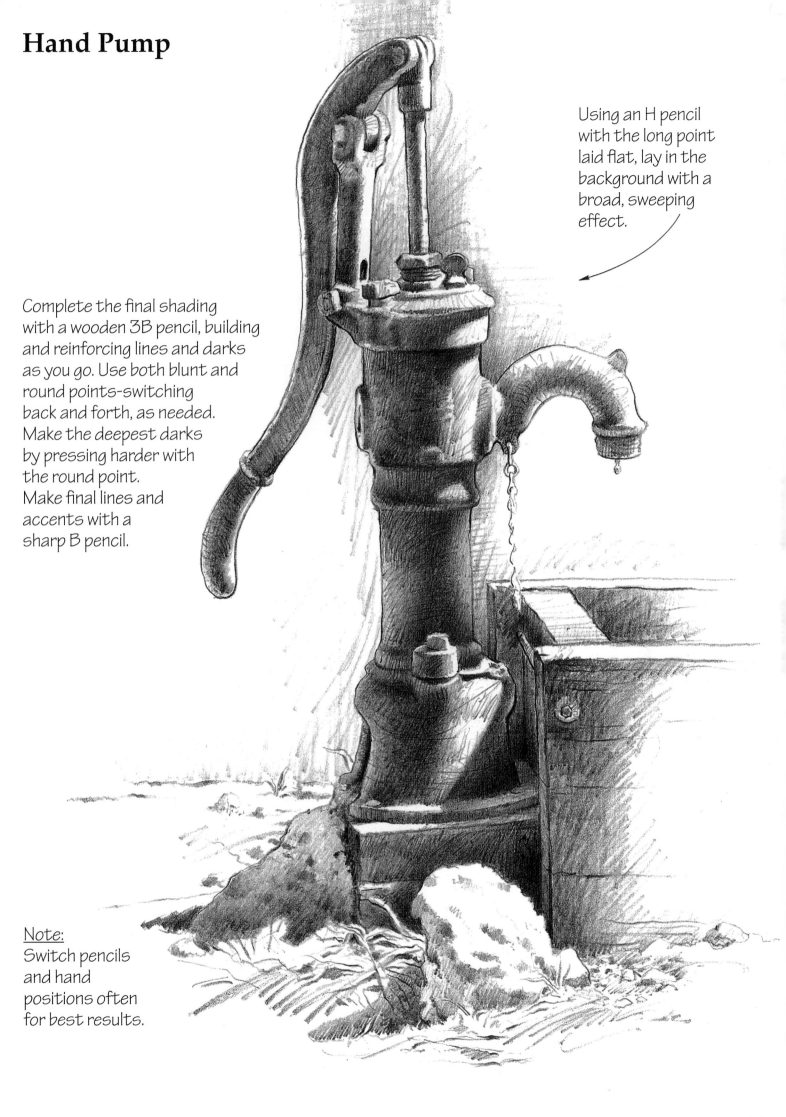

Using an H pencil with the long point laid flat, lay in the background with a broad, sweeping effect.

Complete the final shading with a wooden 3B pencil, building and reinforcing lines and darks as you go. Use both blunt and round points-switching back and forth, as needed. Make the deepest darks by pressing harder with the round point. Make final lines and accents with a sharp B pencil.

<u>Note:</u>
Switch pencils and hand positions often for best results.

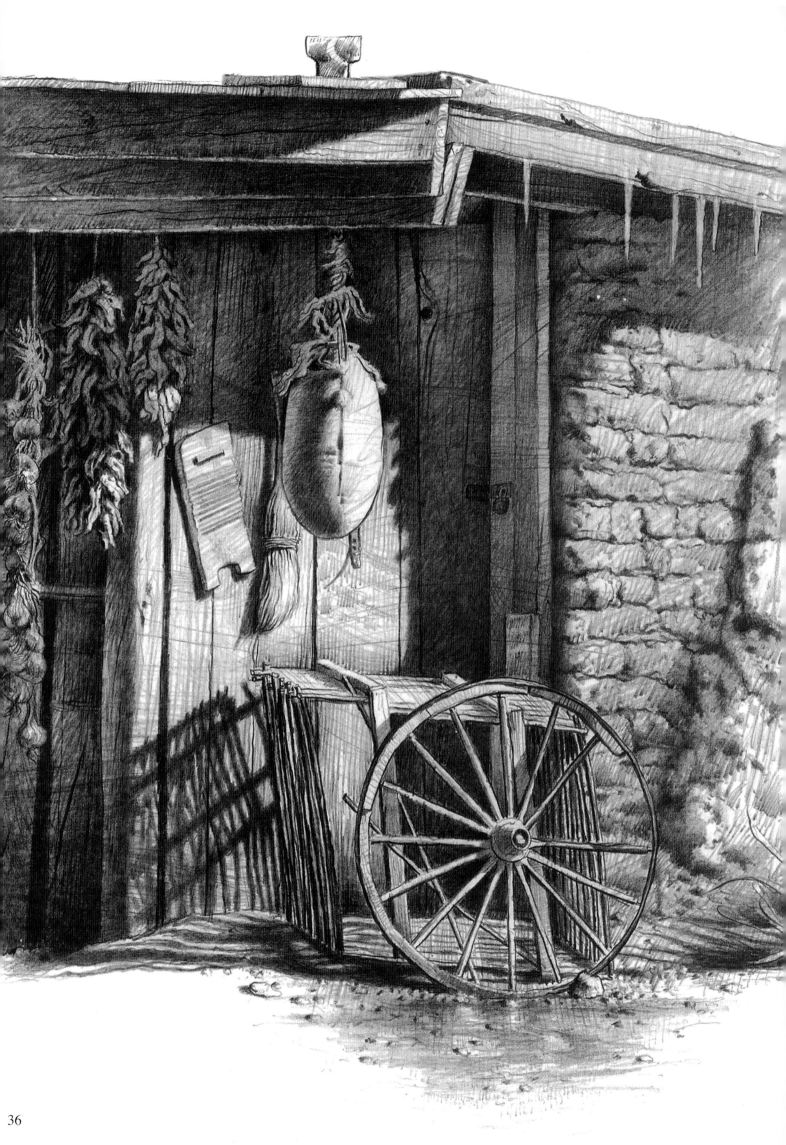

Buildings

Buildings are great subjects for pencil drawing; they are a good source of texture and design. Remember, they were originally architectural drawings before they became houses and sky-scrapers!

CHOOSING THE SUBJECT

Always be on the lookout for interesting structures in your travels. The old railroad station in town or an old farmhouse out in the country may excite you. Perhaps that remodeled urban center downtown has some artistic elements. Learn to glean inspiration from the history or an interesting incident that may have occurred in and around the building. Often, old structures tell a compelling story about our past. As you absorb the "feel" of the place, you will become more expressive in the way you represent it on paper. Whether you choose a new building or an old one, be sure to take plenty of photos and slides for future use.

PLANNING THE COMPOSITION

When selecting the building for your work, walk around and view it from various angles. There is usually a 'best side" to any structure. Remember to consider the surrounding landscape: trees, bushes, walkways, fences, stone walls, and lampposts can all be used to enhance the composition. Here in the West we often find mountains looming behind a building. Mountains can add a dramatic dimension to your drawings. Don't be reluctant to change your landscape elements or move them around in your picture. For example, decide if the tree would look better on the left corner of the house rather than on the right corner.

Here are some tips to ensure success in selecting and drawing your buildings:
- View the structure at different times of the day and from all angles for the proper lighting.
- Good "cross lighting" is found in the early morning and late afternoon.
- Look for interesting lights and shadows.
- Strive for good perspective. There are many good books on this subject—study some of them!
- Plan the composition and shape of your picture to enhance the building.

Add some loose strokes to create eye movement and action, and to enrich your technique.

SECTION 3

Sketching

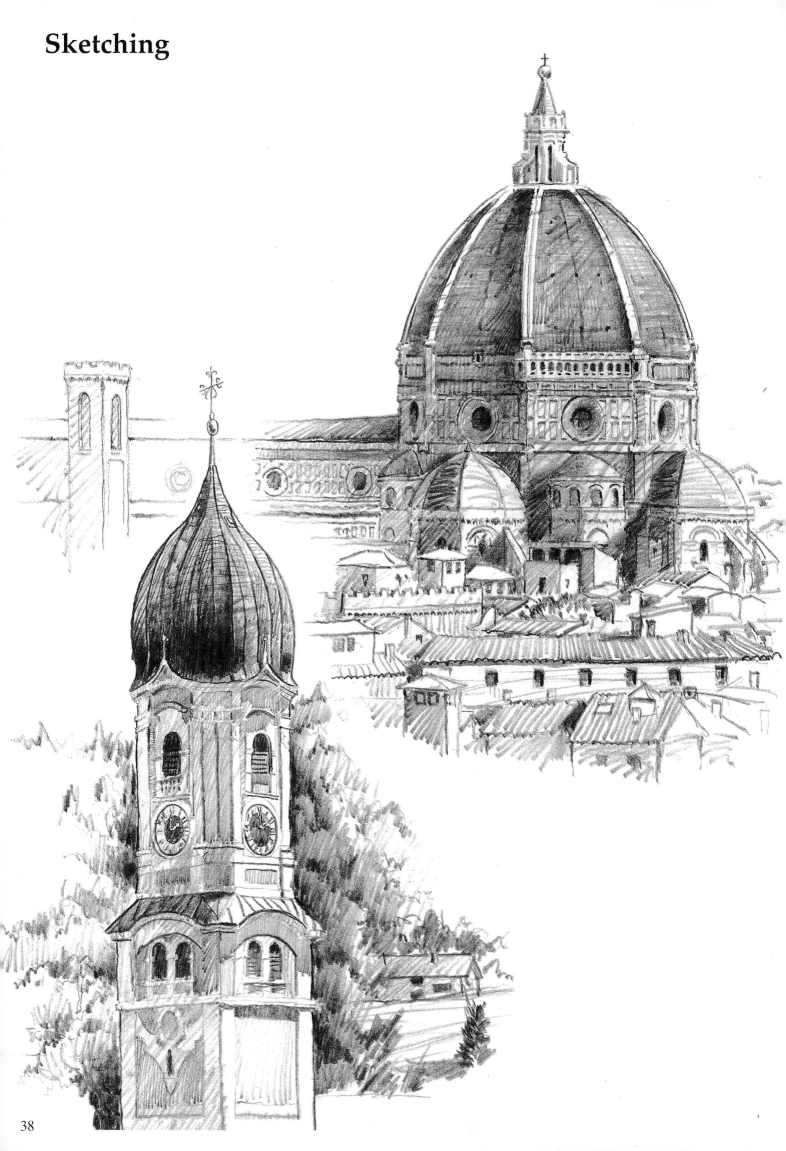

The fun sketches on these pages were done with a B pencil, and a 3B for final darks.

Oregon Barn

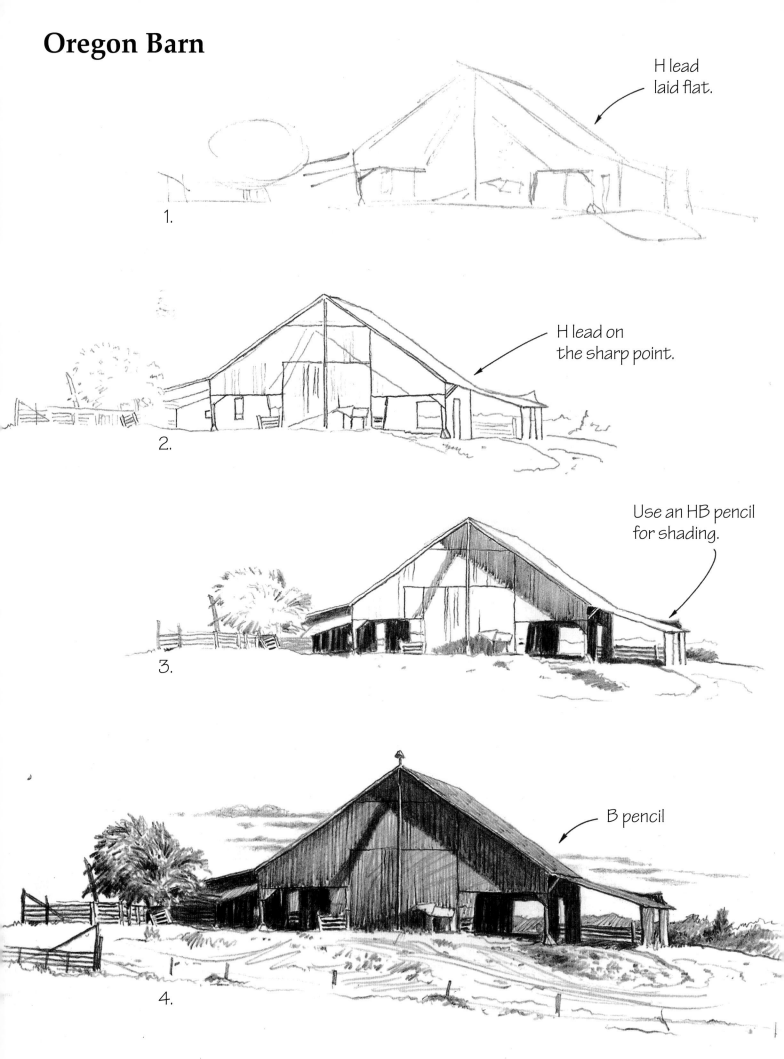

H lead
laid flat.

1.

H lead on
the sharp point.

2.

Use an HB pencil
for shading.

3.

B pencil

4.

Complete the final darks with B pencils in the blunt and sharp point modes.

Farmhouse

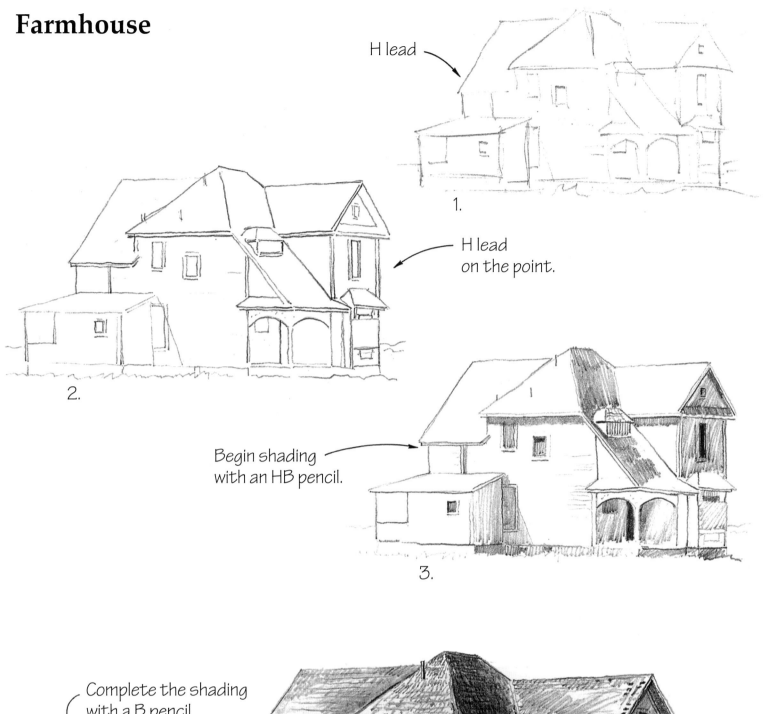

H lead

1.

H lead
on the point.

2.

Begin shading
with an HB pencil.

3.

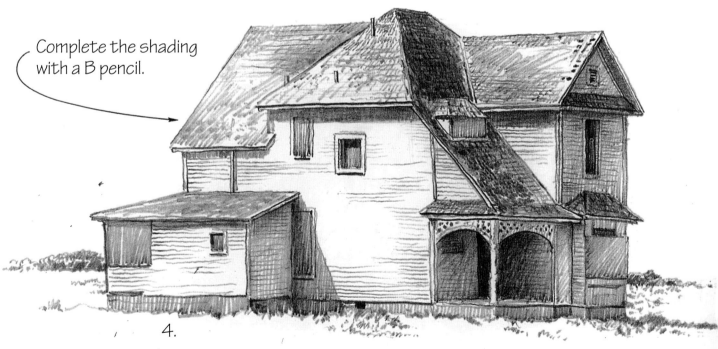

Complete the shading
with a B pencil.

4.

This interestingly-shaped and well-lit building is handled in a bold and simple
drawing technique.

Root Cellar

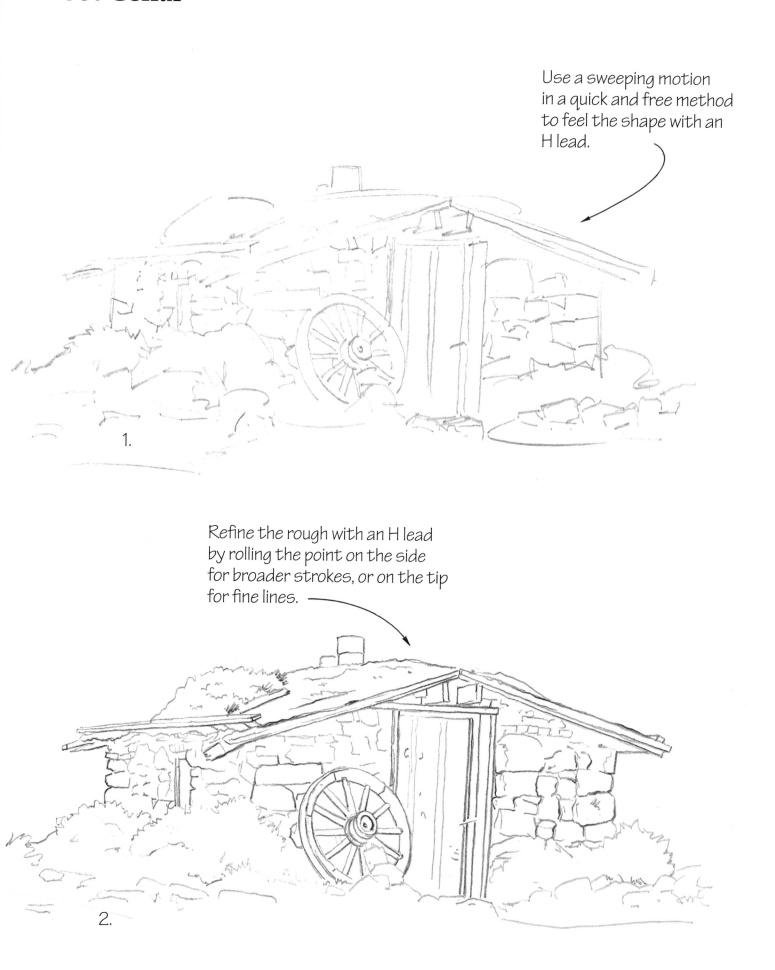

Use a sweeping motion in a quick and free method to feel the shape with an H lead.

1.

Refine the rough with an H lead by rolling the point on the side for broader strokes, or on the tip for fine lines.

2.

Observe carefully as you study the steps and apply information learned to the finished drawing.

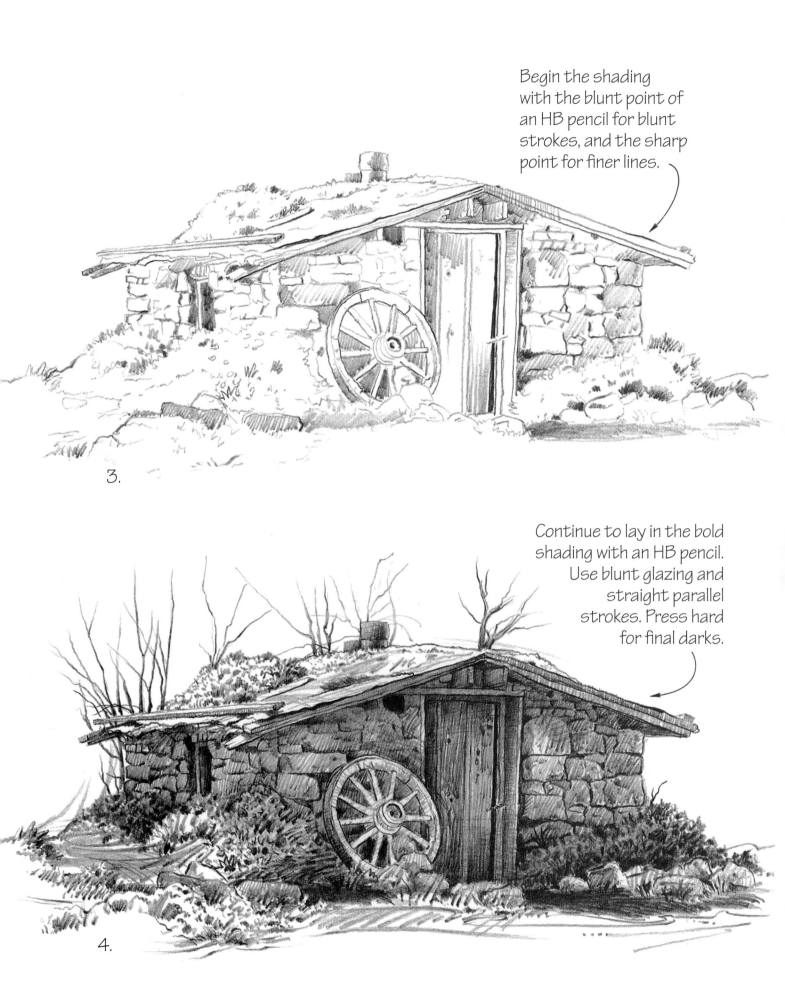

Begin the shading with the blunt point of an HB pencil for blunt strokes, and the sharp point for finer lines.

3.

Continue to lay in the bold shading with an HB pencil. Use blunt glazing and straight parallel strokes. Press hard for final darks.

4.

The trees in the final step were added for a special effect and to create variety of design.

Country Church

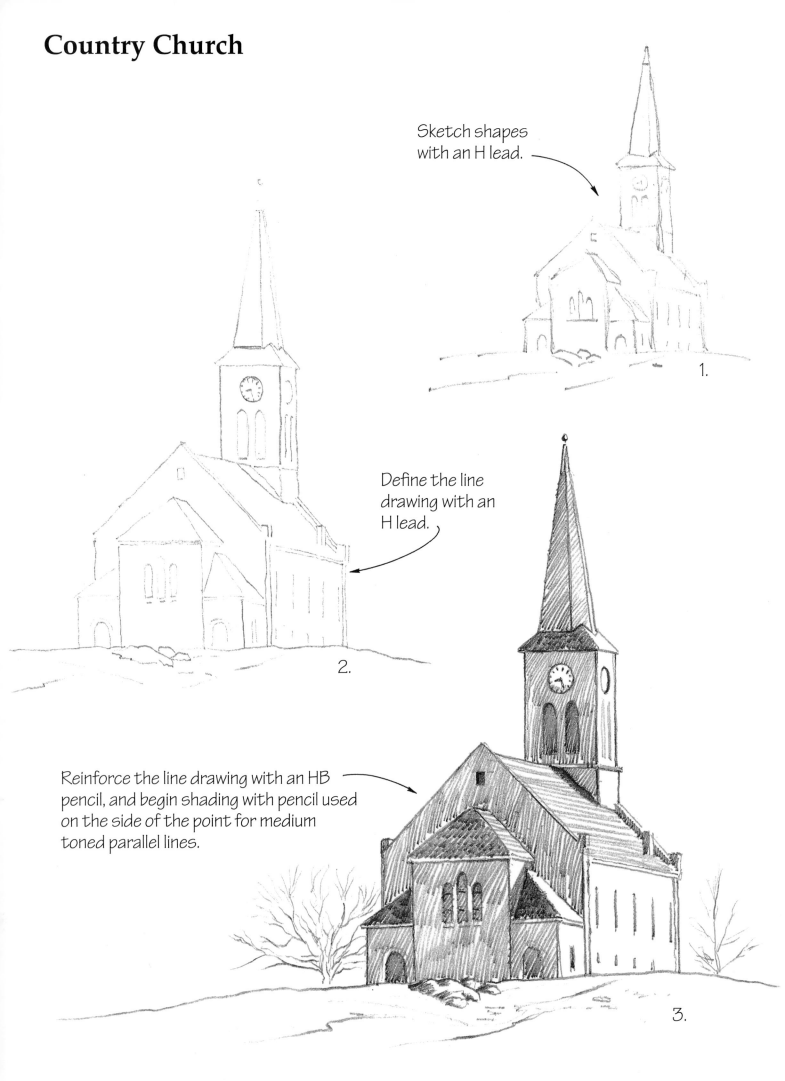

Sketch shapes with an H lead.

1.

Define the line drawing with an H lead.

2.

Reinforce the line drawing with an HB pencil, and begin shading with pencil used on the side of the point for medium toned parallel lines.

3.

Practice this bold method of preliminary shading in your own work.

Use strong darks against light
areas for dramatic contrast
as demonstrated here.

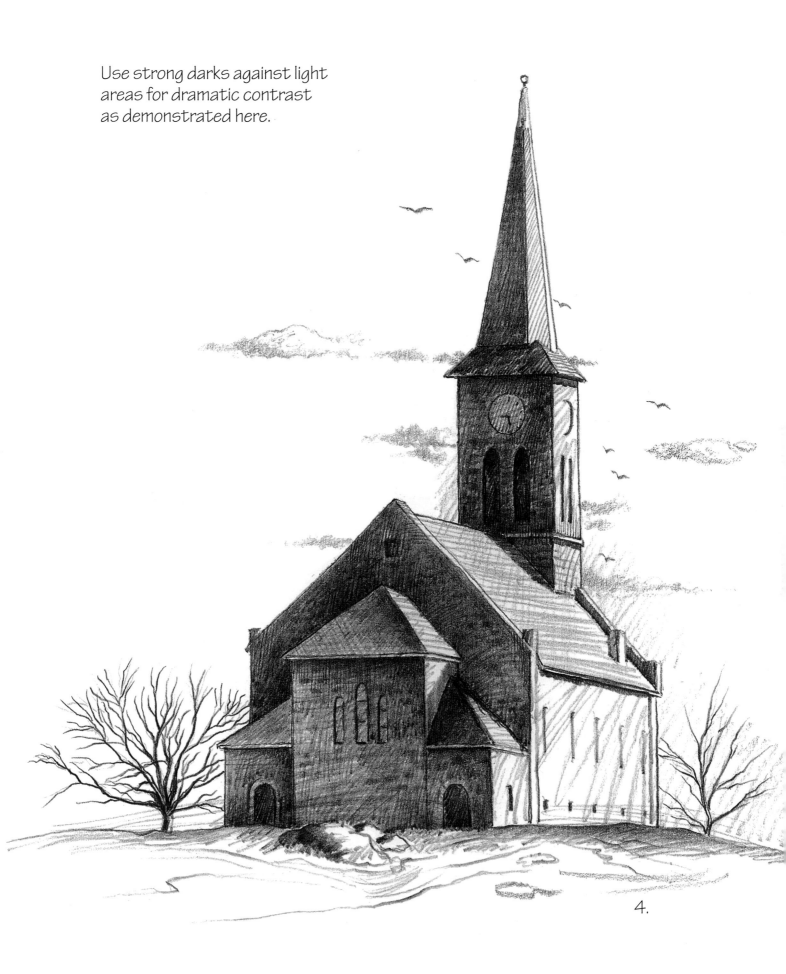

4.

Establish shadows with an HB pencil, then come on with a B pencil used on the blunt
and round points—pressing hard for dark contrasting tones and accented lines. A 3B
pencil may be needed for final blacks.

Windmill

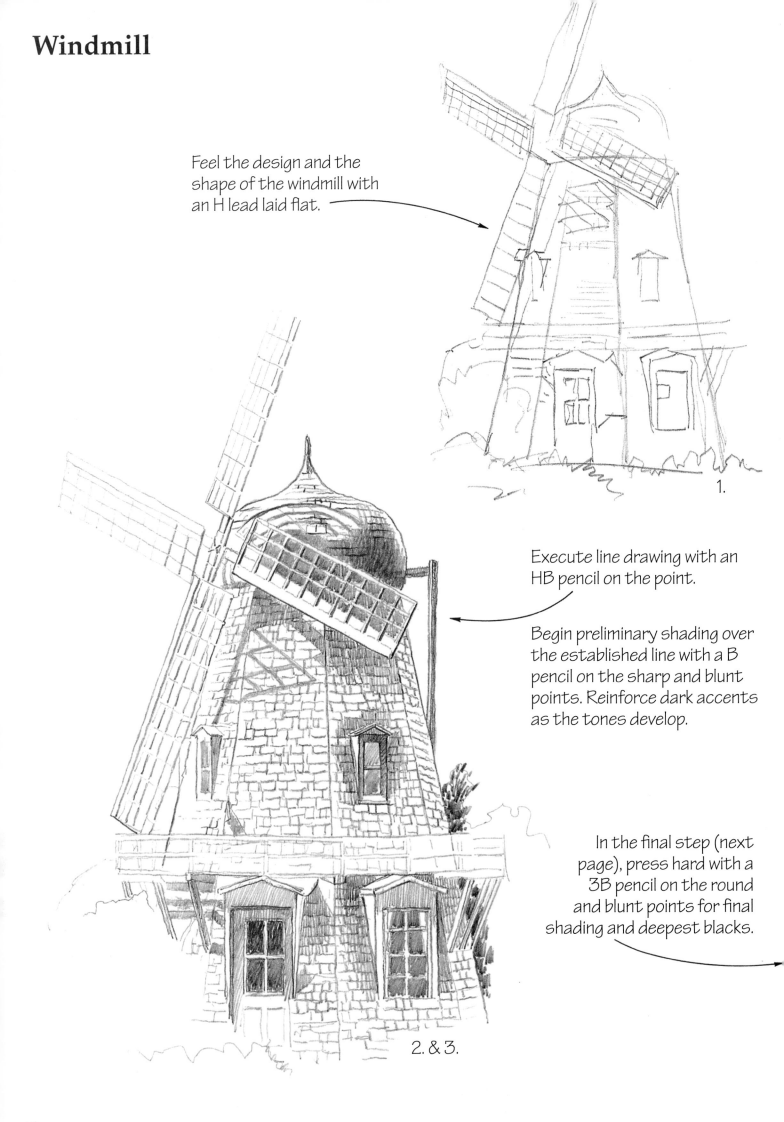

Feel the design and the shape of the windmill with an H lead laid flat.

1.

Execute line drawing with an HB pencil on the point.

Begin preliminary shading over the established line with a B pencil on the sharp and blunt points. Reinforce dark accents as the tones develop.

In the final step (next page), press hard with a 3B pencil on the round and blunt points for final shading and deepest blacks.

2. & 3.

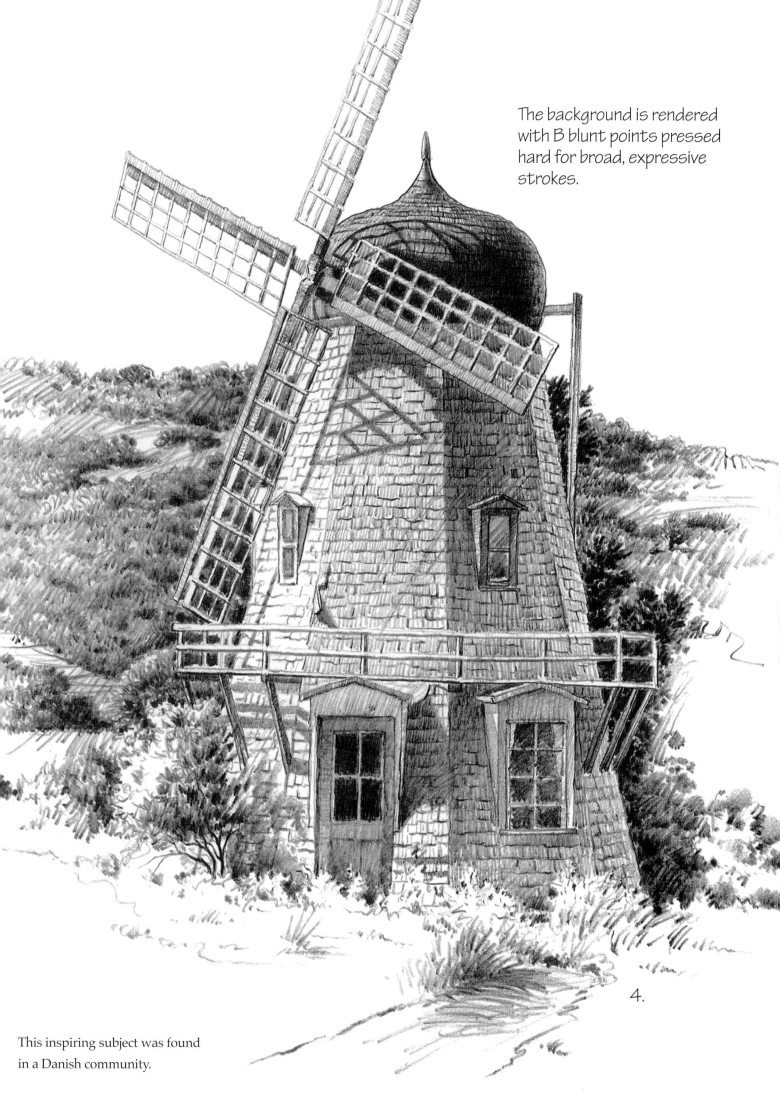

The background is rendered with B blunt points pressed hard for broad, expressive strokes.

4.

This inspiring subject was found in a Danish community.

Cliff Dwelling

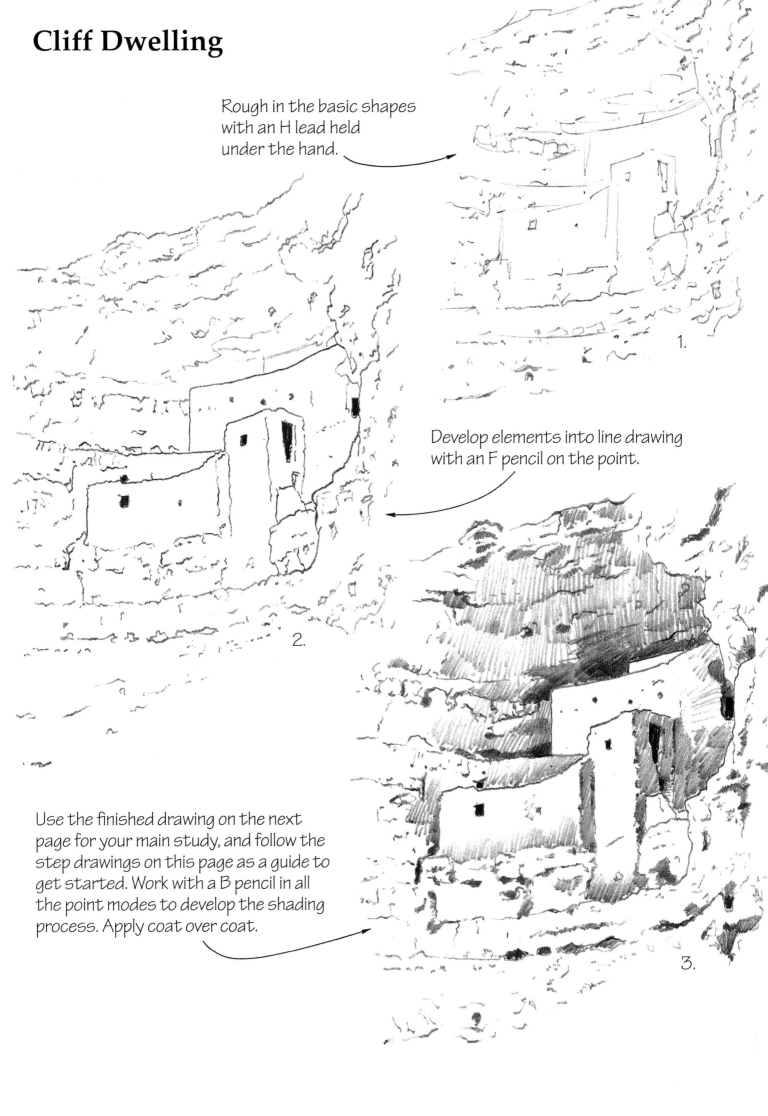

Rough in the basic shapes with an H lead held under the hand.

1.

Develop elements into line drawing with an F pencil on the point.

2.

Use the finished drawing on the next page for your main study, and follow the step drawings on this page as a guide to get started. Work with a B pencil in all the point modes to develop the shading process. Apply coat over coat.

3.

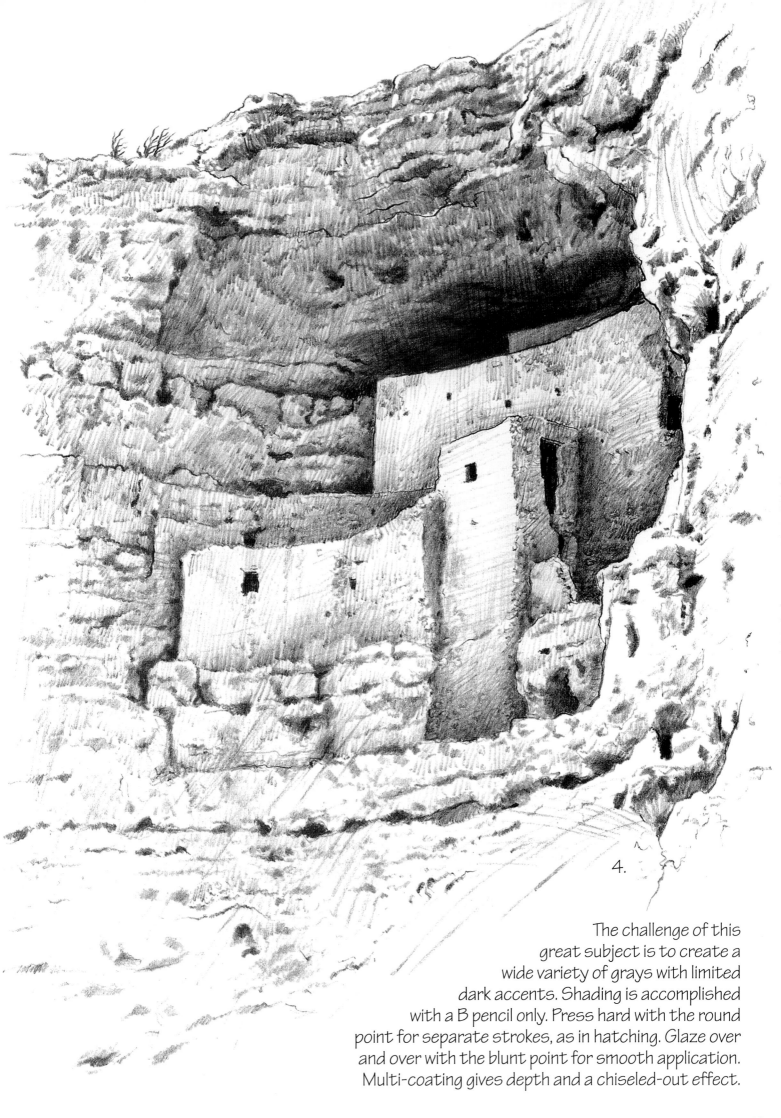

4.

The challenge of this
great subject is to create a
wide variety of grays with limited
dark accents. Shading is accomplished
with a B pencil only. Press hard with the round
point for separate strokes, as in hatching. Glaze over
and over with the blunt point for smooth application.
Multi-coating gives depth and a chiseled-out effect.

Spanish Mission

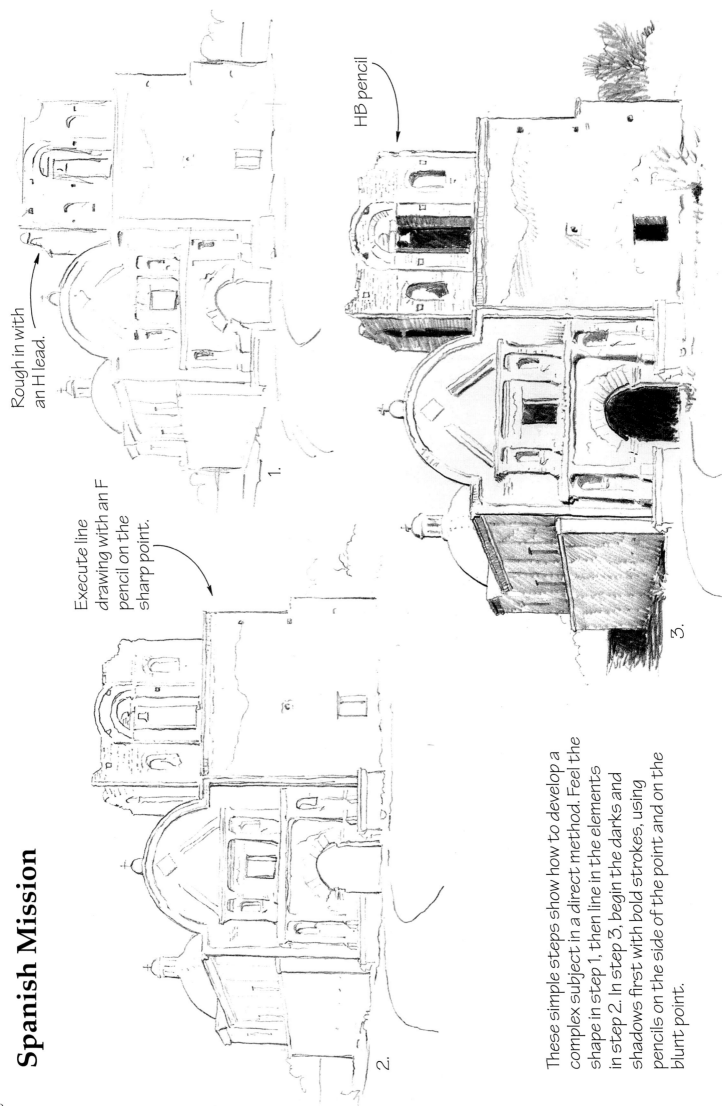

Rough in with an H lead.

1.

Execute line drawing with an F pencil on the sharp point.

2.

HB pencil

3.

These simple steps show how to develop a complex subject in a direct method. Feel the shape in step 1, then line in the elements in step 2. In step 3, begin the darks and shadows first with bold strokes, using pencils on the side of the point and on the blunt point.

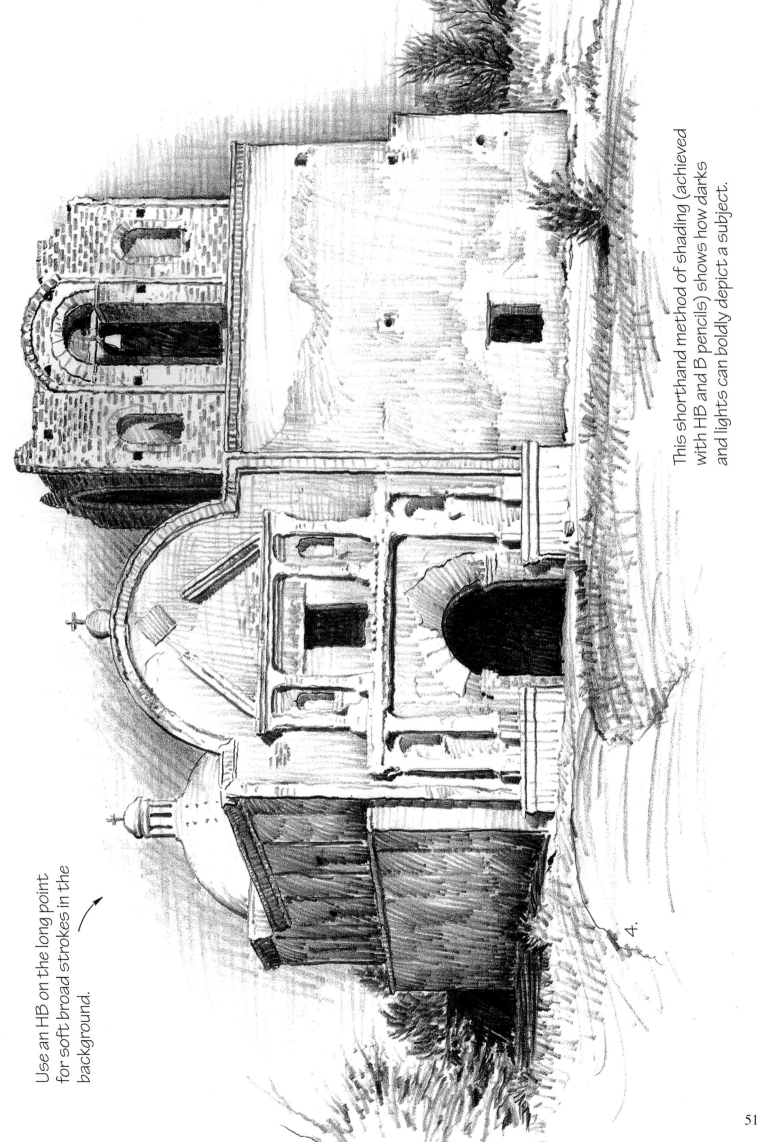

Use an HB on the long point for soft broad strokes in the background.

This shorthand method of shading (achieved with HB and B pencils) shows how darks and lights can boldly depict a subject.

4.

51

Lighthouse

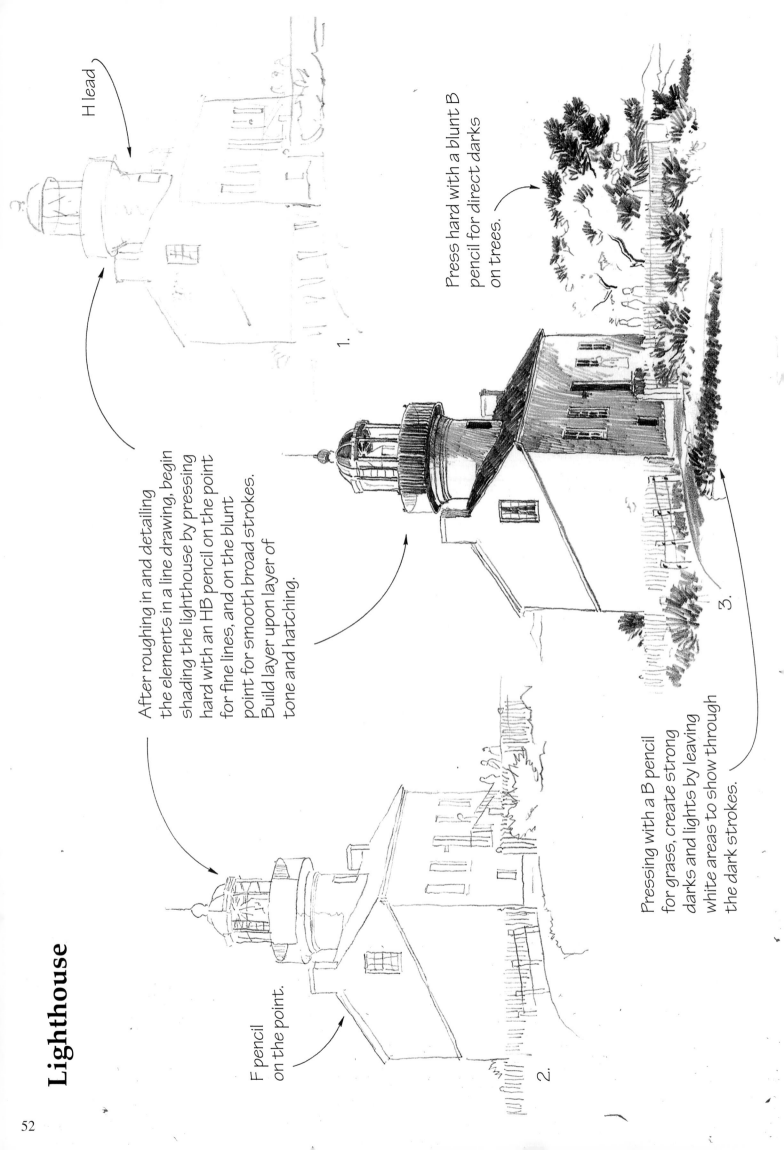

H lead

1.

Press hard with a blunt B pencil for direct darks on trees.

After roughing in and detailing the elements in a line drawing, begin shading the lighthouse by pressing hard with an HB pencil on the point for fine lines, and on the blunt point for smooth broad strokes. Build layer upon layer of tone and hatching.

3.

Pressing with a B pencil for grass, create strong darks and lights by leaving white areas to show through the dark strokes.

F pencil on the point.

2.

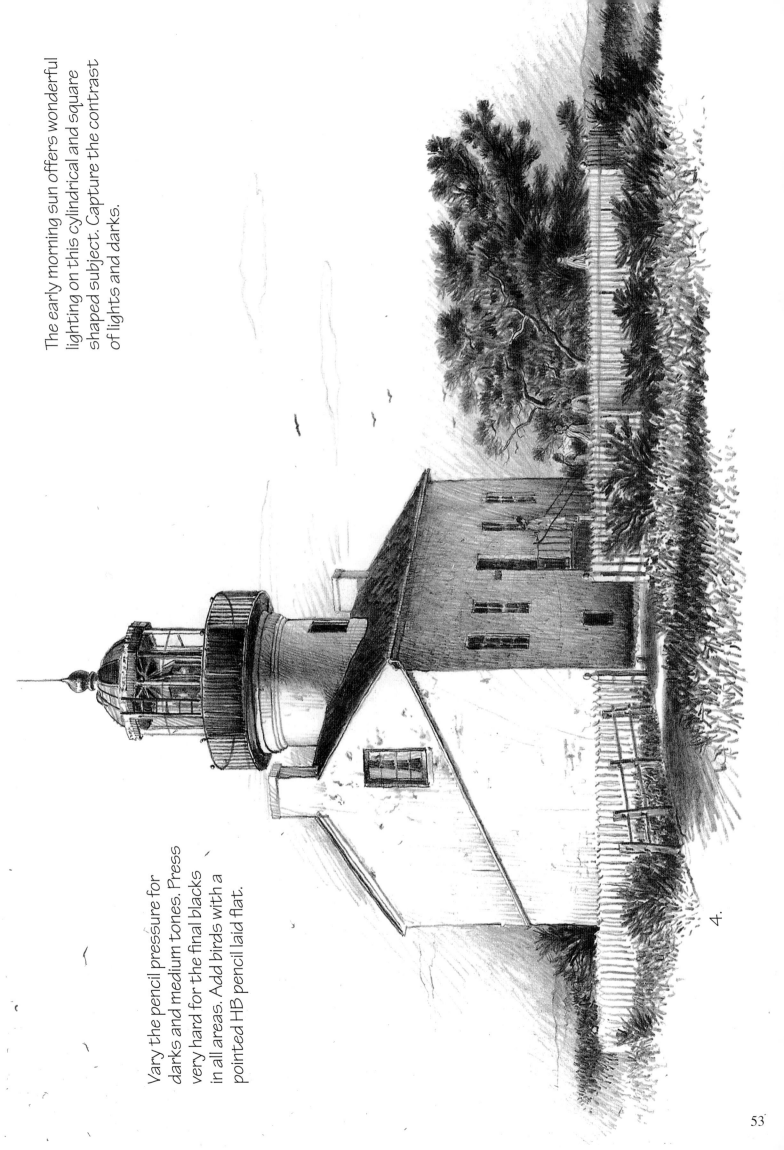

The early morning sun offers wonderful lighting on this cylindrical and square shaped subject. Capture the contrast of lights and darks.

Vary the pencil pressure for darks and medium tones. Press very hard for the final blacks in all areas. Add birds with a pointed HB pencil laid flat.

4.

Schoolhouse

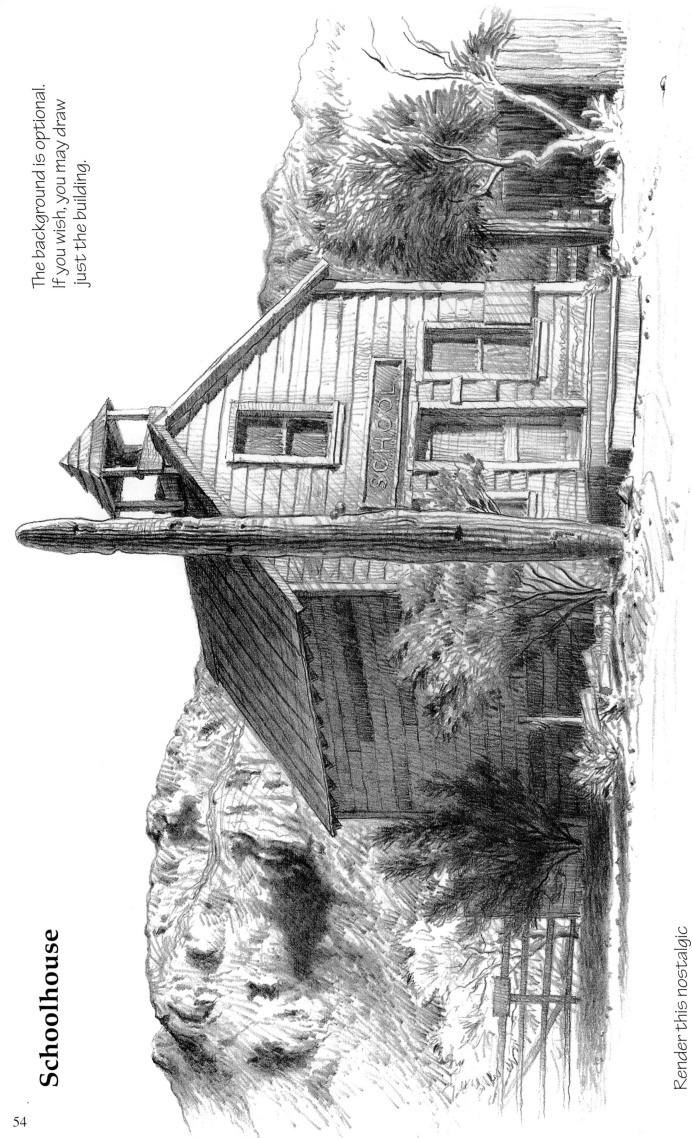

The background is optional. If you wish, you may draw just the building.

Render this nostalgic subject with care and patience. Leave the white paper showing through in places for highlights, and bring the shadows in deep for contrast and sparkle. Use a smooth B pencil in different modes for medium tones. Do final darks and accents with a 3B pencil.

The Cantina

Do the final shading with HB and B pencils.

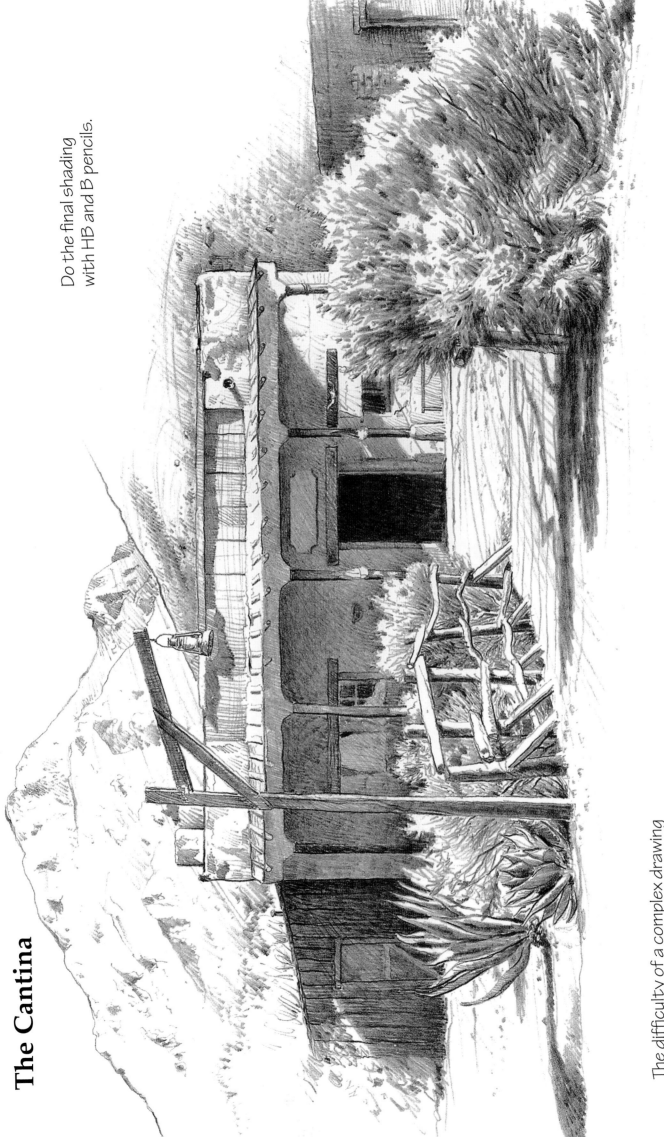

The difficulty of a complex drawing can be overcome by careful observation, concentrated effort, and dedicated practice. Pencil is a natural and normal tool for all people to use. Believe it and do it!

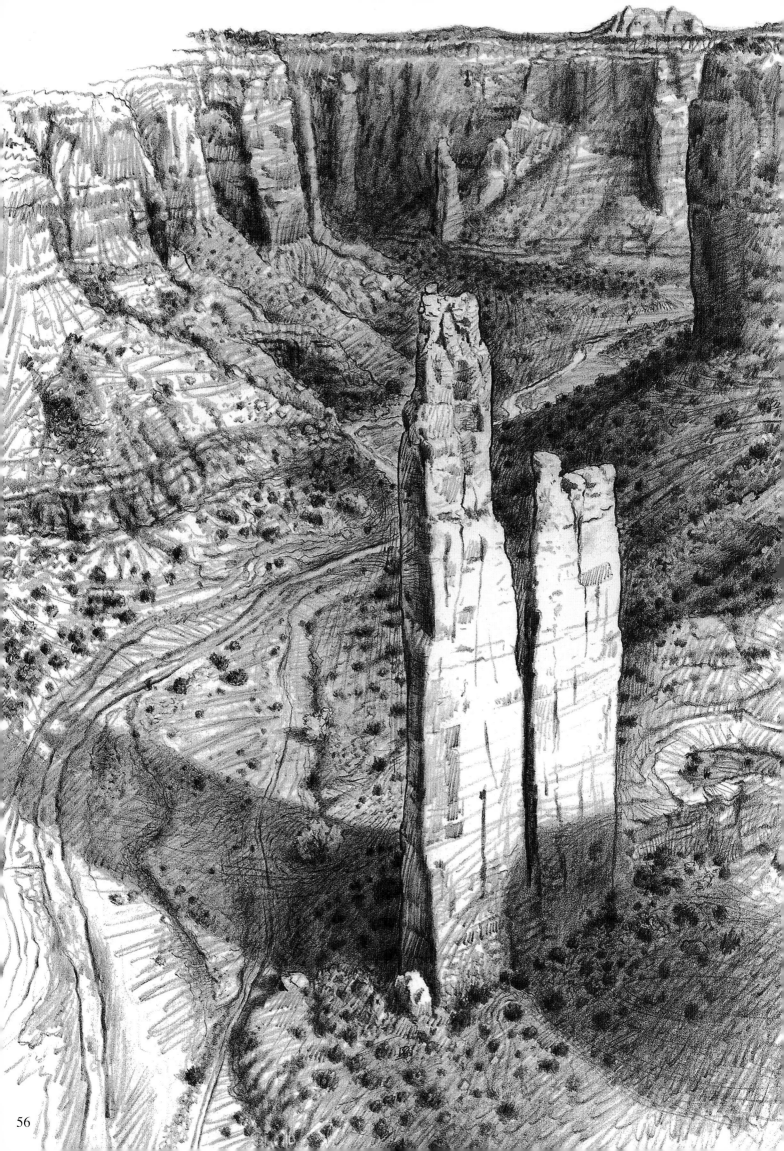

Landscapes

Our world has such a rich variety of landscapes to choose from—mountains, prairies, deserts, and farmland; with lakes, streams, pastures, and oceans. You should try your hand at drawing a few of them. It is also rewarding and healthy in our stress-filled society to be out-of-doors absorbing the beauty and tranquility of nature through an artist's eyes. The old masters' etchings done centuries ago helped inspire me to do landscapes in pencil.

CHOOSING THE SCENE

Look for a landscape that has good appeal and beauty and one that fits your artistic expectations. The eye should be drawn to a main interest first and then travel around the picture to other elements.

ARRANGING THE COMPOSITION

Study the view carefully. Think in terms of adjusting the elements; if necessary, move the tree or the rock to another location, enlarge the mountain, or add more bushes. Draw and redraw your piece until you arrive at a satisfactory layout.

THE CORRECT LIGHTING

Observe your scene at different times of the day for best selection of lighting. Mid-morning and mid-afternoon are best for cross lighting. Sunset and sunrise present dramatic lighting effects, also. The viewer should be impressed by the impact of the composition and lighting.

Here are some additional suggestions to help your landscape drawings come alive:

- Train your eyes to search out the scenic information before you. Study elements such as mountains, grass, trees, and rocks intently for texture and tone.
- Think in terms of background, middle ground and foreground—overlap and change them as needed. (These concepts are discussed at length on page 60.)
- Begin sketching lightly at first, then as the composition develops, work with more surety and bolder strokes.

Your landscape drawings can serve as preliminary studies for painting, or they can be finished works in themselves.

SECTION 4

Thumbnail

KEY TO VISUALIZATION

Pastoral Scene

Southwest Desert

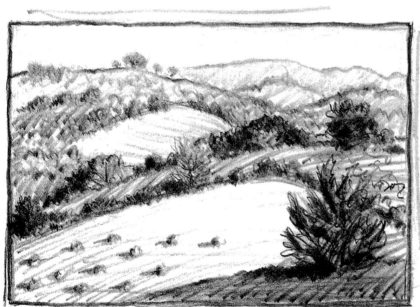

Rolling Hills

The use of small "thumbnail," or brief, concise sketches is
a good way to get your ideas on paper and to develop your
compositions before beginning a finished drawing. You can
move elements such as rocks and trees into various positions
until you find one that pleases you. Do several sketches
before deciding on the final composition for your piece.
These sketches are quick, easy, and a lot of fun!

Sketching

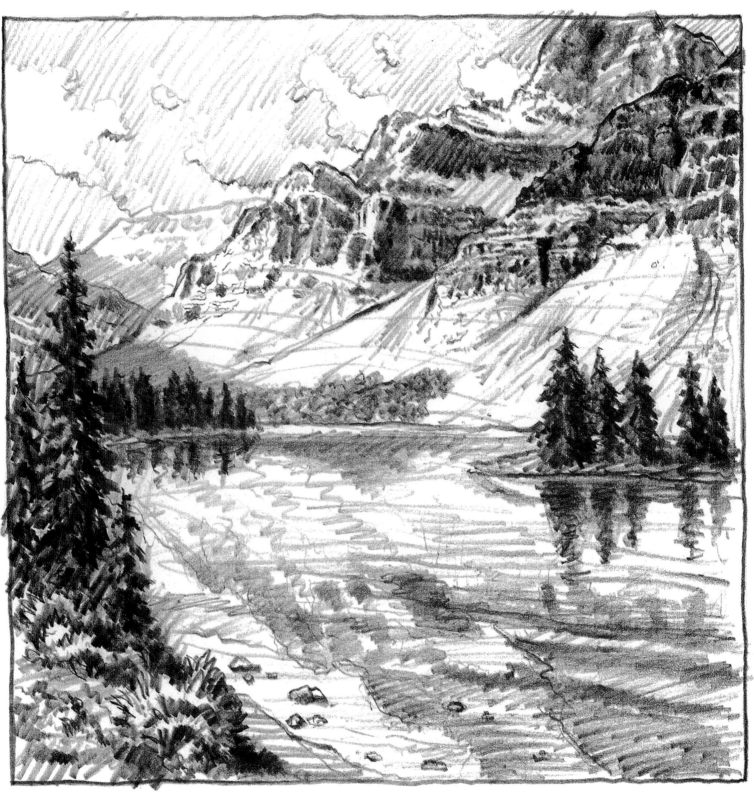

Alpine Lake

This sketch was done quite large, with B and 3B pencils to demonstrate a bold and quick method for capturing scenic ideas.

Whether working from sight or from photographs, try to think in mass tone. You will actually work in solid tone on some areas (such as the trees), and you will use looser strokes in other areas (such as the sky). Hold pencils under the hand and press hard for darks. Use lighter pressure for sweeping soft strokes and paler tones.

Note: Try squinting your eyes while viewing the scene. This will help you simplify the major shapes and shadows.

Composition

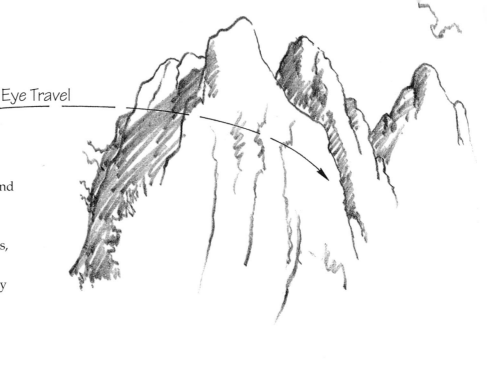

Eye Travel

BACKGROUND ...

... The distant part of a landscape.

Depending on the composition, the background may be just a setting for the main subject, or it may be used to show great distance. The background may be composed of clouds, trees, mountains, rocks, or any element of nature. Here, the mountains are the background. They also happen to be the center of interest. They catch the eye, move it from left to right, and lead the viewer down into the picture.

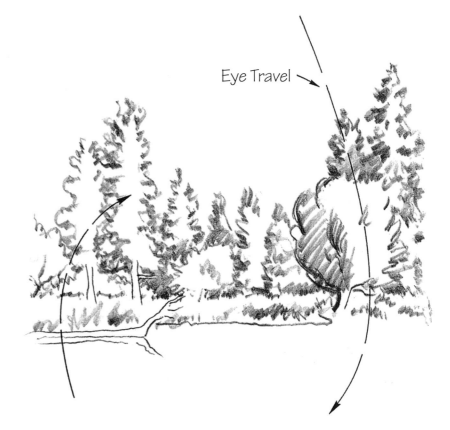

Eye Travel

MIDDLE GROUND ...

... The space in between.

The middle ground is usually made up of things that help tie the objects in the front to the shapes in the back. But, sometimes the center of interest is located in the middle ground, with the close objects used to complement the main subject, and the background arranged to set off the center of interest. In this picture, the middle ground is serving to tie the picture together and move the eye to the foreground. The incidental objects, like grass and brush, make the prominent objects, like the trees and mountains, stand out.

FOREGROUND ...

... The part of a scene nearest the viewer.

Objects in the foreground are usually used to help direct the viewer's eye to the main subject. These objects can be in deep shadow to create depth and contrast, or well-lit to stand out against the middle and background elements. Here, the eye moves from the round tree in the middle ground to the old snag and rocks in the foreground. It then continues left and up into the picture again.

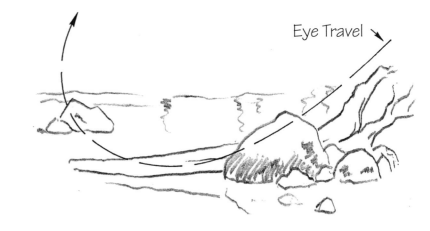

Eye Travel

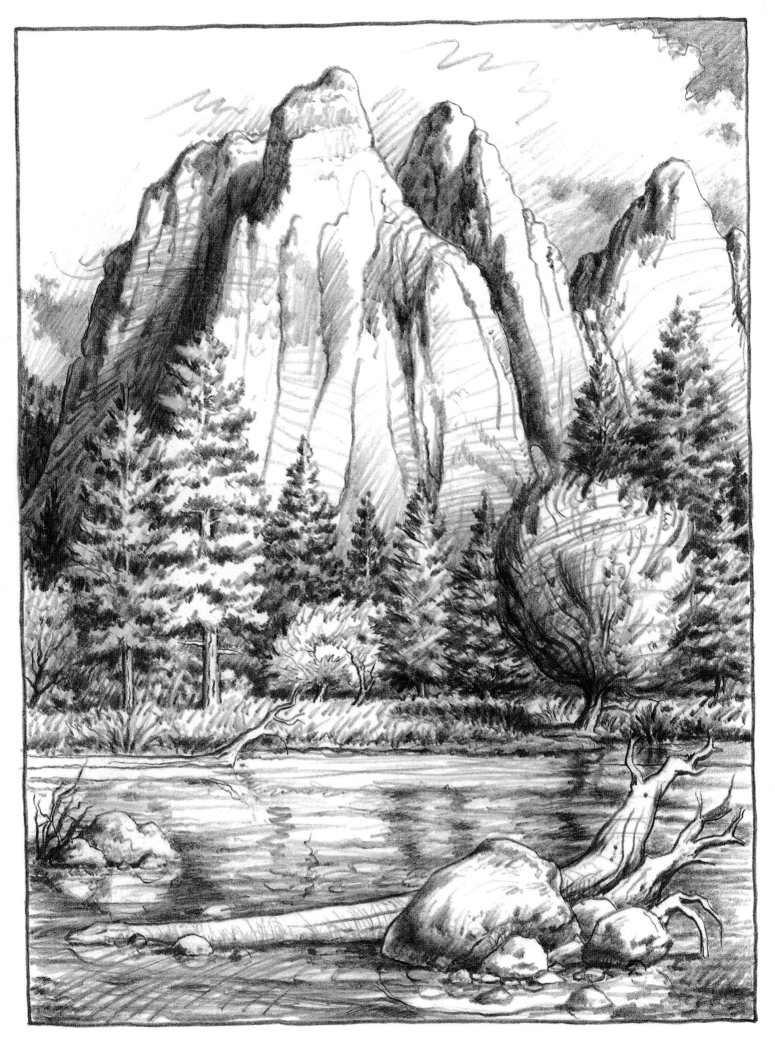

It is important that each part of a landscape be artfully arranged to insure good eye travel. Proper composition will move the eye from shape to shape as the mind processes the visual information.

Close-ups: Hollyhocks

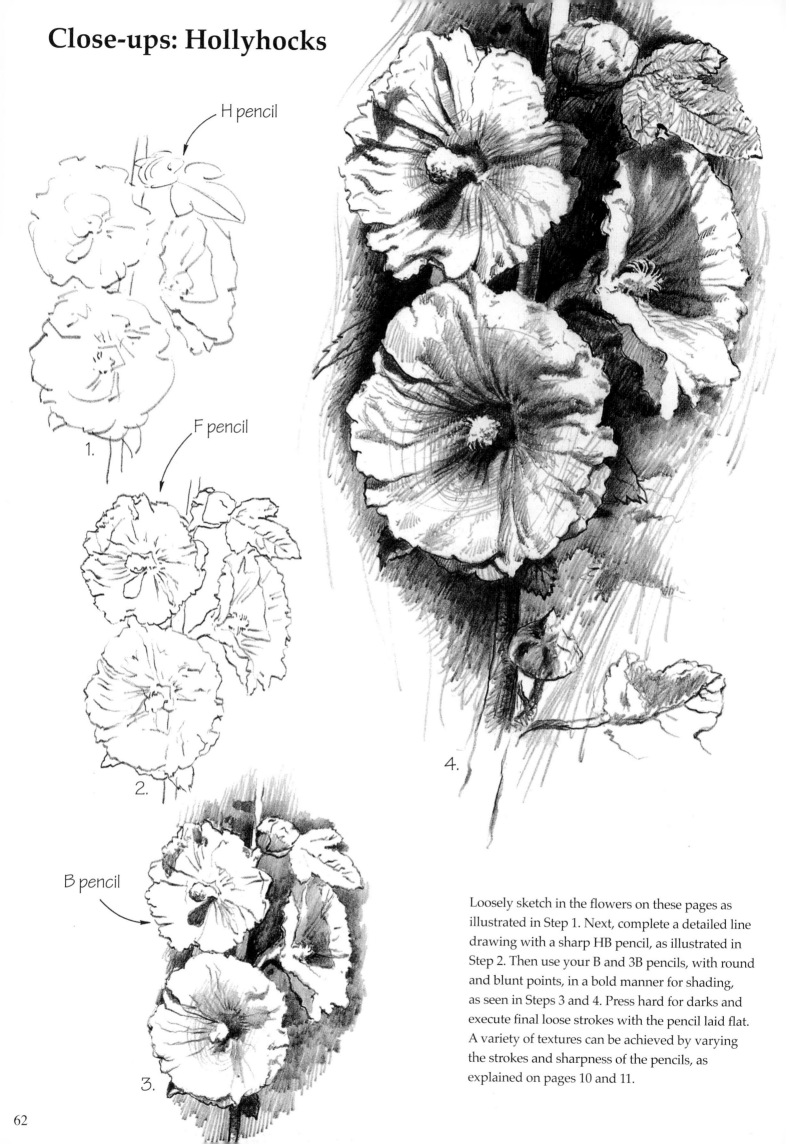

H pencil

1.

F pencil

2.

B pencil

3.

4.

Loosely sketch in the flowers on these pages as illustrated in Step 1. Next, complete a detailed line drawing with a sharp HB pencil, as illustrated in Step 2. Then use your B and 3B pencils, with round and blunt points, in a bold manner for shading, as seen in Steps 3 and 4. Press hard for darks and execute final loose strokes with the pencil laid flat. A variety of textures can be achieved by varying the strokes and sharpness of the pencils, as explained on pages 10 and 11.

Close-ups: Sunflower

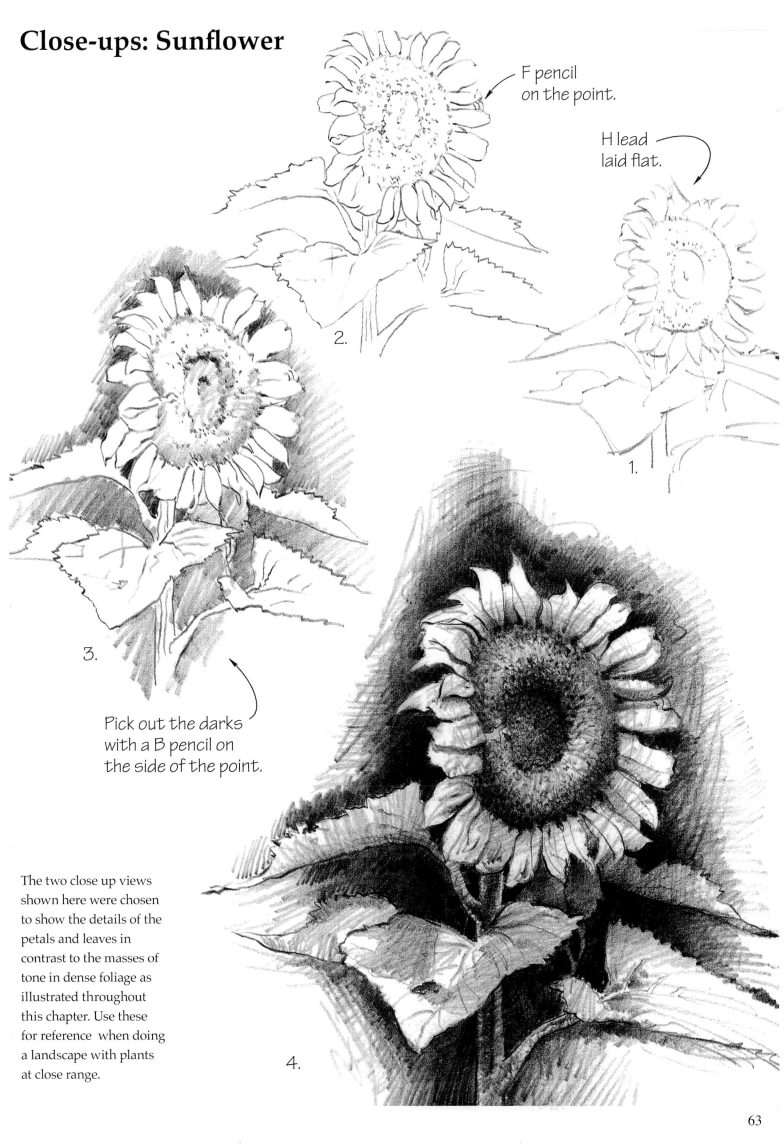

F pencil
on the point.

H lead
laid flat.

2.

1.

3.

Pick out the darks
with a B pencil on
the side of the point.

The two close up views
shown here were chosen
to show the details of the
petals and leaves in
contrast to the masses of
tone in dense foliage as
illustrated throughout
this chapter. Use these
for reference when doing
a landscape with plants
at close range.

4.

Rock Study

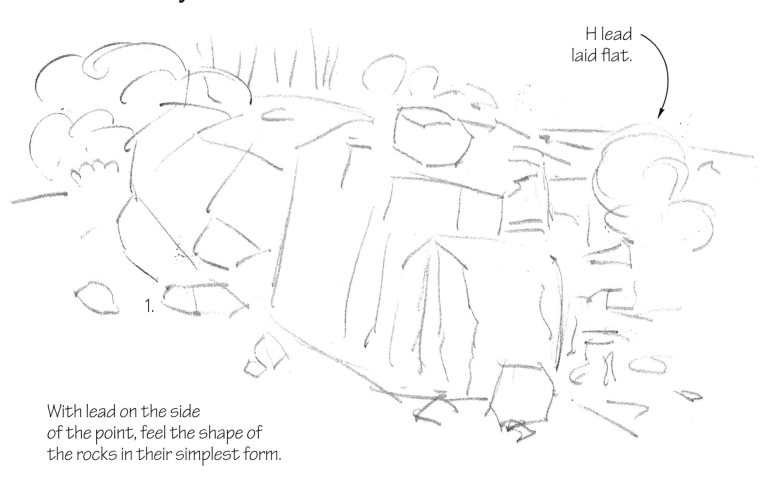

H lead
laid flat.

1.

With lead on the side
of the point, feel the shape of
the rocks in their simplest form.

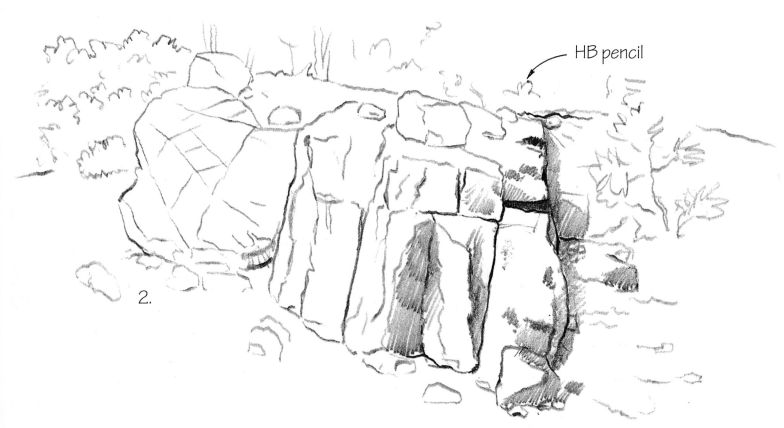

HB pencil

2.

Define the shapes...
Develop the line drawing...
Then begin shading by accenting the major darks...
Press hard with the blunt point.

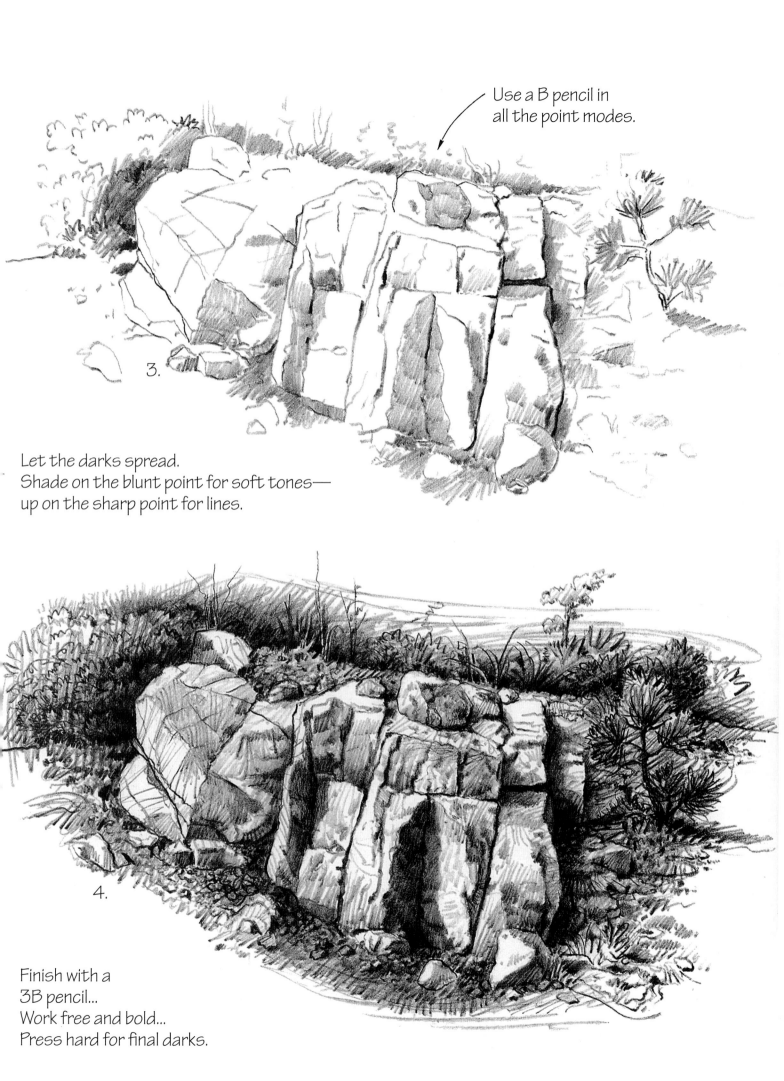

Use a B pencil in
all the point modes.

3.

Let the darks spread.
Shade on the blunt point for soft tones—
up on the sharp point for lines.

4.

Finish with a
3B pencil...
Work free and bold...
Press hard for final darks.

Foliage Study

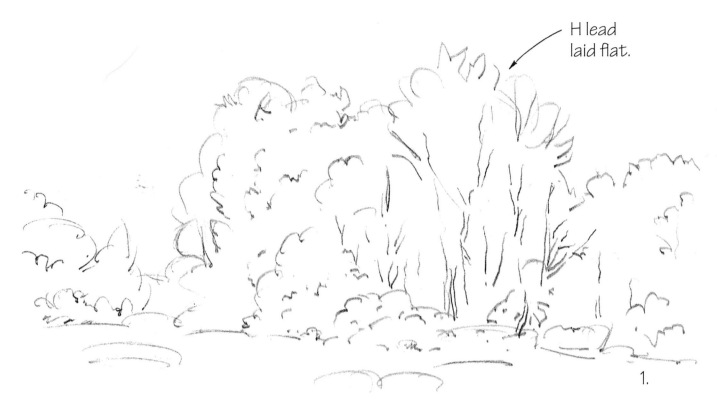

H lead
laid flat.

1.

Sketch the shapes loosely, holding the pencil in the underhand position.

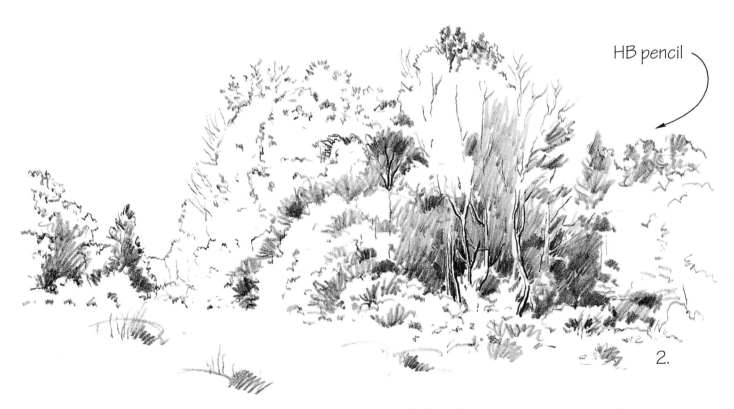

HB pencil

2.

Develop the line drawing with an HB pencil, then begin shading with a B pencil, concentrating on the shapes of the dark areas.

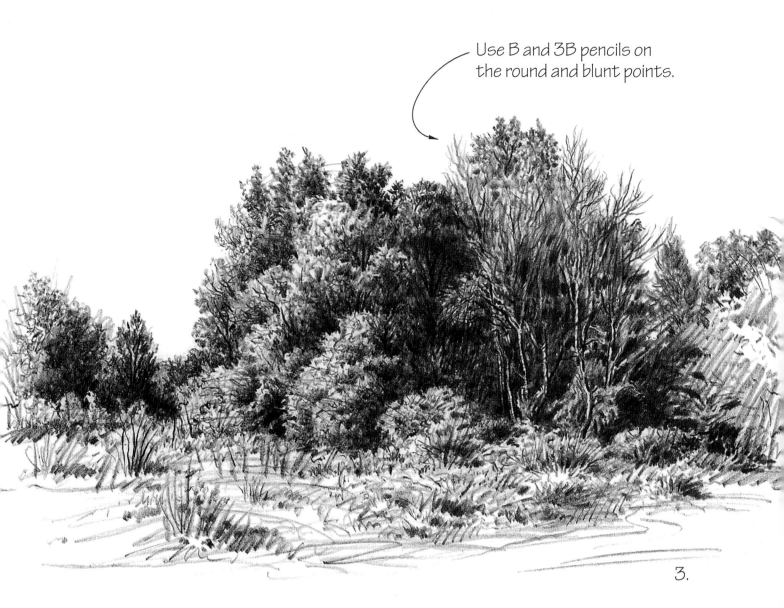

Use B and 3B pencils on the round and blunt points.

3.

Continue shading with close attention to detail; change hand positions and point modes as needed. Press hard for tree trunks and indication of leaves.

For a more artistic feel to your work learn to do masses of foliage and underbrush in brief description, rather than literally copying each leaf.

"Simplify" the subject by squinting your eyes. This eliminates unwanted detail and brings out the highlights. Concentrate on simulating the foliage with bold, expressive strokes. Think in shorthand with the pencil. The B pencil, held under the hand on the side of the point, works well for preliminary shading and developing the character of the foliage. Roll your 3B pencil on the side of the point for a soft indication of distant leaves. Come up on the point and press hard for tree trunks.

In these landscapes it is my aim to emulate the black and whites and the etchings done by the old masters, but with a bolder application.

Victorian Cemetery

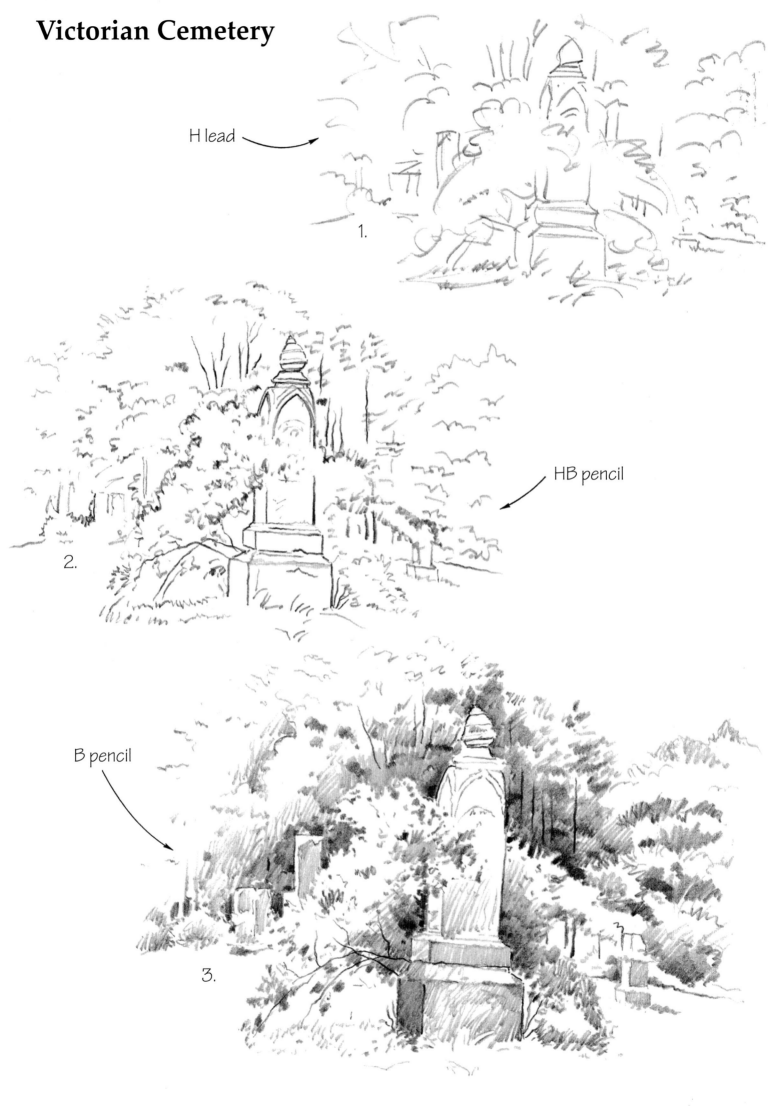

H lead

1.

HB pencil

2.

B pencil

3.

Here is an example of foliage combined with solid form. In this drawing, let the white of the paper come through your strokes on the tombstone to show contrast between the darks and the lights. Strive for variety in textures and play one against the other. For example, the dark leaves of the rosebush and the trees in the background really make the light tombstone "pop."

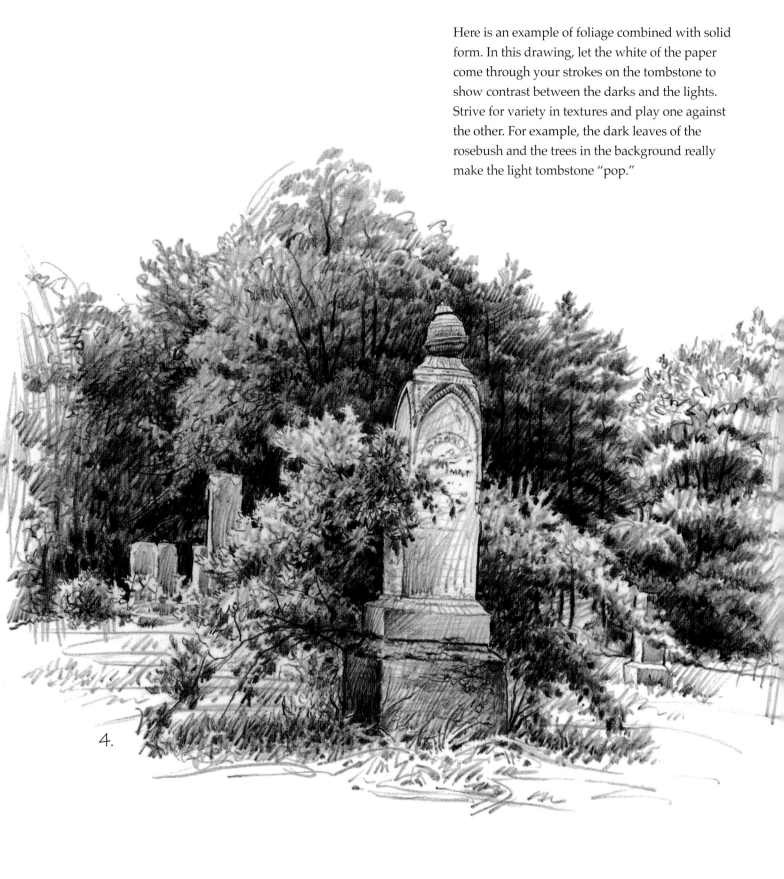

4.

Step One — Feel the shapes lightly with an H lead held under the hand.

Step Two — Identify the shapes more clearly with an HB pencil.

Step Three — Begin shading with a B pencil used on the blunt point.

Step Four — Continue shading with a 3B pencil—layer over layer, pressing hard for darks.

Colorado Creek

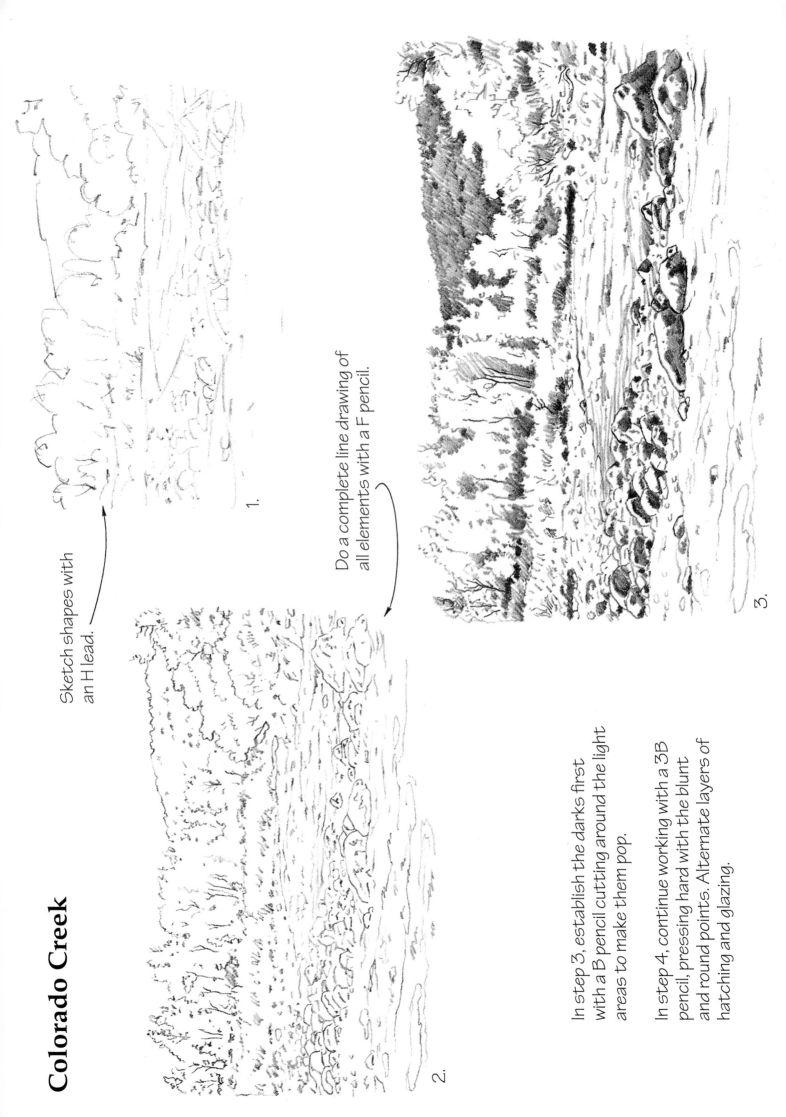

Sketch shapes with
an H lead.

1.

Do a complete line drawing of
all elements with a F pencil.

2.

In step 3, establish the darks first
with a B pencil cutting around the light
areas to make them pop.

In step 4, continue working with a 3B
pencil, pressing hard with the blunt
and round points. Alternate layers of
hatching and glazing.

3.

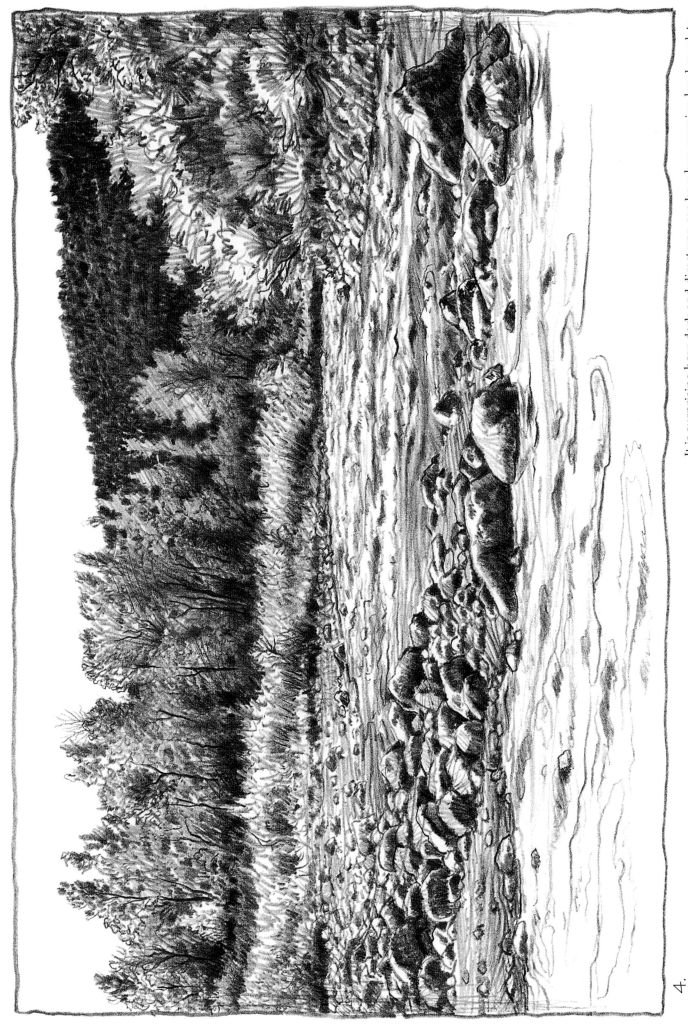

4. It is surprising how dark and direct you can be when pressing hard on plate finish paper. Work on a maulstick with blunt and round points to achieve depth of tone as seen here. Use a sharp point laid flat for final action strokes.

Oregon Farm

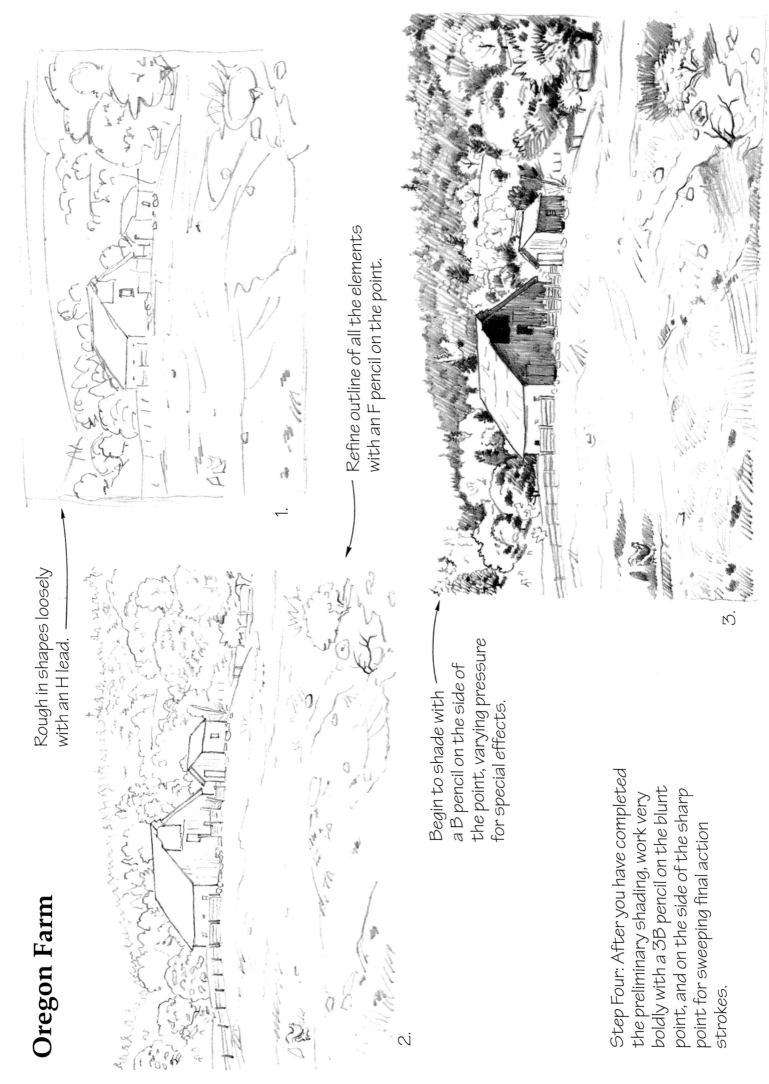

Rough in shapes loosely with an H lead.

1.

Refine outline of all the elements with an F pencil on the point.

2.

Begin to shade with a B pencil on the side of the point, varying pressure for special effects.

3.

Step Four: After you have completed the preliminary shading, work very boldly with a 3B pencil on the blunt point, and on the side of the sharp point for sweeping final action strokes.

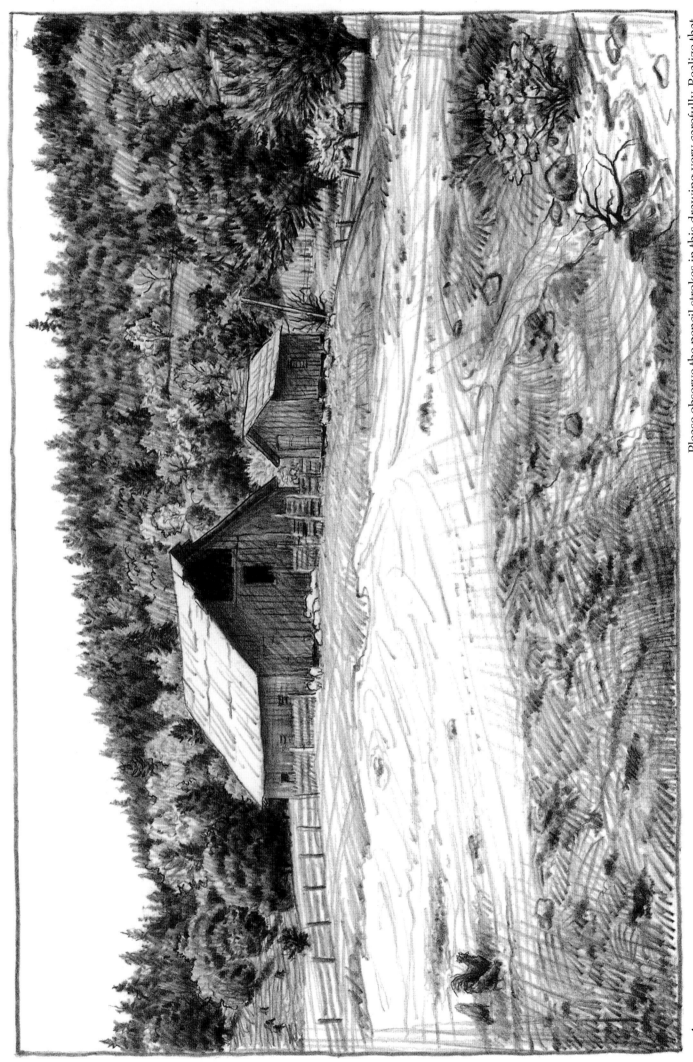

Please observe the pencil strokes in this drawing very carefully. Realize that most of the shading was done with a bold approach using the 3B pencil.

4.

Desert Juniper

This drawing was executed almost entirely with a 3B pencil. The mountains were rendered in broad strokes with the pencil laid flat. The tree achieved by pressing hard on blunt and round points for good, deep darks.

Surf and Sea

Using a 3B pencil, press hard, turning the point for deep-set darks. Let the white paper show through for sparkle. Build tones layer on layer with hatching and glazing.

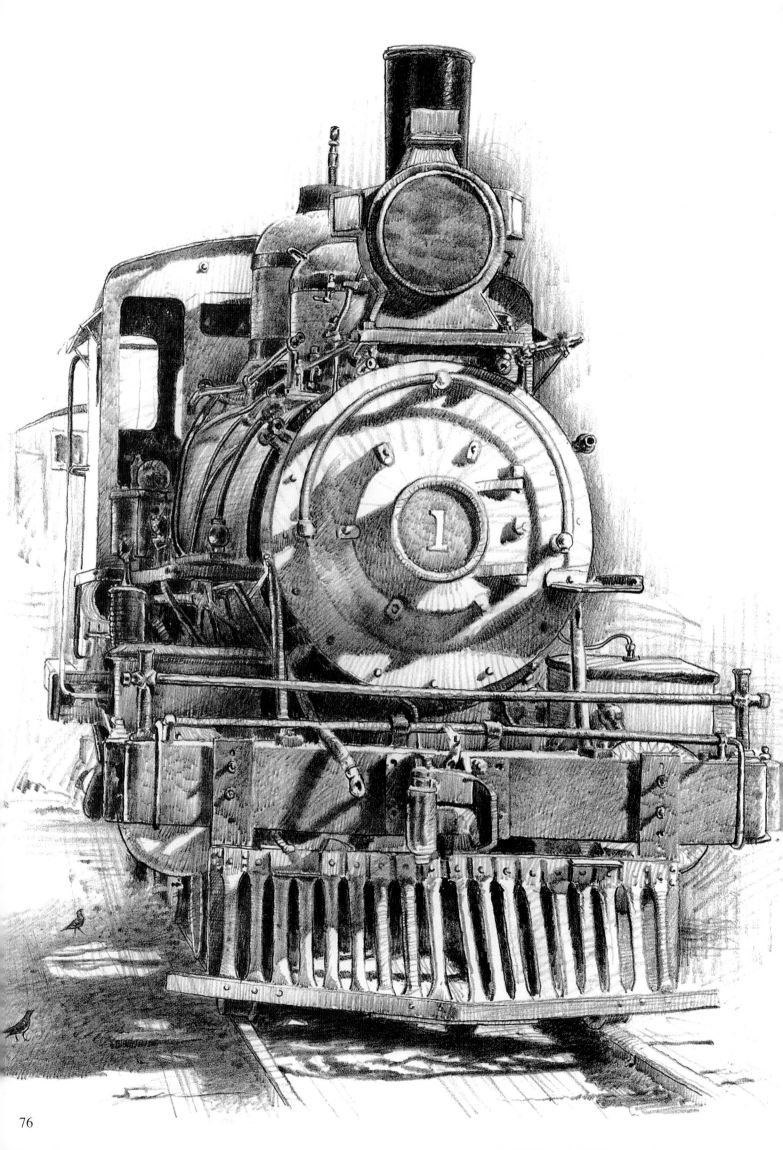

Transportation

Vehicles are an important part of our lives. Without them, it would be very difficult to get from one place to another—and impossible to go to some areas of the world. It is fascinating to trace the history of transportation, and what better way than to draw interesting vehicles and vessels?

CHOOSING THE SUBJECT

Fine examples of classic cars, trucks, and trolleys can be found in auto museums and car clubs. Magazines are another good source for transportation subjects. You will find many books, postcards, and calendars produced by railroad buffs that offer a rich variety of trains and rail equipment. Also, search libraries and bookstores for sources. There is no end to this vast body of subjects.

HANDLING THE SUBJECT

Boats, automobiles, trucks, and locomotives lend themselves to a more exacting or mechanical approach. You may achieve greater success by using metal drafting pencils for very fine lines such as found in the rigging of the fishing boat on page 83, or the details of the "Iron Horse" on page 76. Your wood pencils should be sharp and used on the point or laid on the side for thick lines. With practice, these tools provide good results for drawing smooth, straight, or curved lines, as well as the small details found on most vehicles. You may want to utilize a ruler and/or drafting tools for certain areas, but a word of caution: use these tools sparingly because a freehanded approach creates a more "fine art" look.

While more demanding than other subjects, vehicles look very good in pencil and if you are suited for this type of art, they can be exciting and rewarding to draw.

Here are some suggestions which should help you with your transportation drawings:

• Make sure your perspective is correct. This is one of the more difficult aspects of drawing vehicles.

• Work by sitting in front of the object, or draw from photos and slides. Be sure the lighting brings out the various details for good black and white contrast.

• These are complex subjects. Sketch the shapes lightly at first, then press harder with the pencil as the piece develops.

SECTION 5

Sketching

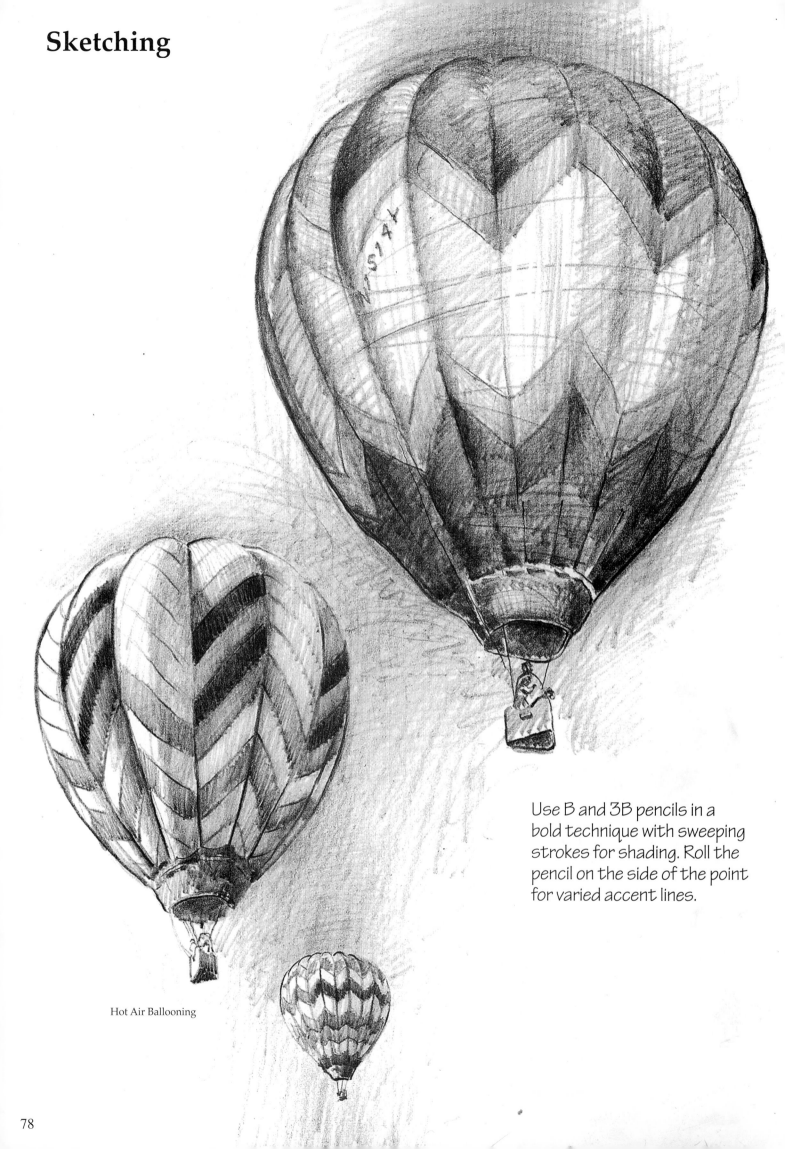

Use B and 3B pencils in a bold technique with sweeping strokes for shading. Roll the pencil on the side of the point for varied accent lines.

Hot Air Ballooning

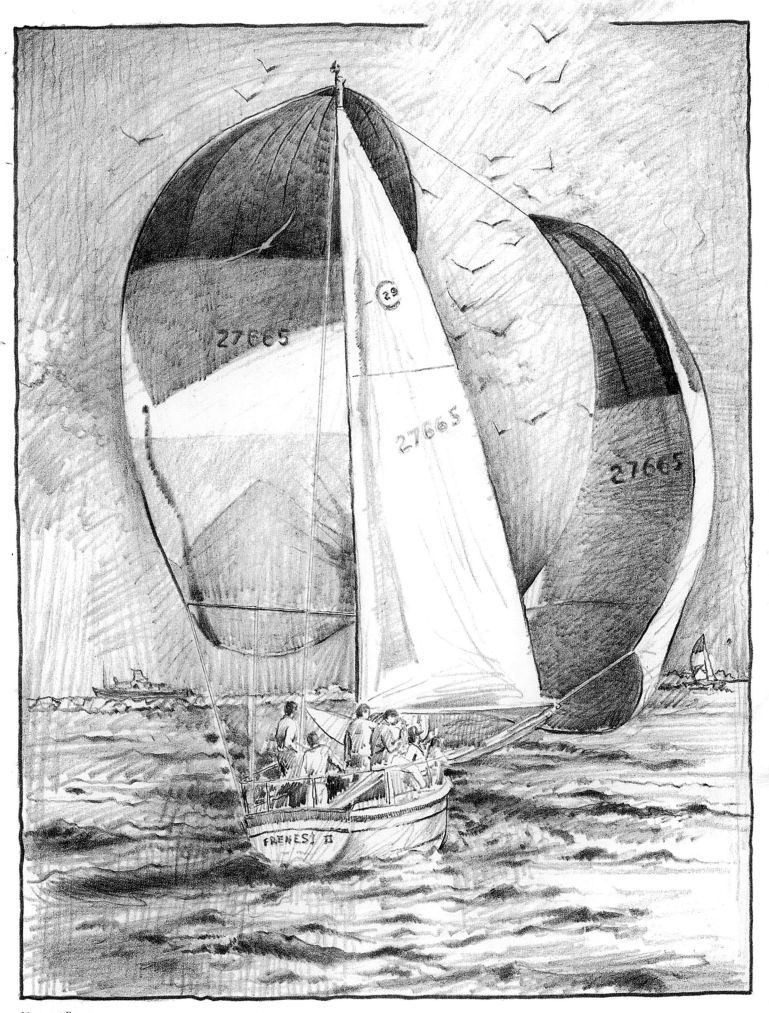

Newport Racer

This subject was executed with B and 3B pencils laid flat for broad strokes. I pressed hard on the point for the dark accents.

Wheelbarrow

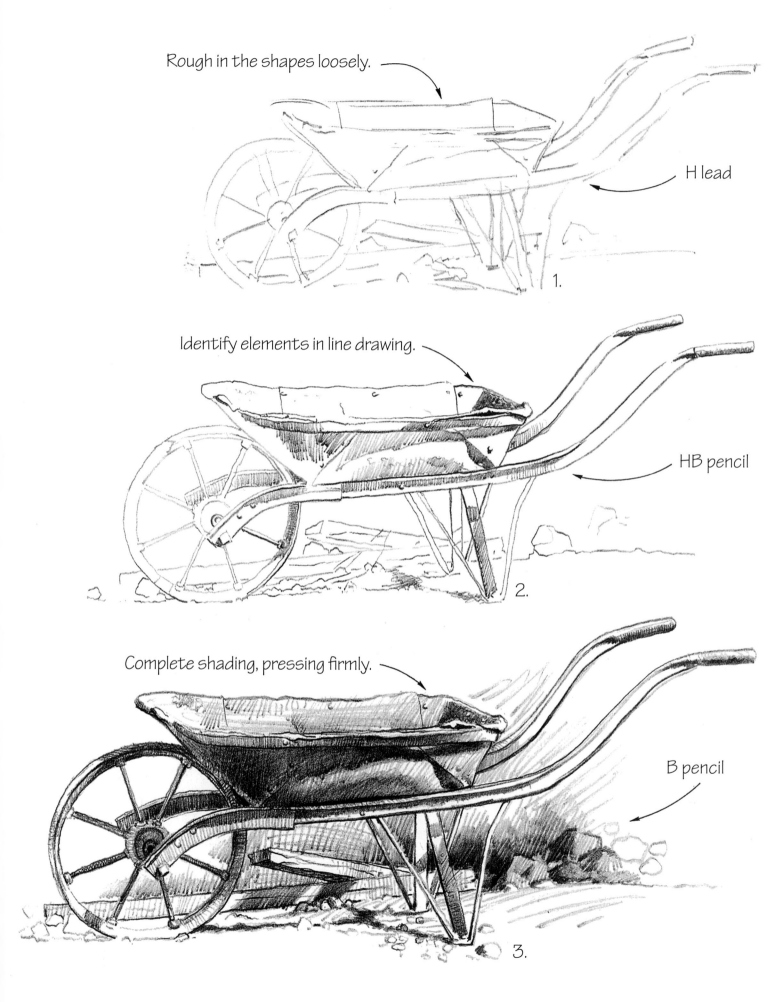

Rough in the shapes loosely.

H lead

1.

Identify elements in line drawing.

HB pencil

2.

Complete shading, pressing firmly.

B pencil

3.

Use both writing and underhand positions (see page 11).

Ore Cart

Rough in shape
with an H lead.

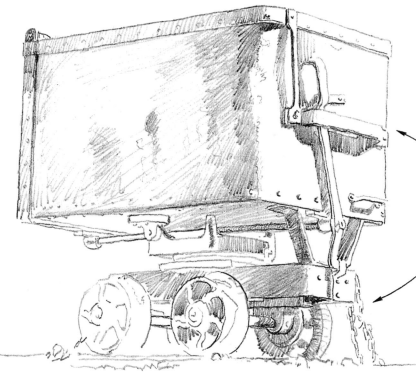

1.

Do your line drawing with a
sharp HB pencil on the point.

Begin preliminary shading
over the established line with
an HB pencil on the sharp
and blunt points.

2. & 3.

Complete shading with
a B pencil using the
three point modes of
the wood pencil
described on page 10.
Interlace layer on
layer of glazing and
hatching (see
glossary, page 143).
Reinforce lines as
you work from light
to dark.

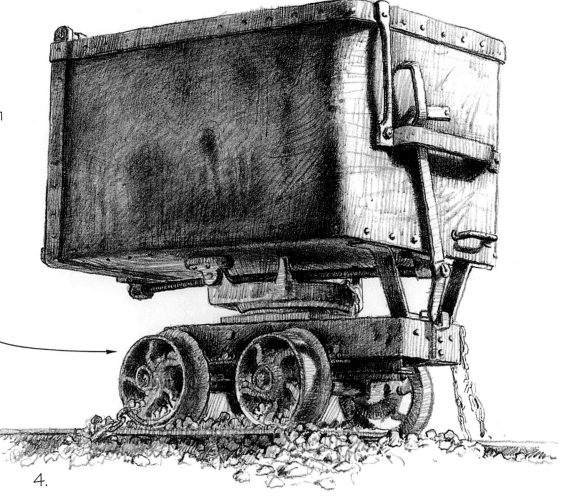

4.

Tugboat

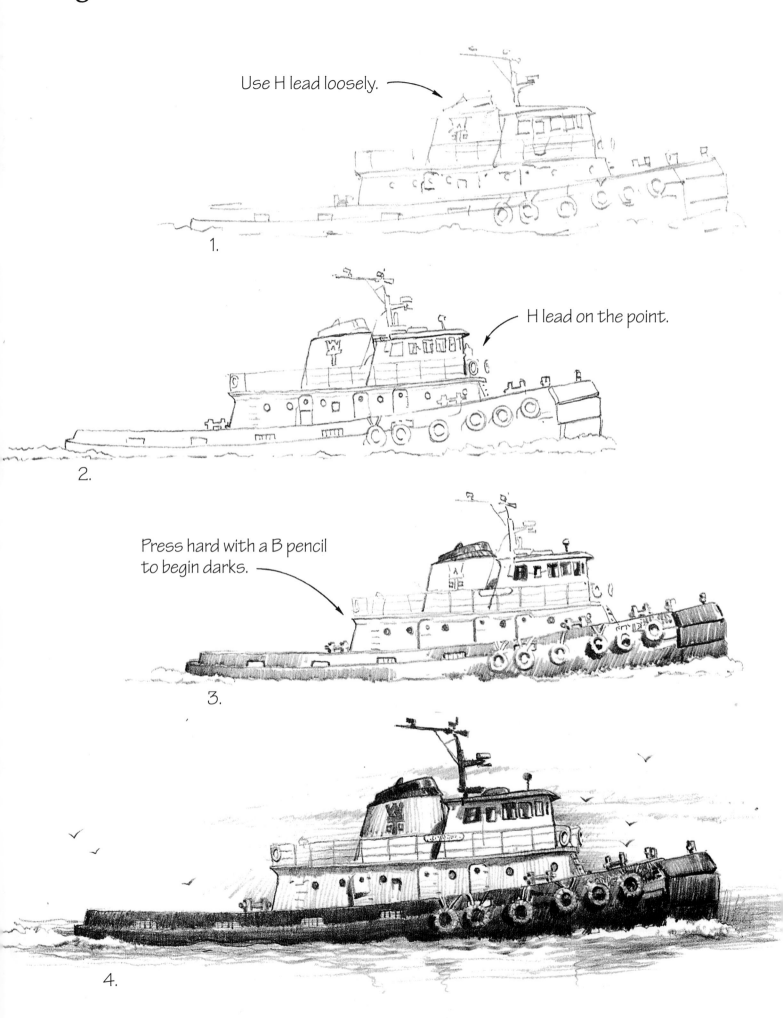

Use H lead loosely.

1.

H lead on the point.

2.

Press hard with a B pencil
to begin darks.

3.

4.

Complete final coats with a 3B pencil, hand supported on the maulstick.

Fishing Boat

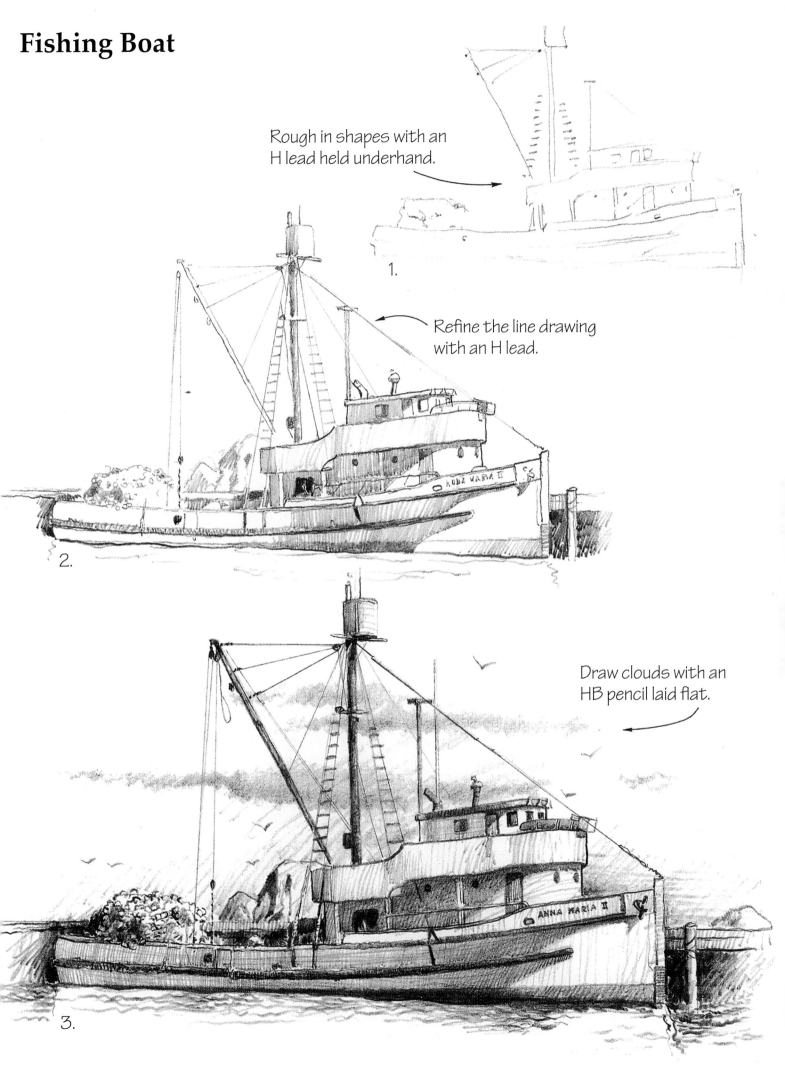

Rough in shapes with an
H lead held underhand.

1.

Refine the line drawing
with an H lead.

2.

Draw clouds with an
HB pencil laid flat.

3.

Execute second coat with a B pencil. Complete with a 3B for final darks.

Stunt Plane

With an H lead laid flat and held under the hand, feel the shape with a swift motion.

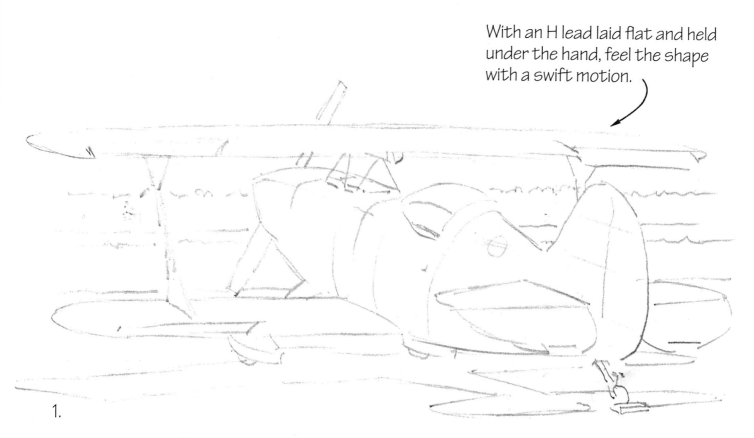

1.

It is easier to make long sweeping lines by swinging the arm.

F pencil on the point.

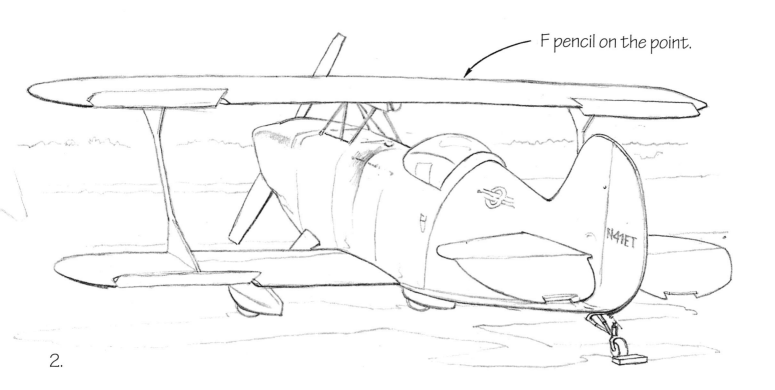

2.

Although rulers and templates are not usually used when doing fine art, you may want to use them for these exacting mechanical drawings.

Begin preliminary shading with an HB pencil on the round point—pressing hard and cutting in darks around the plane.

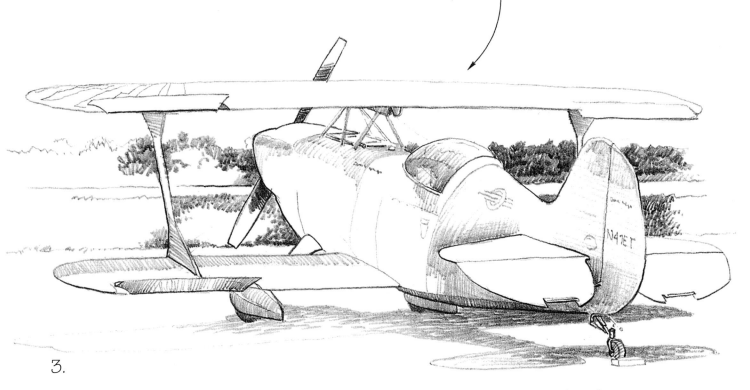

3.

Complete final shading with hand in writing position using a maulstick.

Press hard with a B pencil.

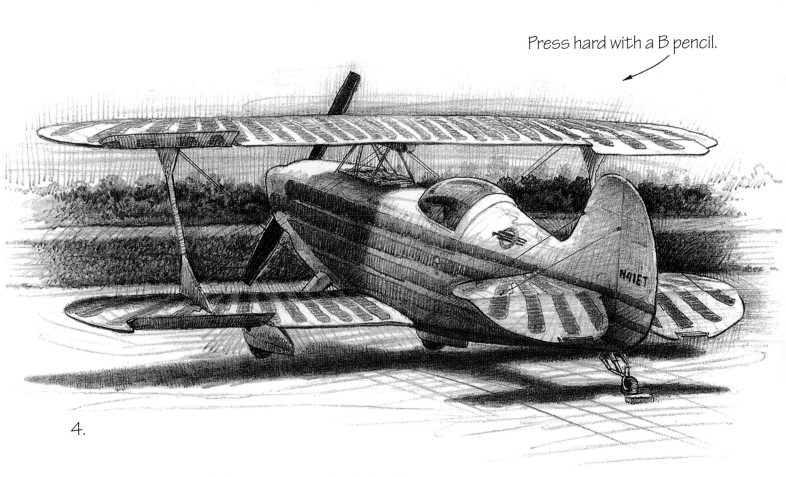

4.

Build tones, layer on layer, with hatches and glazes. I decided to add stripes because the drawing needs the extra design.

Hudson Classic

H lead underhand.

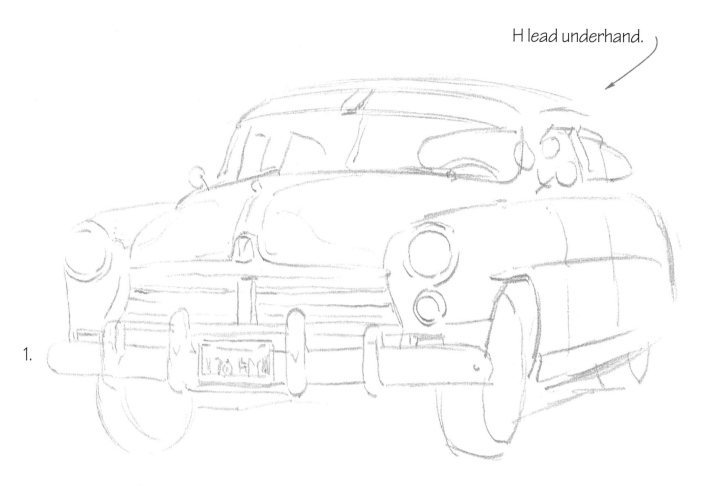

1.

Learn to sketch with a loose hand motion, pencil laid flat.

H lead on the
sharp point.

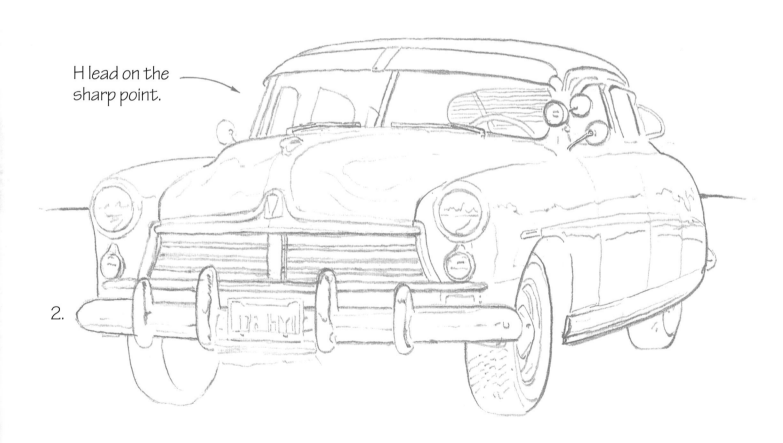

2.

Use a sharp F pencil, rolling it on the side of the point for thick and thin lines.

Control your shading by careful observation of
each stroke as you work. The metal and chrome
of the car will not be as difficult as you may think.
Use wellplaced tones, as shown.

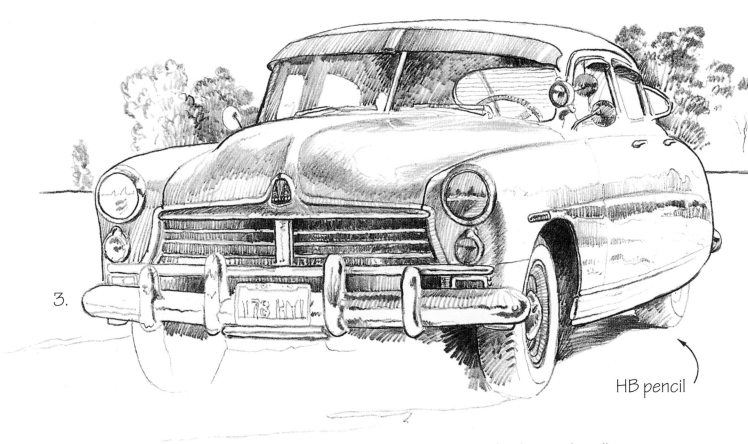

3.

HB pencil

Reinforce the line drawing with an HB. Begin preliminary shading with well-chosen strokes.

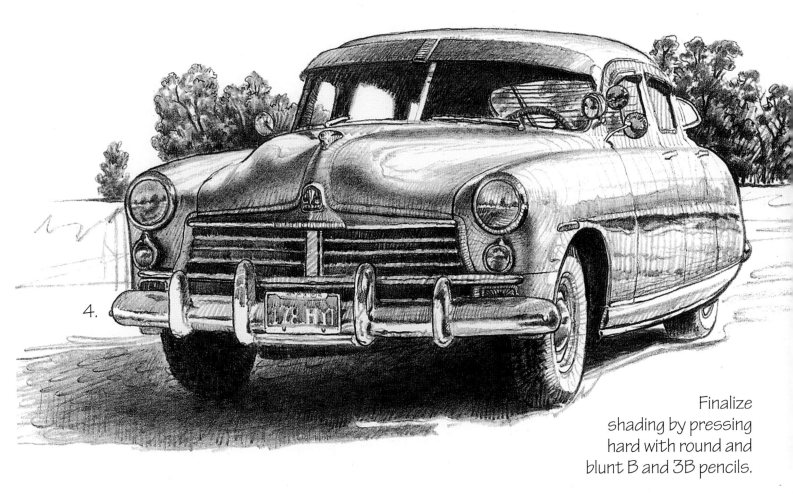

4.

Finalize
shading by pressing
hard with round and
blunt B and 3B pencils.

'39 Jaguar

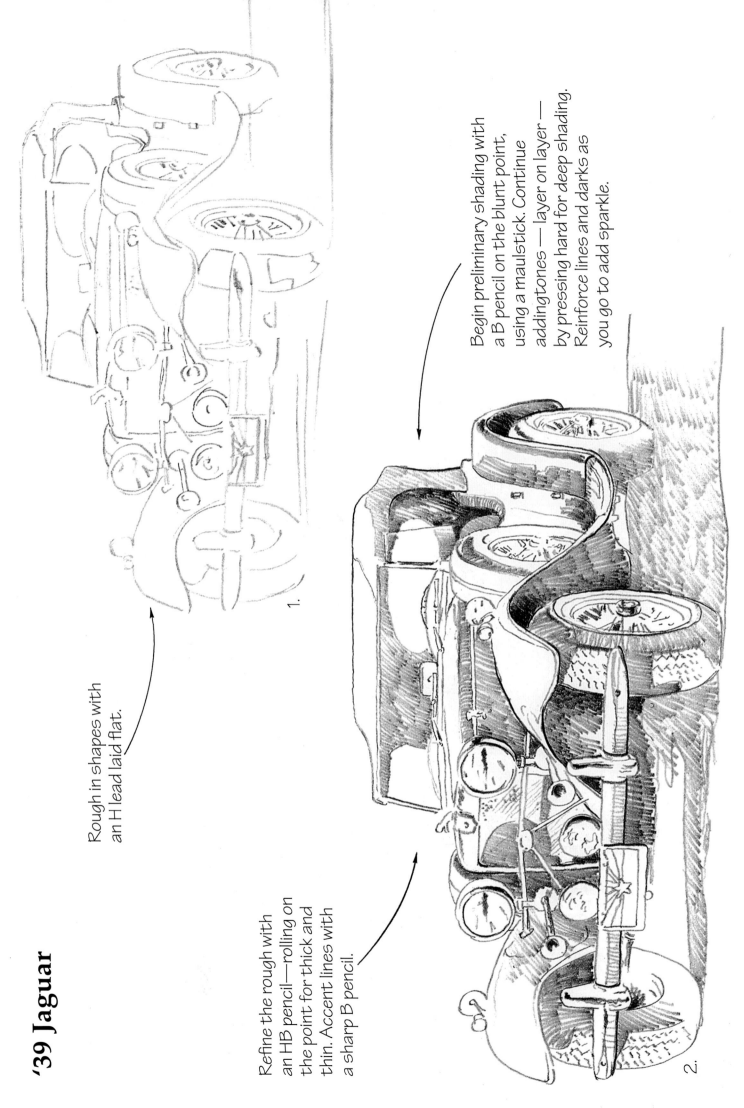

Rough in shapes with an H lead laid flat.

1.

Refine the rough with an HB pencil—rolling on the point for thick and thin. Accent lines with a sharp B pencil.

Begin preliminary shading with a B pencil on the blunt point, using a maulstick. Continue adding tones — layer on layer — by pressing hard for deep shading. Reinforce lines and darks as you go to add sparkle.

2.

88

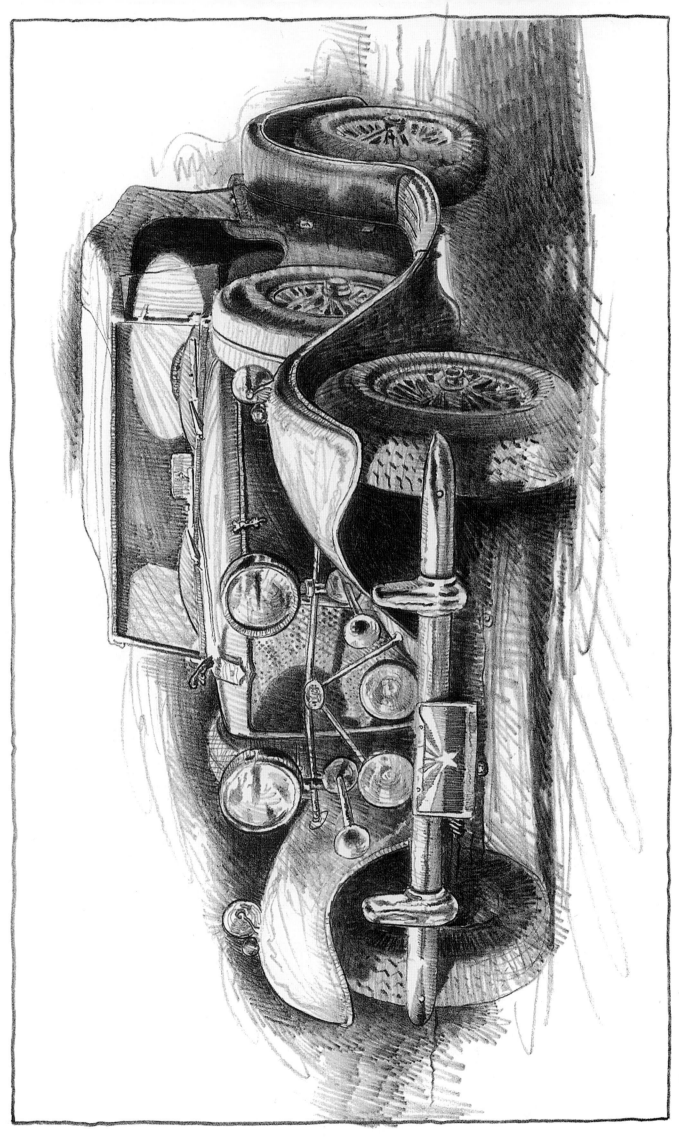

As you progress in your pencil drawing, you will discover that the softer pencils enable you to arrive at the darker tones quickly. Here I used 3B for the finish and the final darks.

3.

Farm Tractor

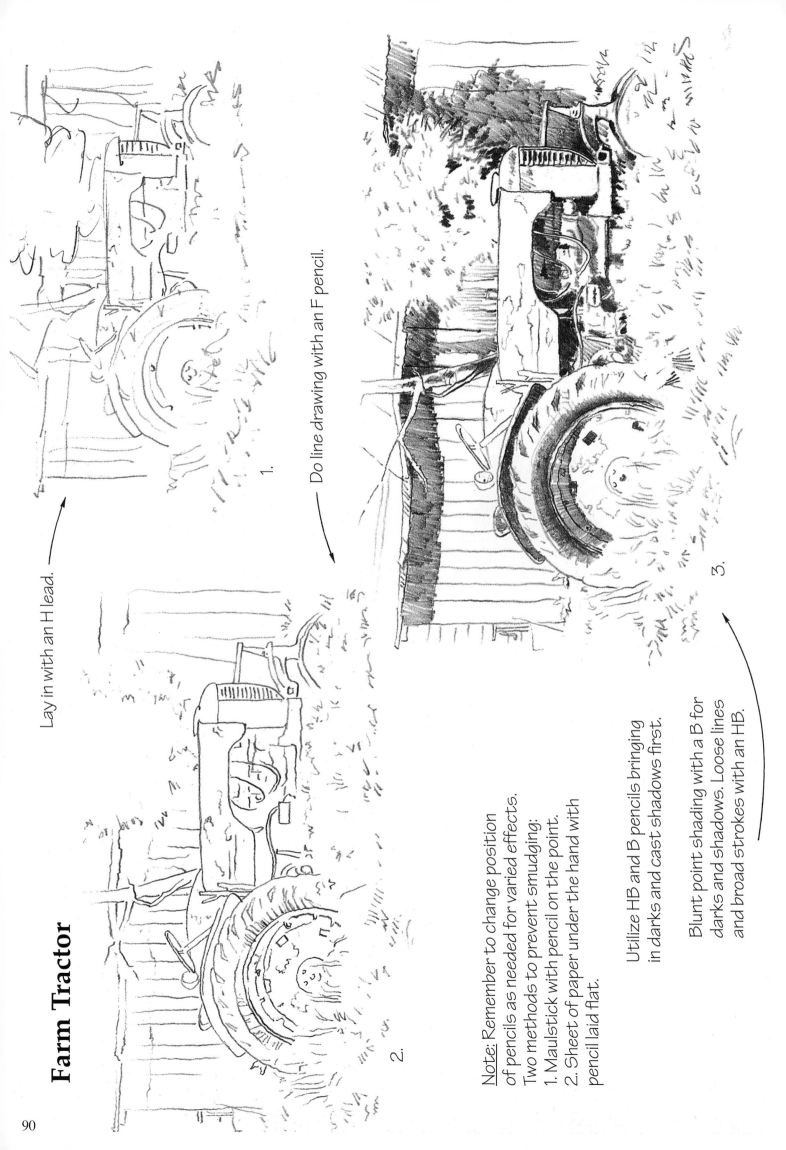

Lay in with an H lead.

1.

Do line drawing with an F pencil.

2.

3.

Note: Remember to change position
of pencils as needed for varied effects.
Two methods to prevent smudging:
1. Maulstick with pencil on the point.
2. Sheet of paper under the hand with
pencil laid flat.

Utilize HB and B pencils bringing
in darks and cast shadows first.

Blunt point shading with a B for
darks and shadows. Loose lines
and broad strokes with an HB.

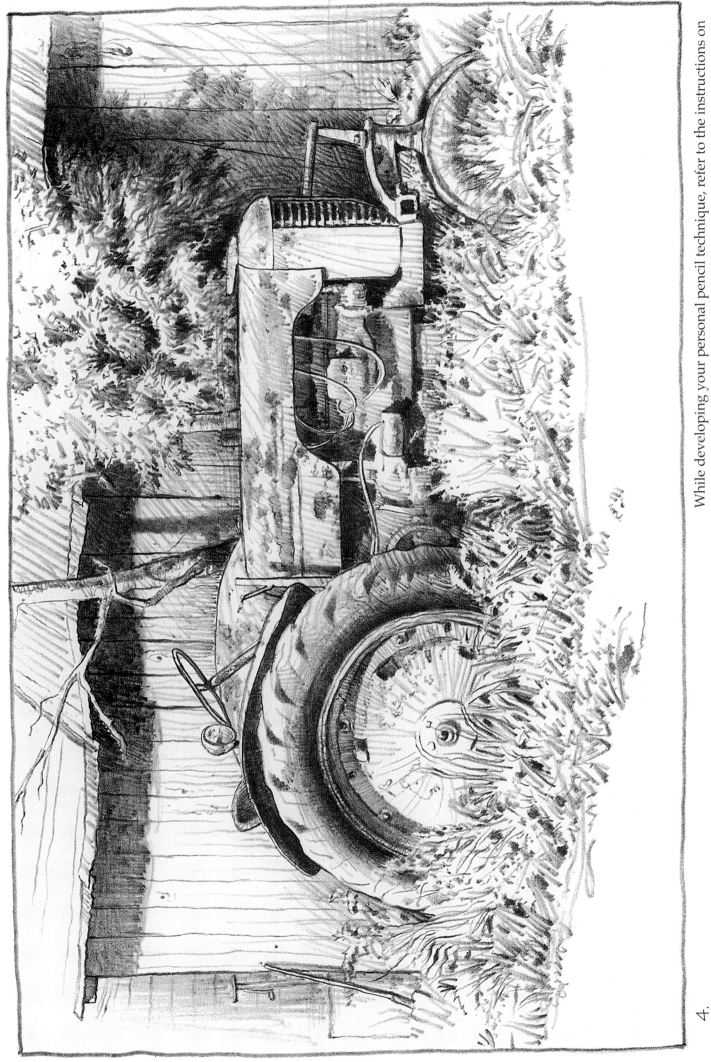

While developing your personal pencil technique, refer to the instructions on pages 10 and 11 for help with the proper choice of pencil and stroke.

4.

Victorian Trolley

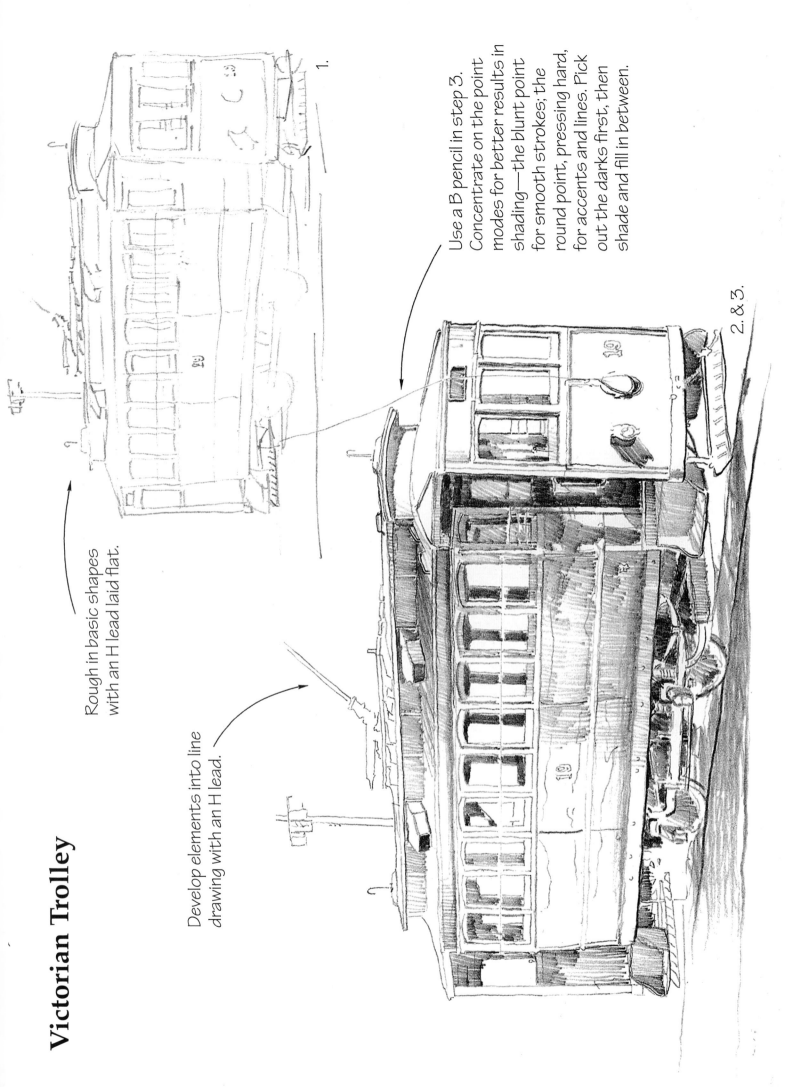

1.

Rough in basic shapes with an H lead laid flat.

Develop elements into line drawing with an H lead.

Use a B pencil in step 3. Concentrate on the point modes for better results in shading—the blunt point for smooth strokes; the round point, pressing hard, for accents and lines. Pick out the darks first, then shade and fill in between.

2. & 3.

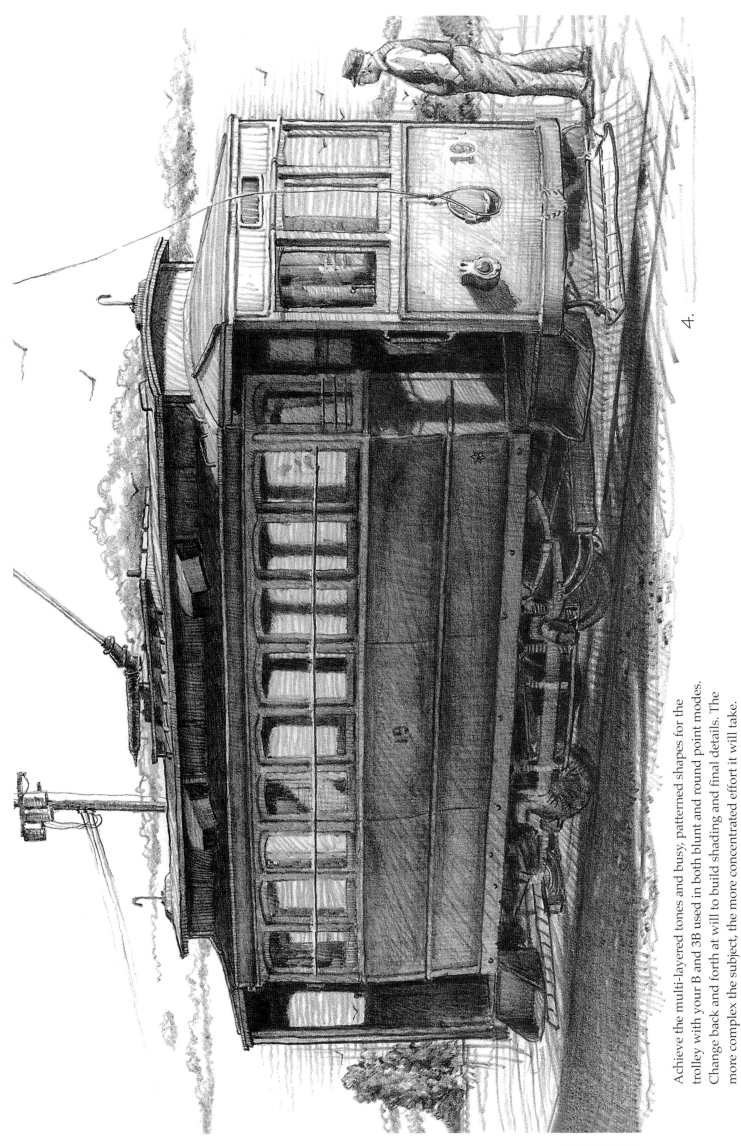

Achieve the multi-layered tones and busy, patterned shapes for the trolley with your B and 3B used in both blunt and round point modes. Change back and forth at will to build shading and final details. The more complex the subject, the more concentrated effort it will take.

4.

93

Steam Replica

Lay in the basic shapes with a loose motion and an H lead laid flat.

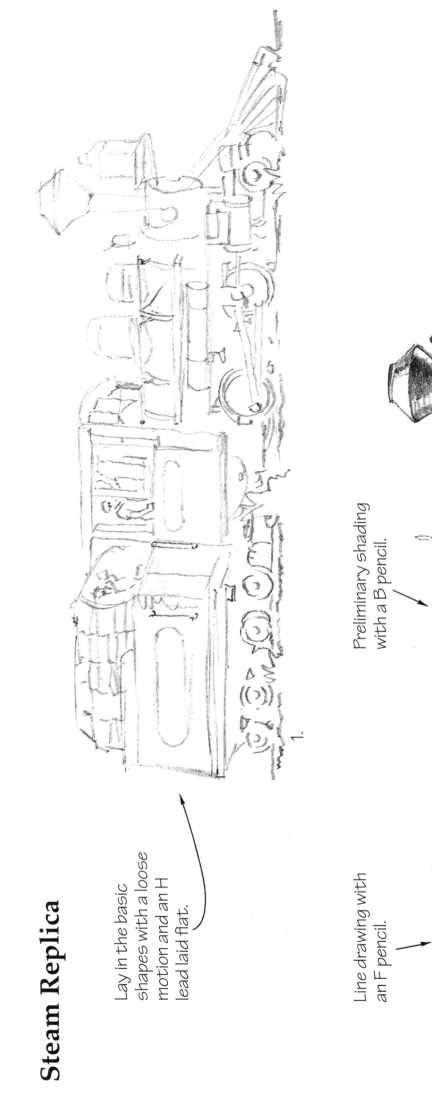

1.

Preliminary shading with a B pencil.

Line drawing with an F pencil.

Pay close attention to the dark patterns first. Reinforce detail and the line drawing as you proceed.

2. & 3.

Work with B and 3B pencils, resting your hand on the maulstick.

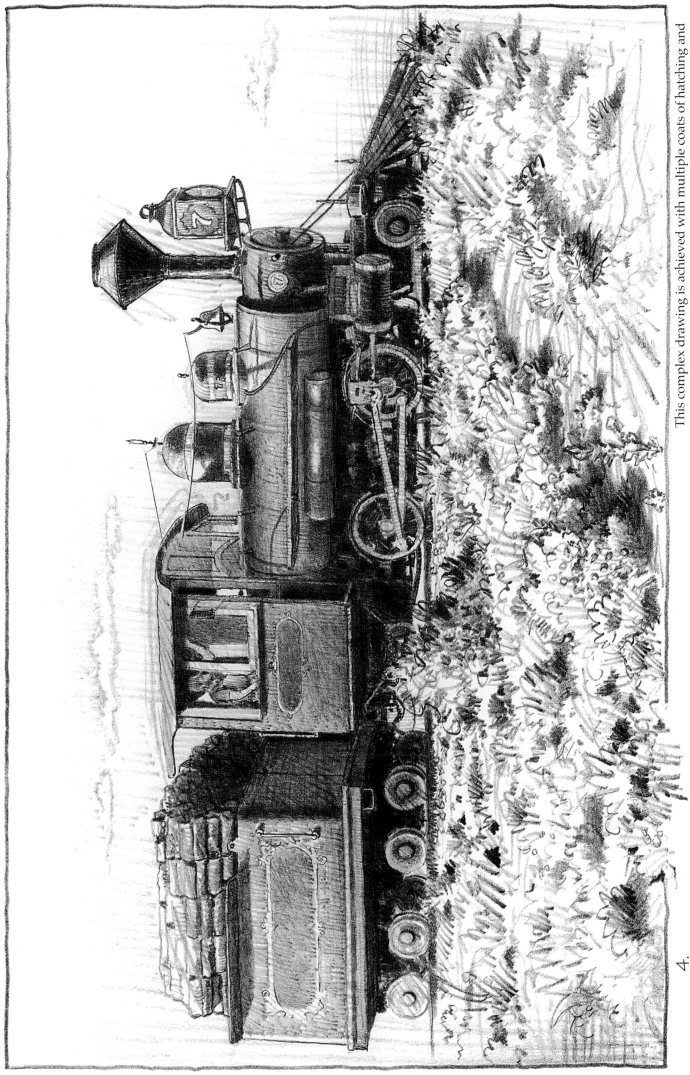

This complex drawing is achieved with multiple coats of hatching and glazing which make the tones darker. Press hard with the 3B pencil, changing point modes as needed for final accents.

4.

Fire Engine

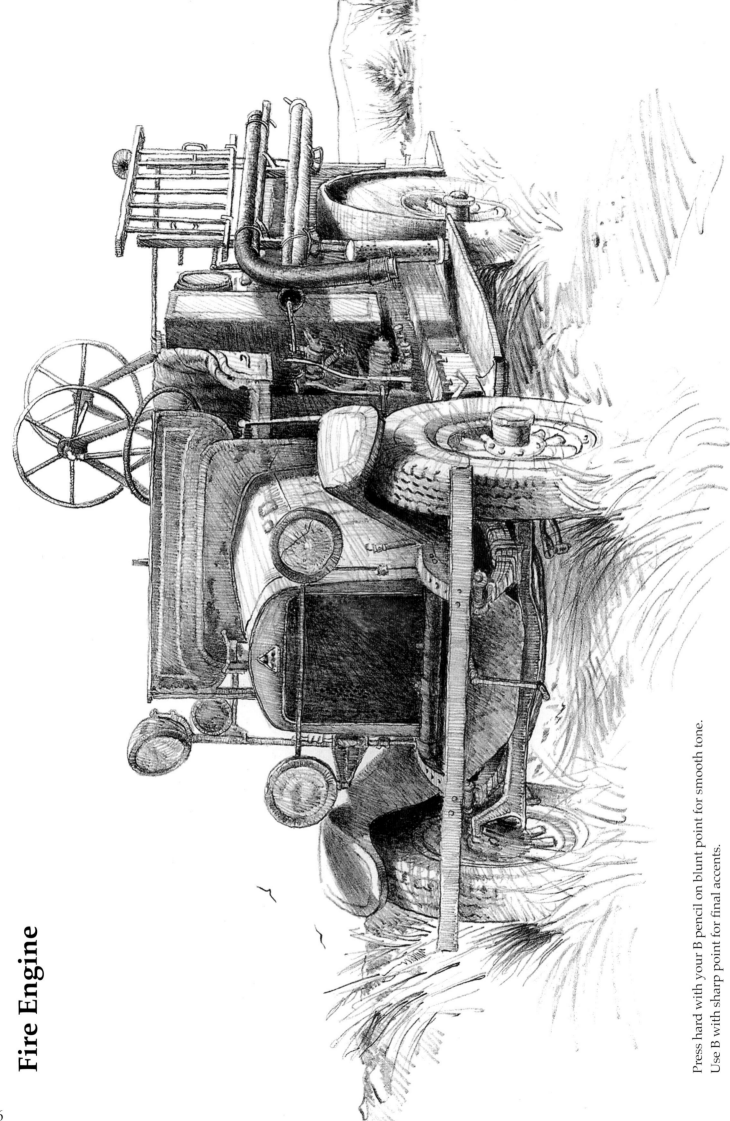

Press hard with your B pencil on blunt point for smooth tone.
Use B with sharp point for final accents.

Flatbed

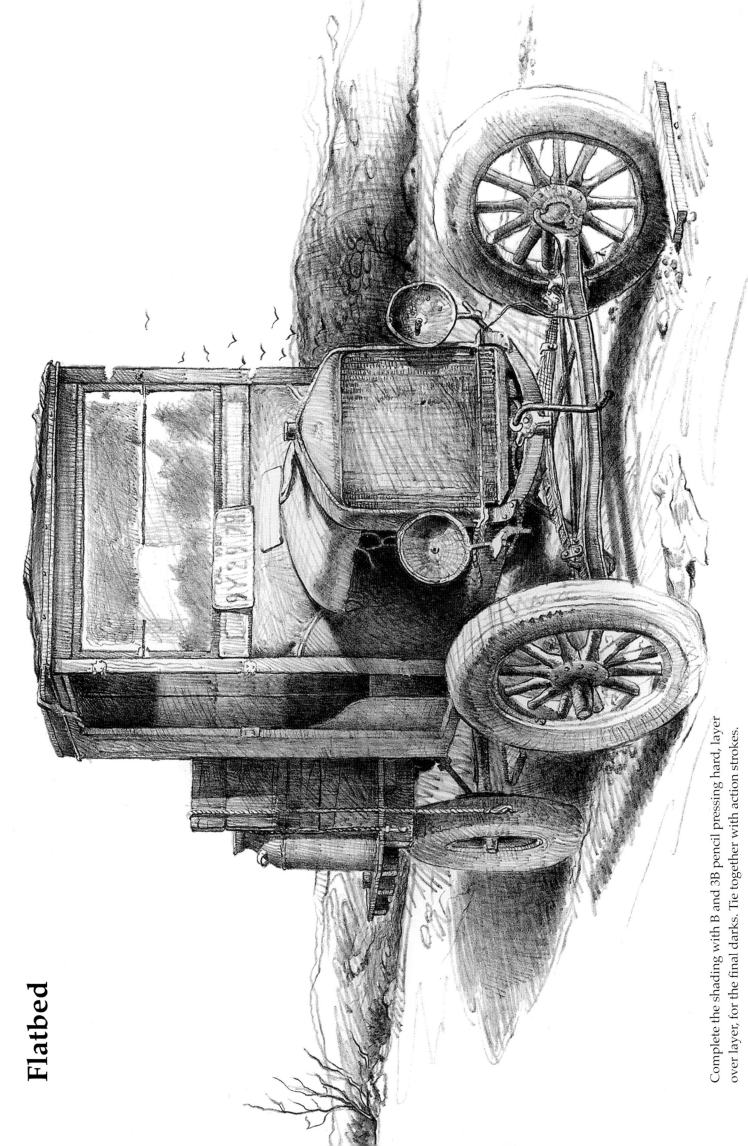

Complete the shading with B and 3B pencil pressing hard, layer over layer, for the final darks. Tie together with action strokes.

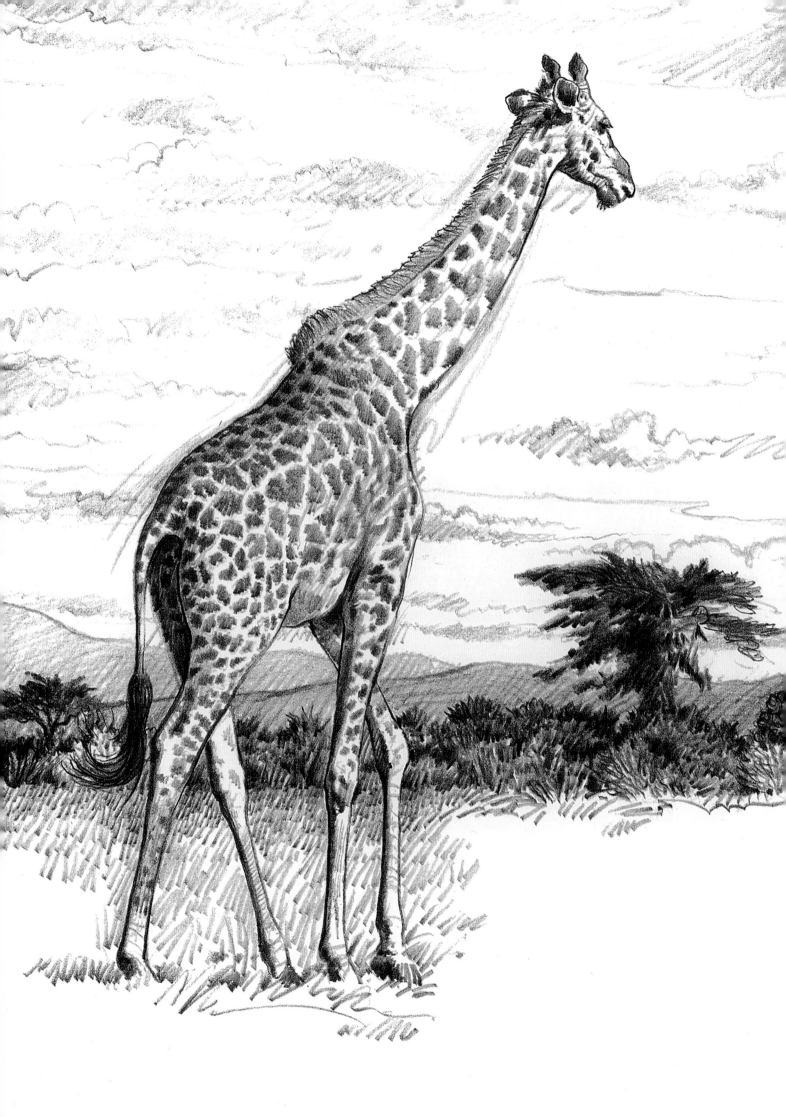

Animals

The natural appeal of animals makes them a favorite subject of young and old artists alike. Who can resist the charm of the lopeared rabbit or prairie dog, the gracefulness of a deer, or the majesty of a red-tailed hawk?

CHOOSING THE SUBJECT

There is a wide variety of subjects to choose from in the animal kingdom—from the cuddly baby lamb to the exotic tiger and zebra, to the somewhat humorous monkey or baby owl—the possibilities are endless. You can find animals almost anywhere; some might even be in your own backyard. Your dog or your cat would make a good subject; a drive in the country might lead youto a farm with a barnyard of animals; or a visit to your city zoo will provide you with hours of sketching or photographing more exotic animals. Sometimes arrangements can even be made with the animal keepers to allow special photo sessions of the animals outside their cages.

RENDERING THE SUBJECT

Animals can be some of the easiest and most enjoyable subjects to draw. Feathers on birds form natural contrasting tones which lend them to black and white; the fur patterns of zebras, giraffes, and tigers also look wonderful in pencil. The hair texture of animals resembles short pencil strokes, making easy to represent.

We think you will especially enjoy this chapter; here are a few tips to ensure success when drawing our furry and feathered friends:

- It is best to photograph the animals and draw from photos or slides because they do not hold still for long! Take many photos in various positions. A long lens on your camera will greatly assist you in getting good shots of birds and wild animals.
- Include some of the animal's natural habitat to enhance your composition. The Guinea Hen on page 113 is a good example.
- It is often more interesting to have the animal doing something such as eating or playing.
- Early morning will provide interesting cross lighting and cast shadows to accentuate fur and feather patterns. You will also find most animals more active and in more interesting poses at this time of day.

SECTION **6**

Sketching

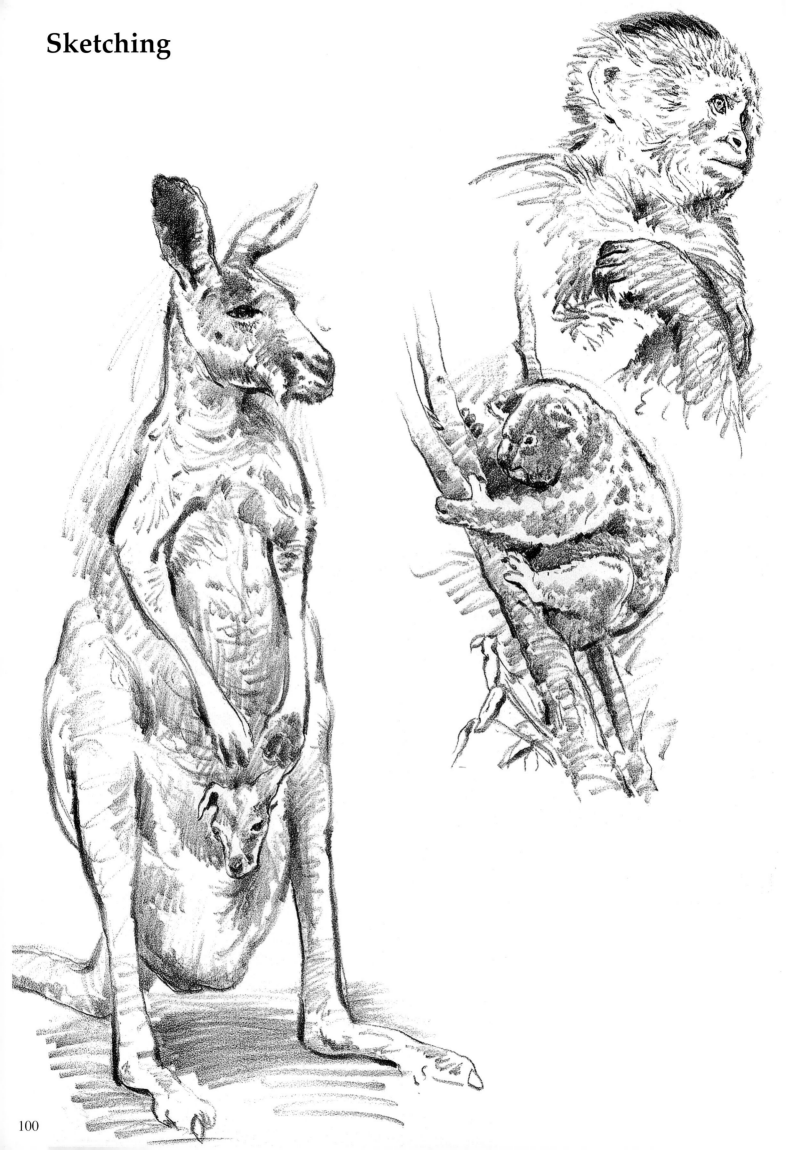

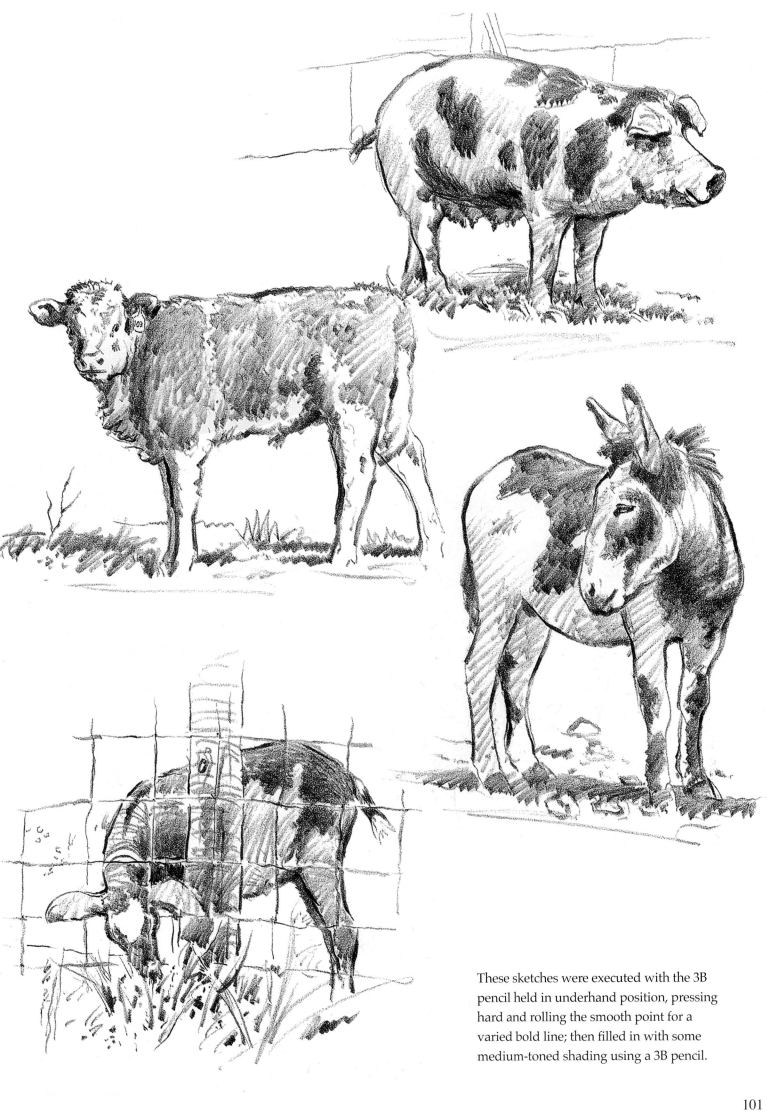

These sketches were executed with the 3B pencil held in underhand position, pressing hard and rolling the smooth point for a varied bold line; then filled in with some medium-toned shading using a 3B pencil.

Little Lamb

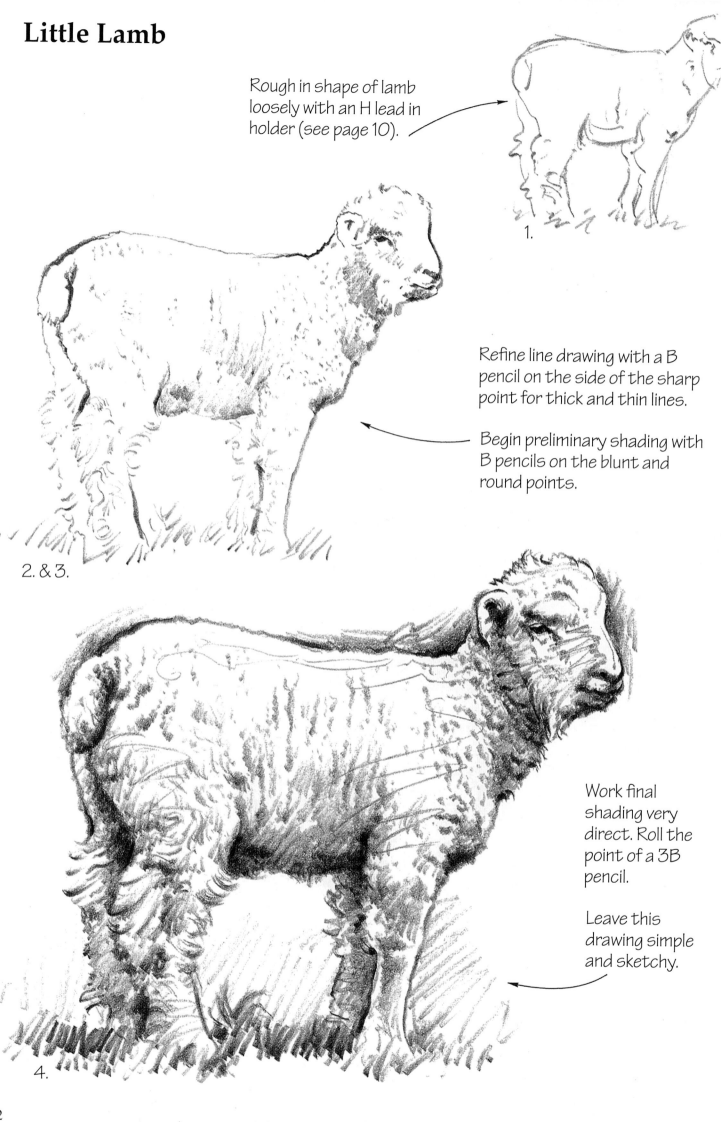

Rough in shape of lamb loosely with an H lead in holder (see page 10).

1.

Refine line drawing with a B pencil on the side of the sharp point for thick and thin lines.

Begin preliminary shading with B pencils on the blunt and round points.

2. & 3.

Work final shading very direct. Roll the point of a 3B pencil.

Leave this drawing simple and sketchy.

4.

Baby Burro

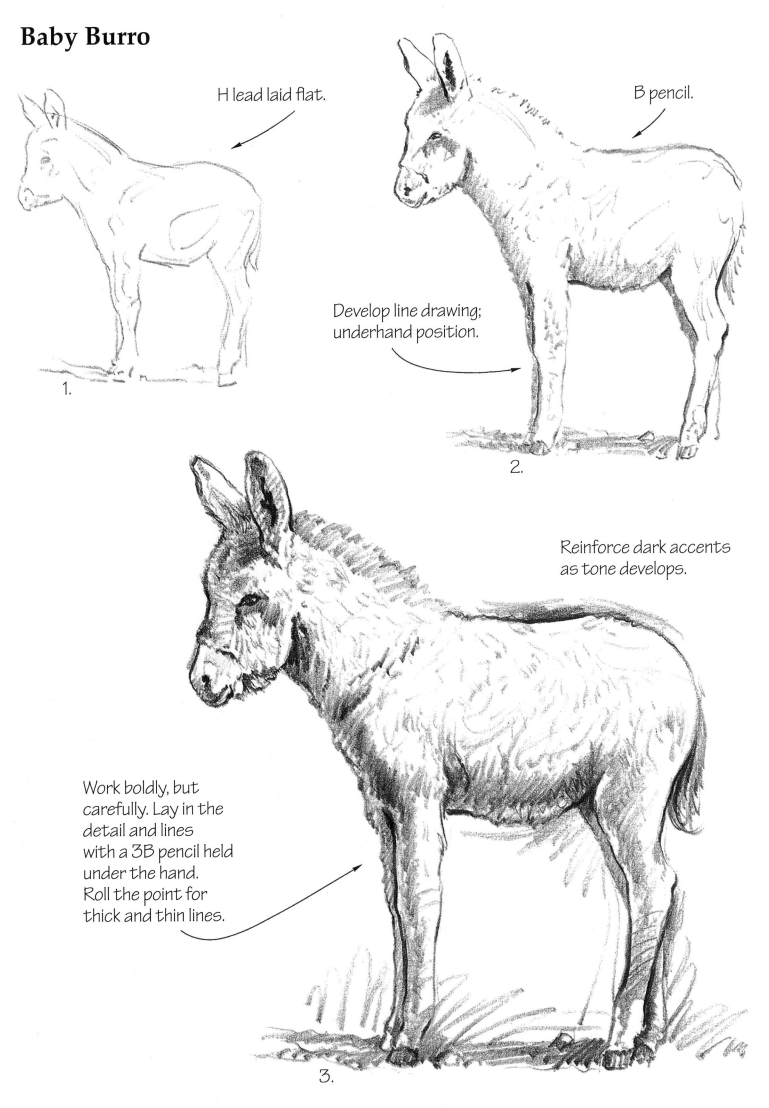

H lead laid flat.

B pencil.

Develop line drawing; underhand position.

1.

2.

Reinforce dark accents as tone develops.

Work boldly, but carefully. Lay in the detail and lines with a 3B pencil held under the hand. Roll the point for thick and thin lines.

3.

Lop-eared Rabbit

Feel shape with an H lead.

1.

Line drawing with an HB pencil.

2.

Begin shading with a B pencil, rolling the point on the side for thick and thin lines. Be bold.

3.

Press hard with a 3B pencil for laying in the darks.

Hatch with the round and blunt points.

4.

Old Goat

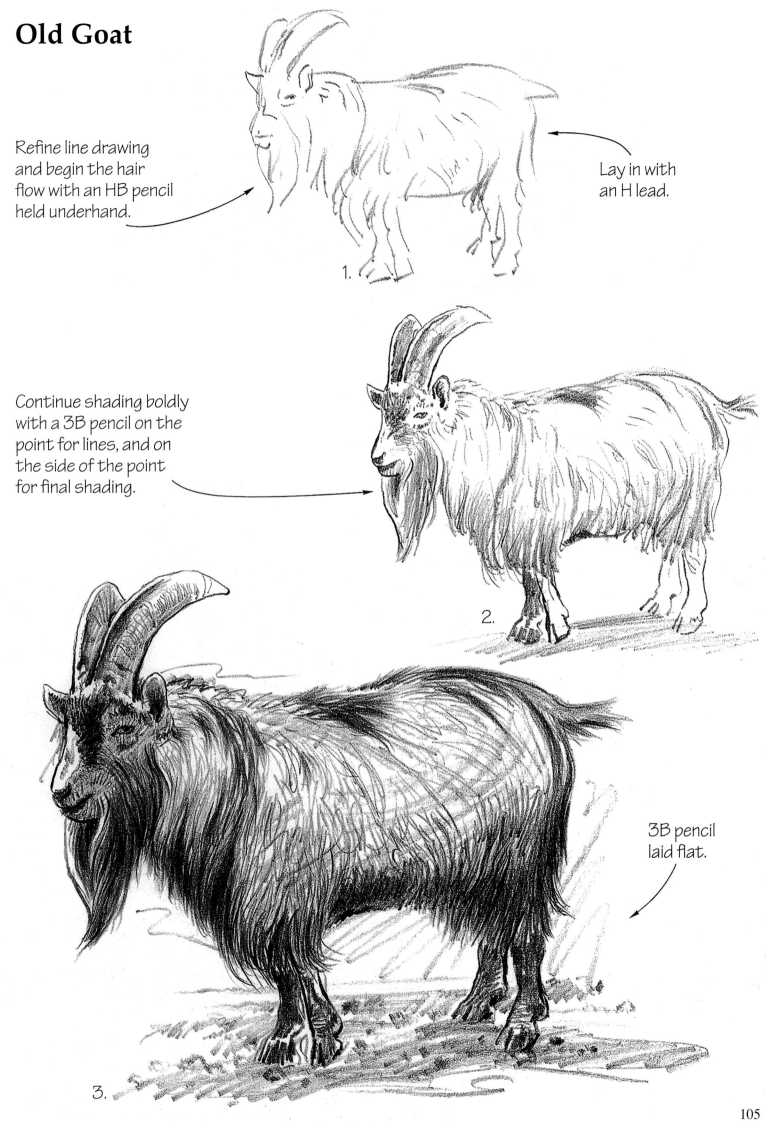

Refine line drawing and begin the hair flow with an HB pencil held underhand.

Lay in with an H lead.

1.

Continue shading boldly with a 3B pencil on the point for lines, and on the side of the point for final shading.

2.

3B pencil laid flat.

3.

Jack Rabbit

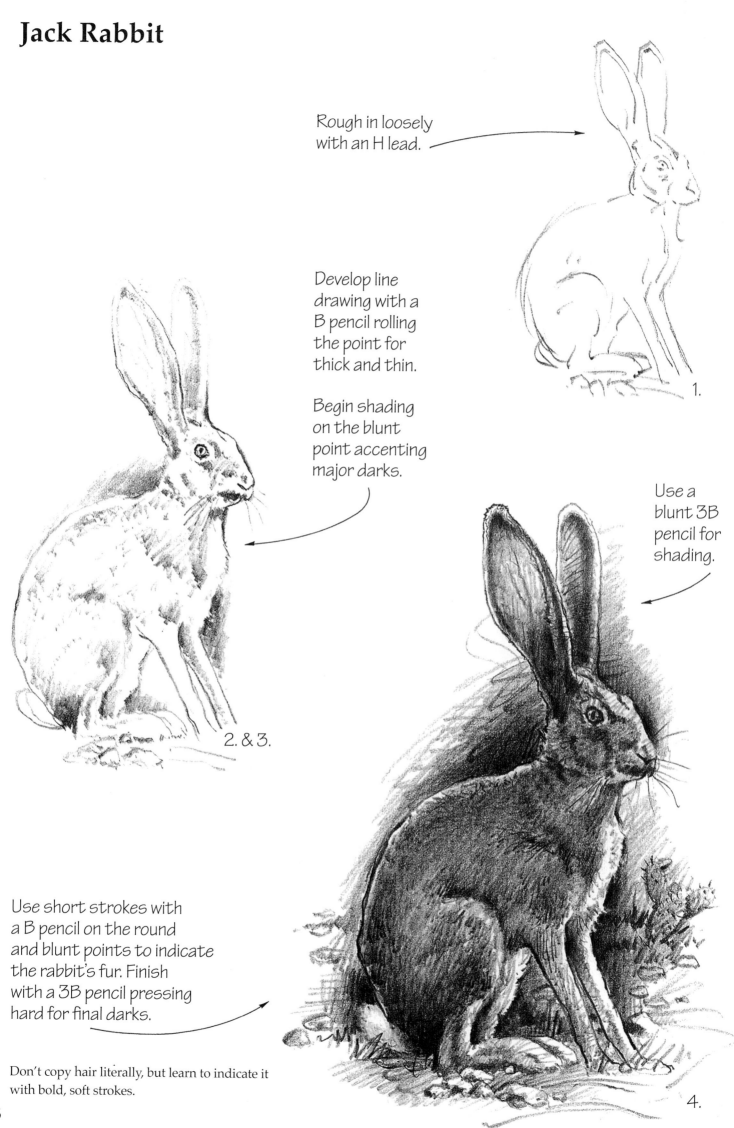

Rough in loosely with an H lead.

1.

Develop line drawing with a B pencil rolling the point for thick and thin.

Begin shading on the blunt point accenting major darks.

2. & 3.

Use a blunt 3B pencil for shading.

Use short strokes with a B pencil on the round and blunt points to indicate the rabbit's fur. Finish with a 3B pencil pressing hard for final darks.

Don't copy hair literally, but learn to indicate it with bold, soft strokes.

4.

Prairie Dog

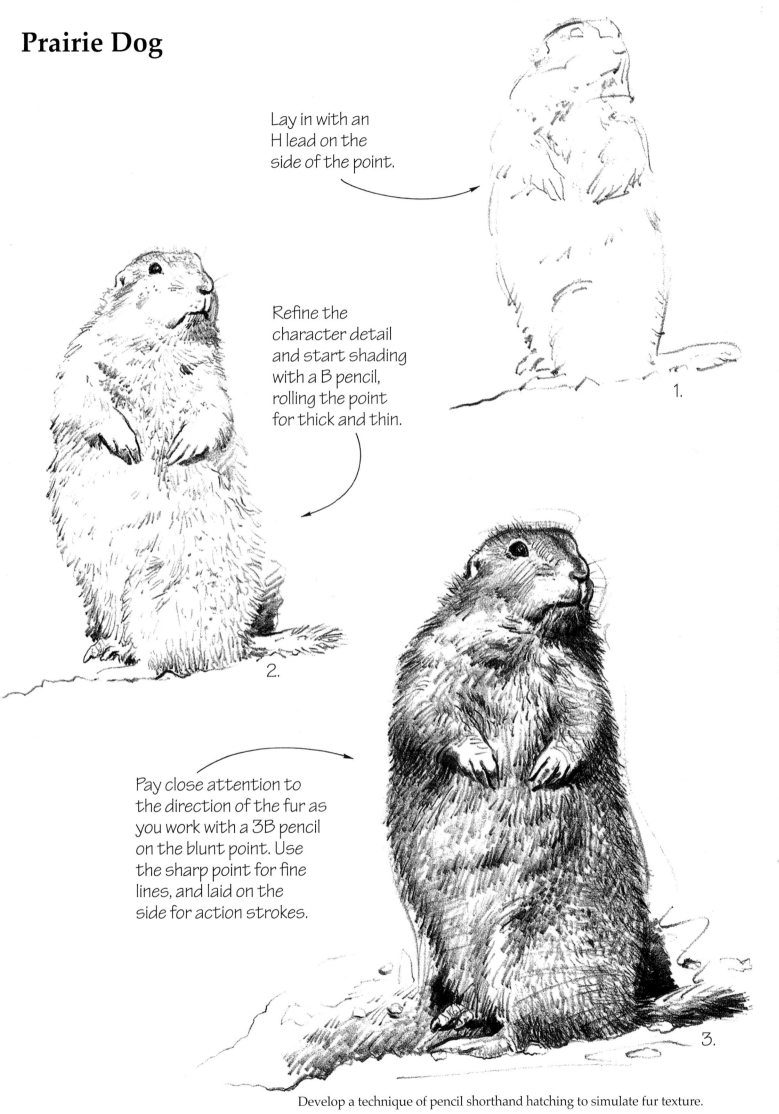

Lay in with an H lead on the side of the point.

1.

Refine the character detail and start shading with a B pencil, rolling the point for thick and thin.

2.

Pay close attention to the direction of the fur as you work with a 3B pencil on the blunt point. Use the sharp point for fine lines, and laid on the side for action strokes.

3.

Develop a technique of pencil shorthand hatching to simulate fur texture.

Young Doe

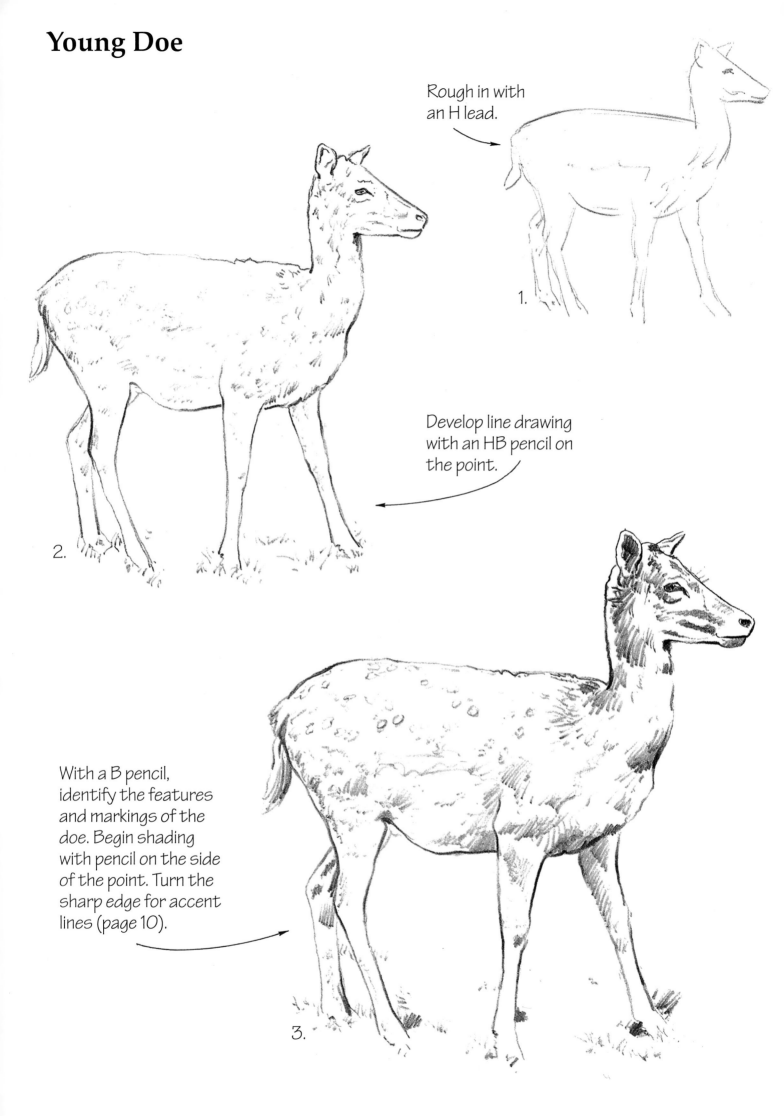

Rough in with an H lead.

1.

Develop line drawing with an HB pencil on the point.

2.

With a B pencil, identify the features and markings of the doe. Begin shading with pencil on the side of the point. Turn the sharp edge for accent lines (page 10).

3.

Use a 3B pencil on the blunt point for hatching and on the side of the point for strong thick and thin lines. Press hard for final darks.

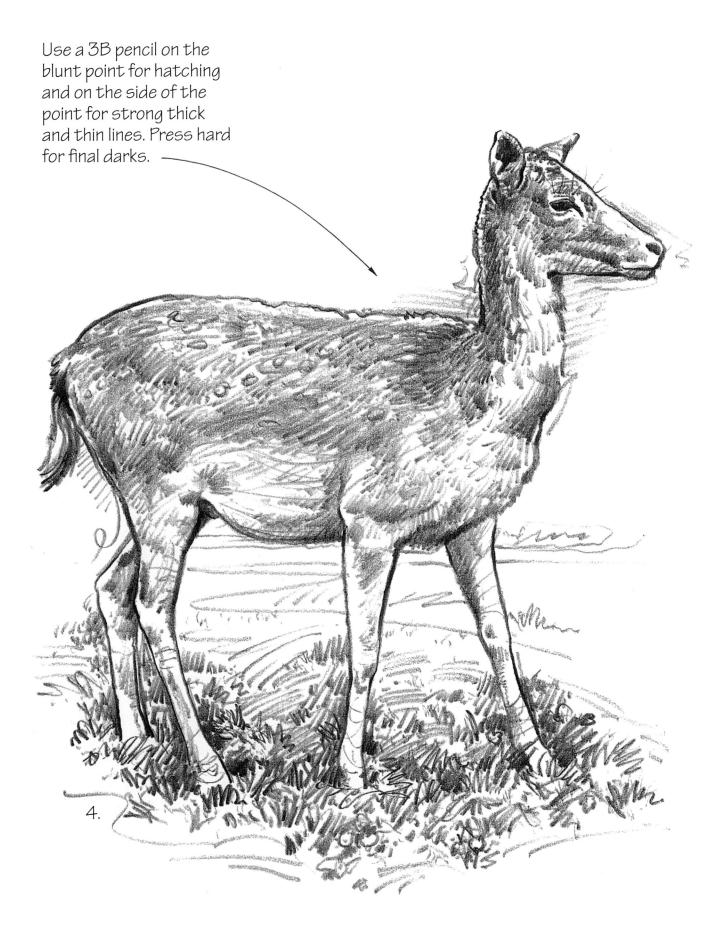

4.

The purpose of this drawing is to show a shorthand method with very little glazing. This spontaneous effect is accomplished by hatching with a blunt pencil while the hand rests on a maulstick to prevent smudging. When you work with a soft pencil on hot-pressed (smooth) paper, you will achieve uniform, overlapping strokes with very little grain. Work with your pencil under the hand, rolling the point for expressive lines. Bring it up to the point for final accents.

Canada Goose

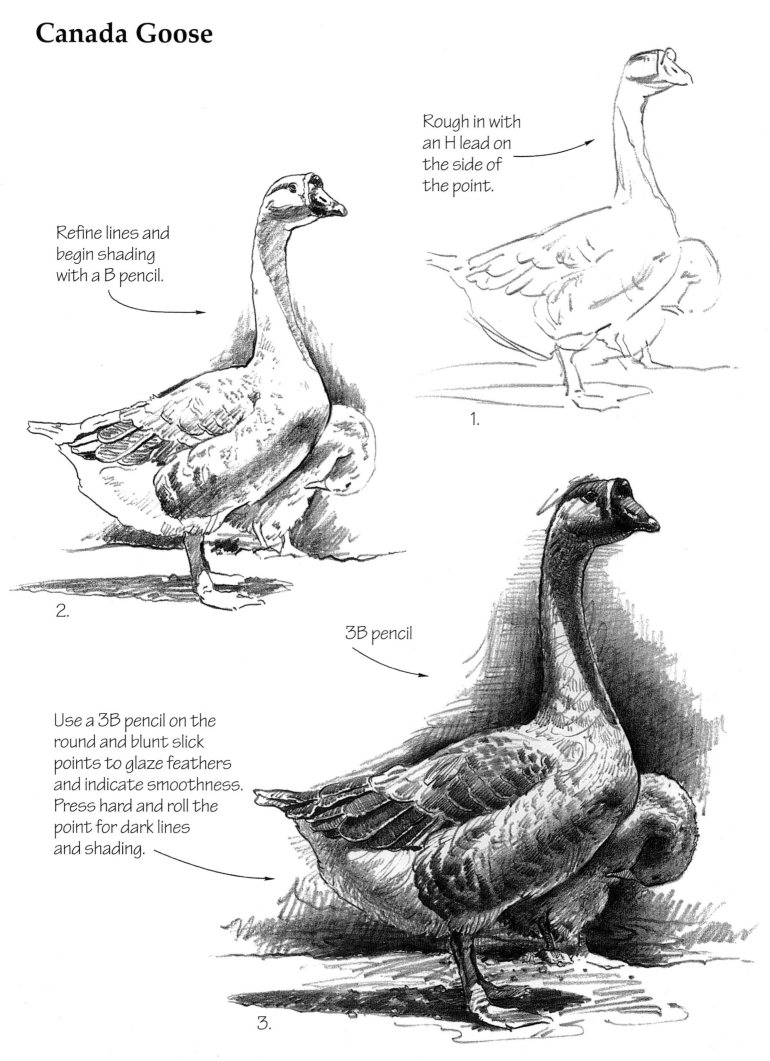

Rough in with an H lead on the side of the point.

1.

Refine lines and begin shading with a B pencil.

2.

3B pencil

Use a 3B pencil on the round and blunt slick points to glaze feathers and indicate smoothness. Press hard and roll the point for dark lines and shading.

3.

Practice this bold method of shading in your own work.

Sea Gull

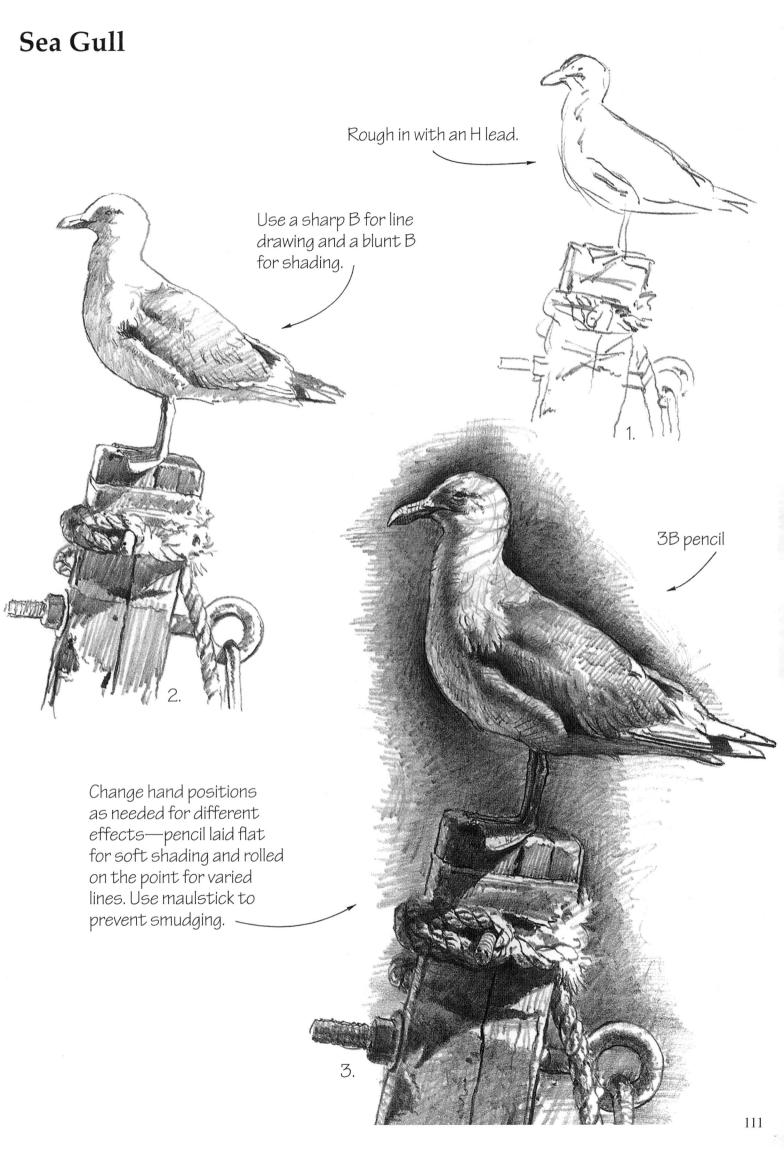

Rough in with an H lead.

Use a sharp B for line drawing and a blunt B for shading.

3B pencil

1.

2.

Change hand positions as needed for different effects—pencil laid flat for soft shading and rolled on the point for varied lines. Use maulstick to prevent smudging.

3.

Guinea Hen

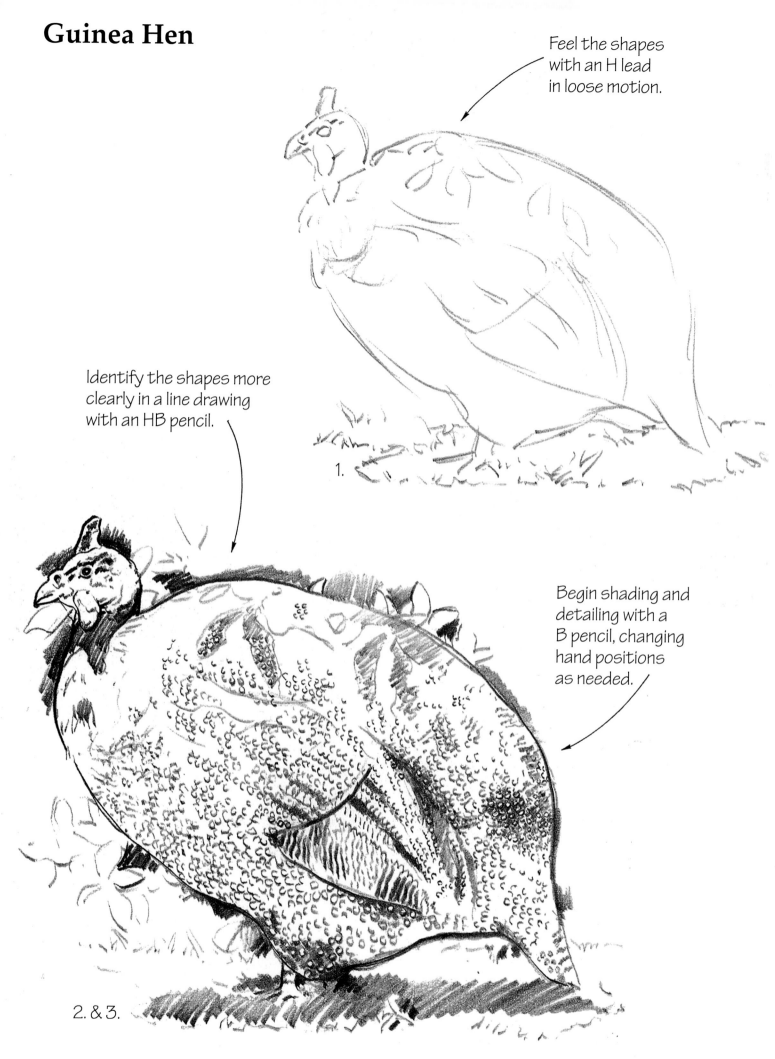

Feel the shapes with an H lead in loose motion.

Identify the shapes more clearly in a line drawing with an HB pencil.

1.

Begin shading and detailing with a B pencil, changing hand positions as needed.

2. & 3.

Pay special attention to detail, and shade around the white spots.

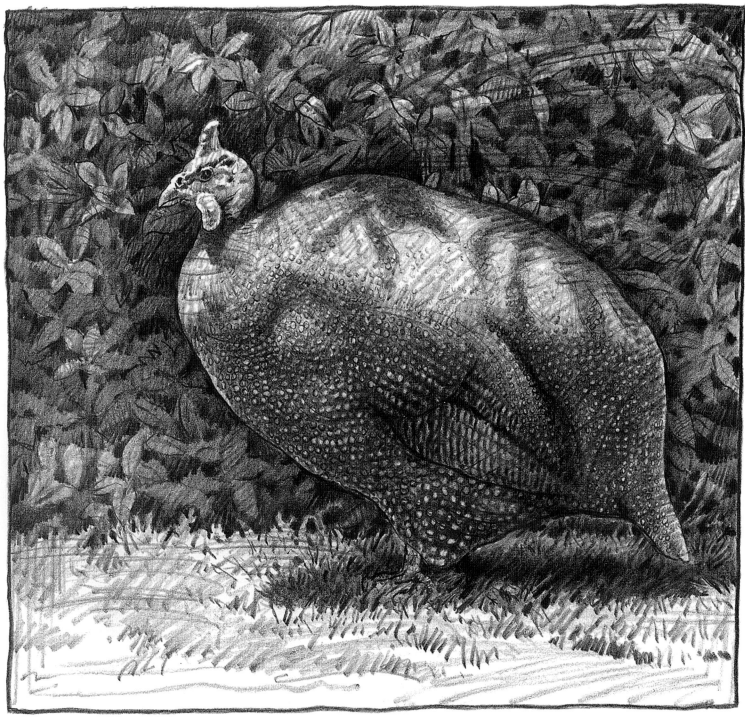

4.

Work boldly, pressing hard with a 3B pencil. Leave white paper showing through in places for contrast and sparkle.

The Guinea hen is a complex drawing. Don't shy away from it. Often our most gratifying experiences come from tackling a difficult subject.

This study demonstrates a variety of design and pattern and shows the effectiveness of black with white. It is important to remember that you must shade around the spots on the guinea hen, leaving them white. Unlike painting where white paint can be added, with pencil drawing we work only in gray and black tones. Therefore, the paper must show through to create white areas.

This drawing also emphasizes texture against texture and dark against light. Concentrate on the use of the pencil points in relation to the pencil stroke effects (see pages 10 and 11). Press hard for darks and expressive lines, varying the pressure for different tones.

With a little extra effort and concentration you can reproduce a guinea hen drawing you will be proud of.

The Owlets

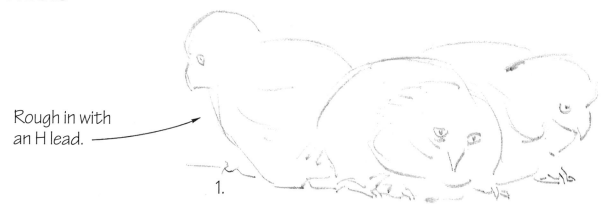

Rough in with an H lead.

1.

Loose motion; pencil held underhand.

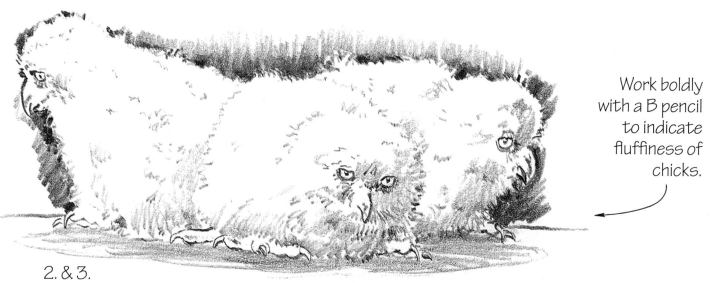

Work boldly with a B pencil to indicate fluffiness of chicks.

2. & 3.

Pencil used on the side of the point for free strokes.

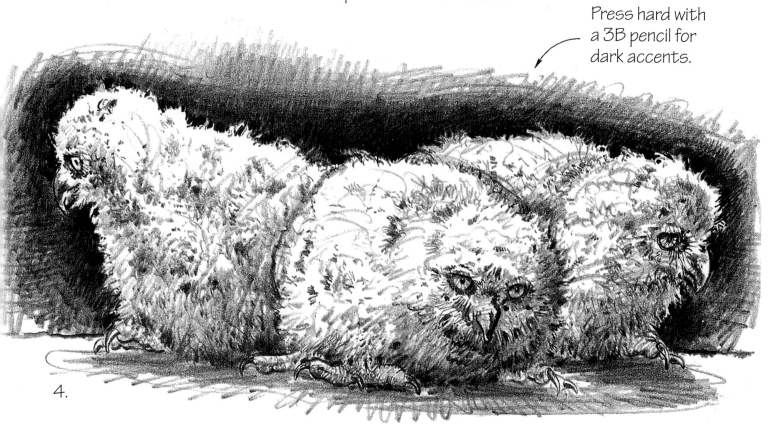

Press hard with a 3B pencil for dark accents.

4.

Use both hand positions for variety of strokes (see page 11).

Barn Owl

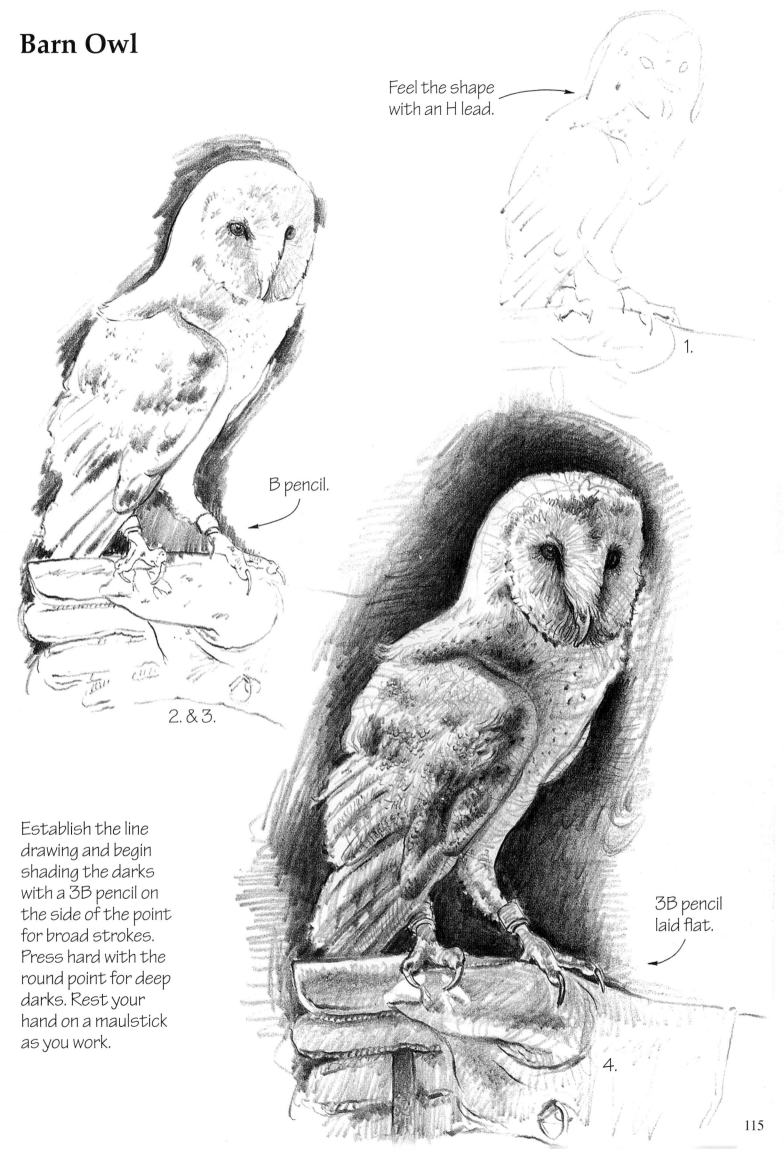

Feel the shape with an H lead.

1.

B pencil.

2. & 3.

Establish the line drawing and begin shading the darks with a 3B pencil on the side of the point for broad strokes. Press hard with the round point for deep darks. Rest your hand on a maulstick as you work.

3B pencil laid flat.

4.

Red-tailed Hawk

Rough in the hawk with an H lead.

Refine the line drawing with a sharp HB pencil.

Begin shading with a blunt B pencil—reinforce elements as you go.

1.

2. & 3.

Refer to "Pencil Procedure" on page 9 for more detailed instructions on developing your pencil drawing. After diligent practice of hand positions and pencil strokes (pages 10 and 11) you will be amazed at the effects you can achieve.

Birds and animals are easier to render than you might think. In time, you will develop a shorthand method for handling fur and feathers.

116

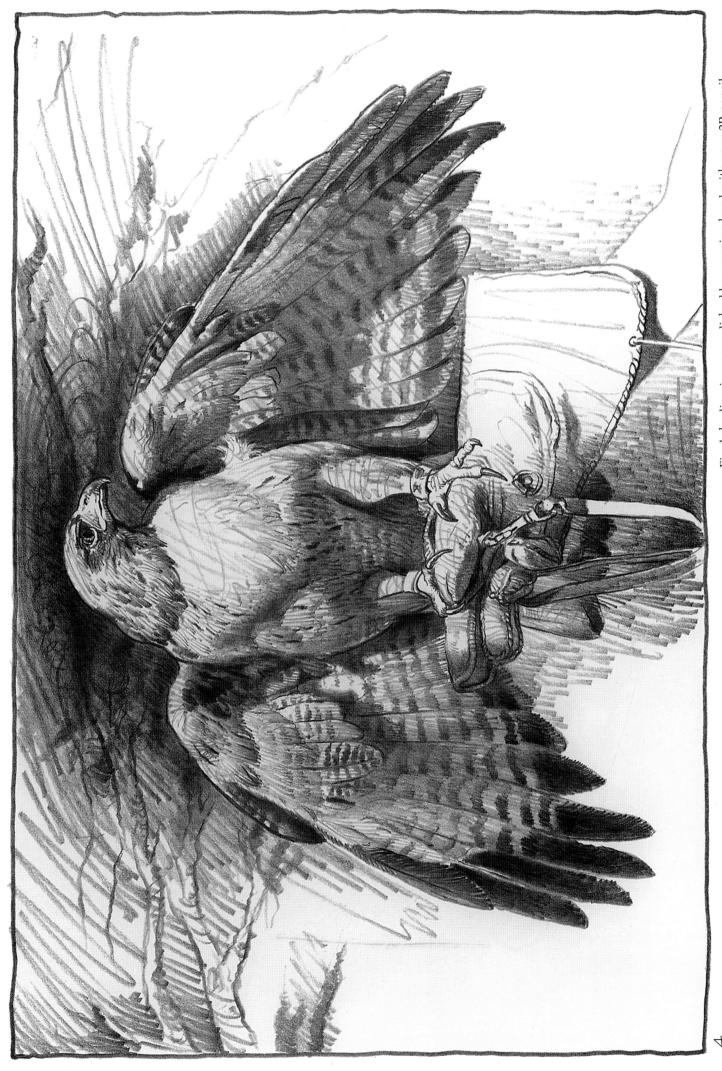

Final shading is accomplished by pressing hard with your 3B pencil.

4.

117

Tiger Head

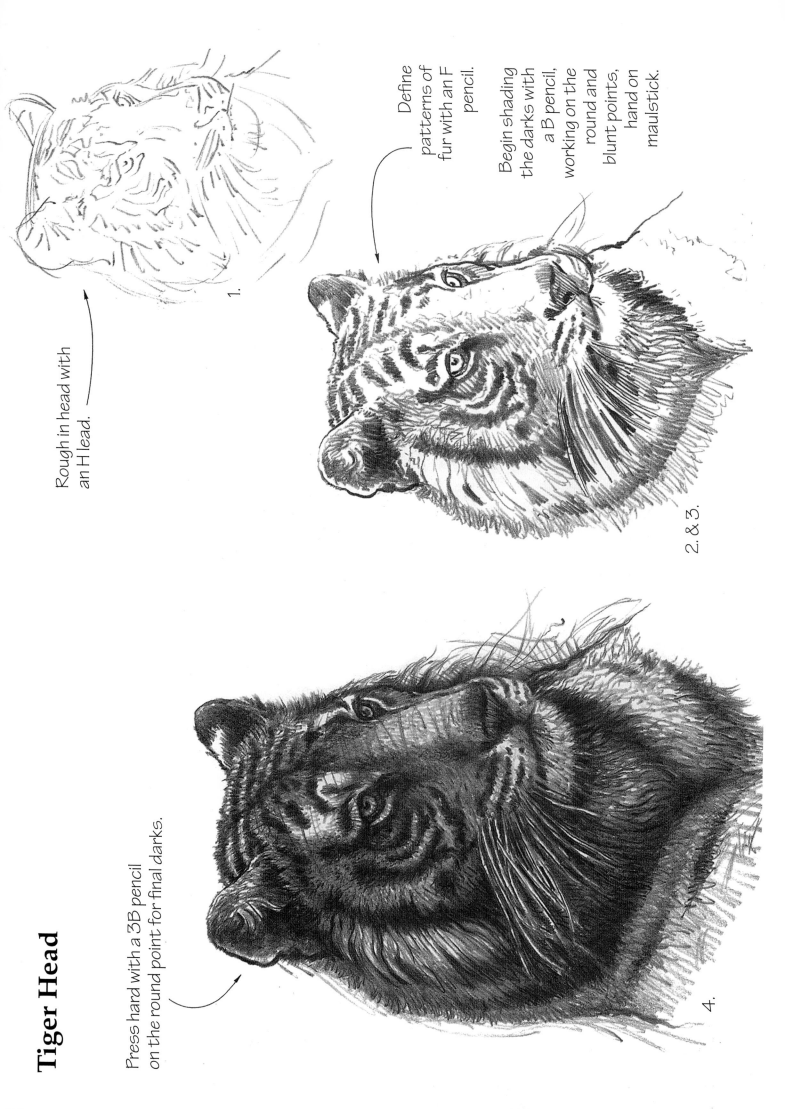

Rough in head with an H lead.

Define patterns of fur with an F pencil.

Begin shading the darks with a B pencil, working on the round and blunt points, hand on maulstick.

Press hard with a 3B pencil on the round point for final darks.

1.

2. & 3.

4.

118

The Lioness

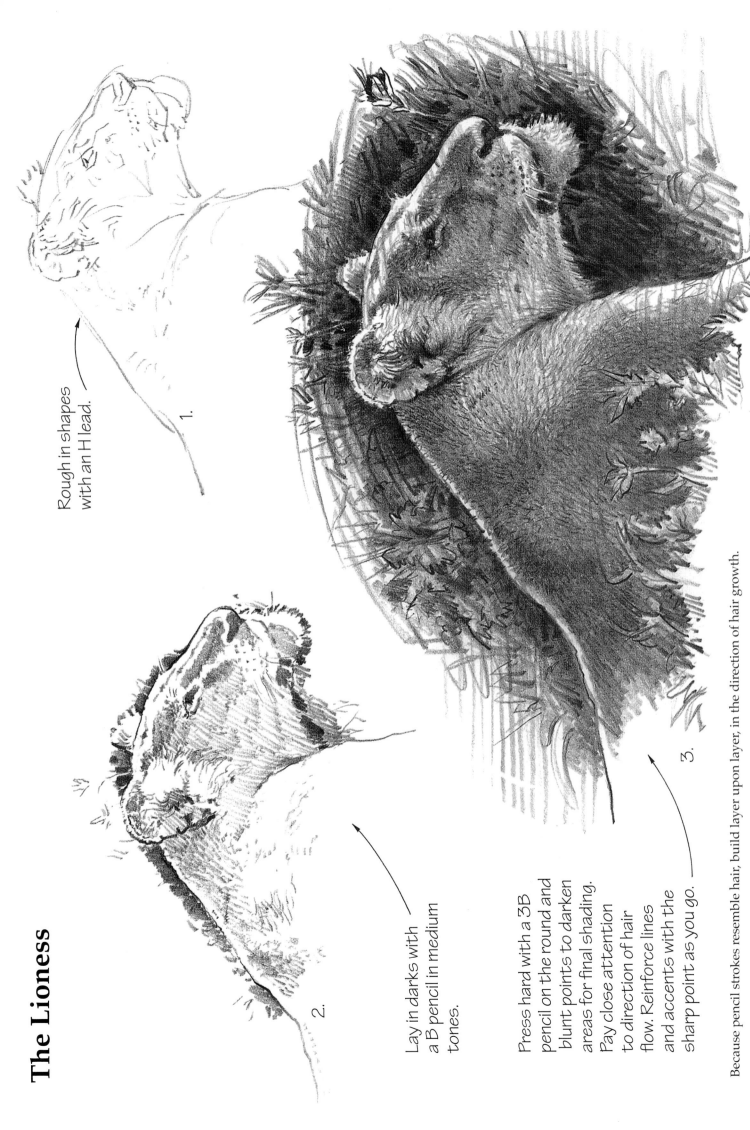

Rough in shapes with an H lead.

1.

2.

Lay in darks with a B pencil in medium tones.

Press hard with a 3B pencil on the round and blunt points to darken areas for final shading. Pay close attention to direction of hair flow. Reinforce lines and accents with the sharp point as you go.

3.

Because pencil strokes resemble hair, build layer upon layer, in the direction of hair growth.

Elephant Family

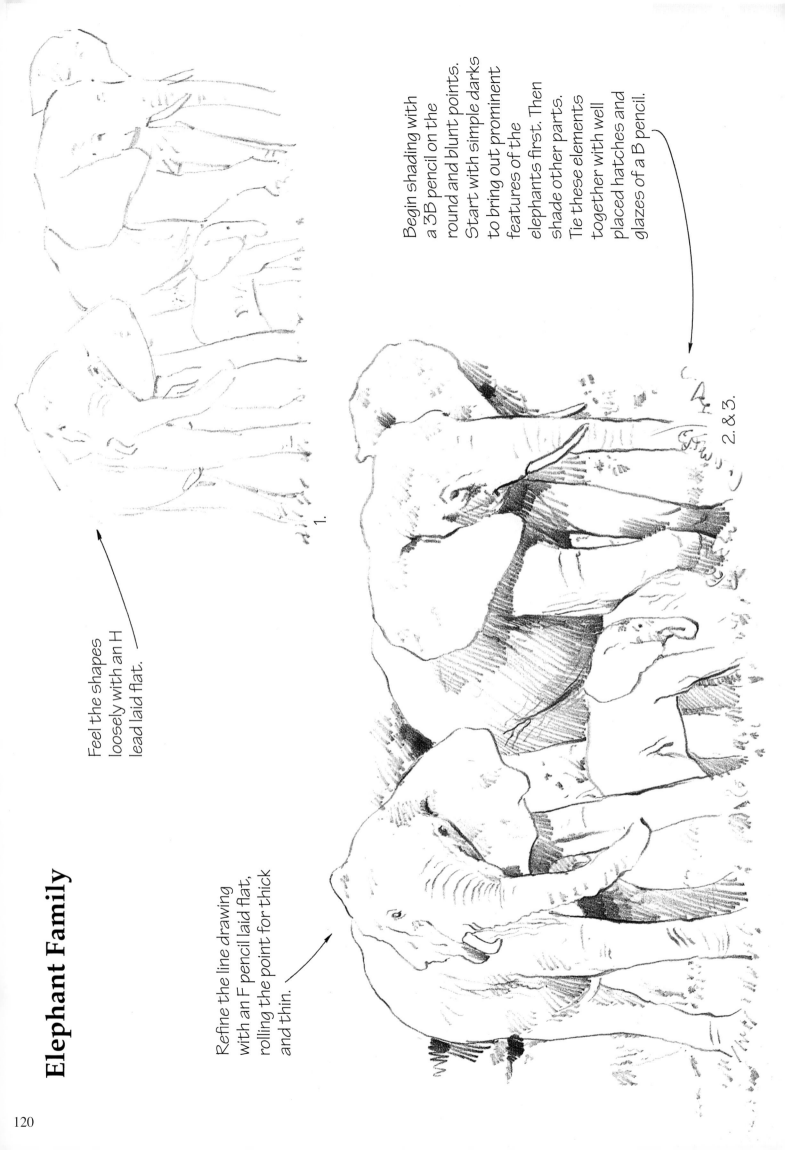

Feel the shapes loosely with an H lead laid flat.

Refine the line drawing with an F pencil laid flat, rolling the point for thick and thin.

Begin shading with a 3B pencil on the round and blunt points. Start with simple darks to bring out prominent features of the elephants first. Then shade other parts. Tie these elements together with well placed hatches and glazes of a B pencil.

1.

2. & 3.

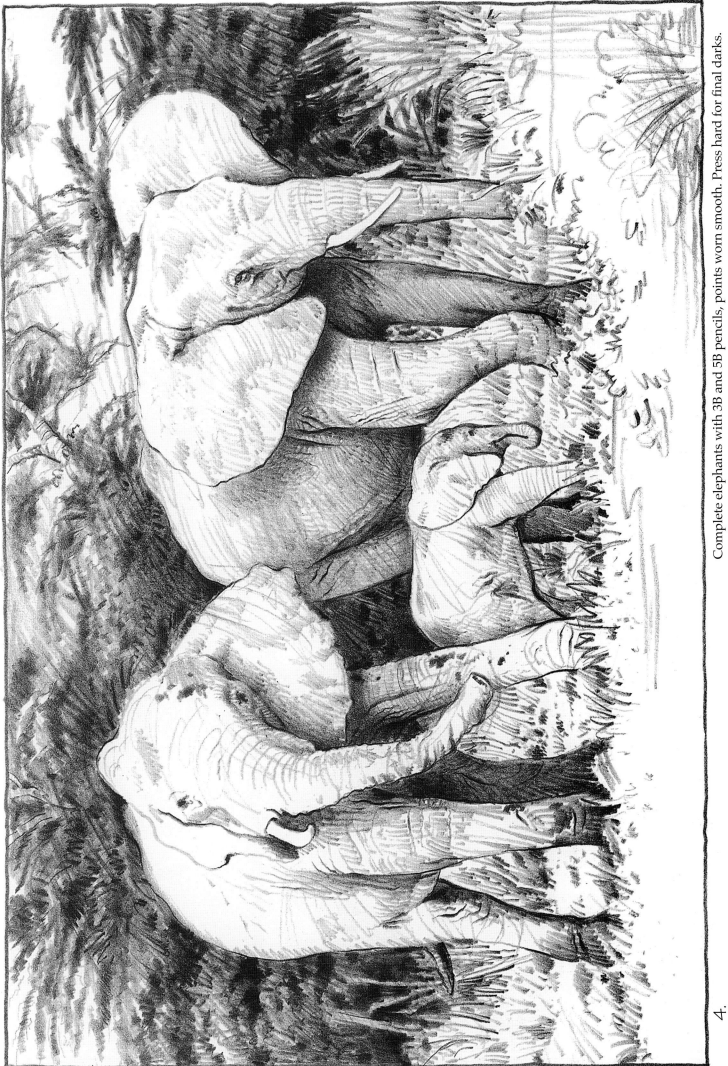

4. Complete elephants with 3B and 5B pencils, points worn smooth. Press hard for final darks.

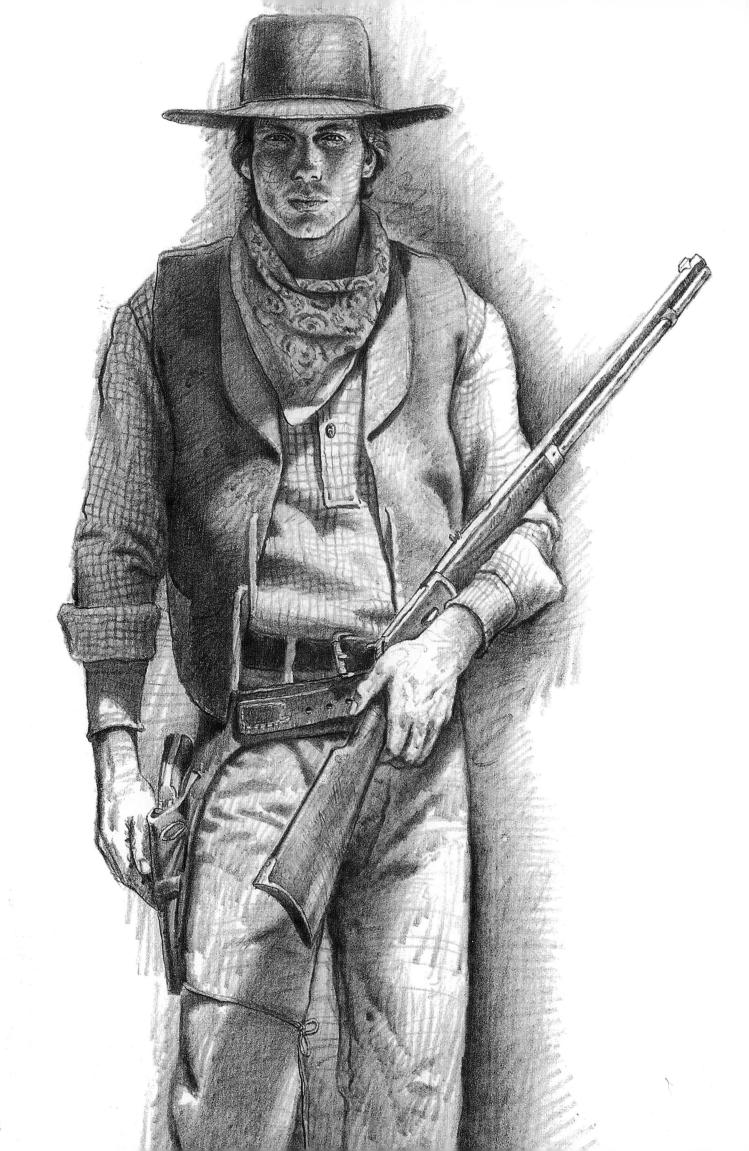

People

A wide variety of people is portrayed in this chapter. Study each one and you will be drawn to their stories. Portraits convey far more than words express. Joy, sadness, innocence, wonder, delight, and wisdom are expressed in these faces.

THE MODEL

Selecting a model is the first and most important step in doing a fine art portrait. Choose someone who appeals to you. Perhaps the person has very good bone structure or beautiful eyes. Maybe there is a profound sadness or lightheartedness about your subject. Whatever the reason, it must mean something to you.

THE POSE

Determine which pose looks best for your model—profile, frontal, or three-quarter view. Carefully study the clothes, hair, and features for best representation of the person. For example, someone with a classic nose often makes a great profile, but if your model has large ears, you should not do a frontal drawing——a three-quarter drawing would probably be best.

THE VIEWER

A well-executed pencil portrait of a compelling model of great character or beauty, in a poetic pose, with dramatic lighting, will attract the viewer.

Here are some further suggestions to help you draw people:

- Light your subject to coincide with the character of your model and the mood you want to convey.
- Turn or tilt the head of your subject to give the personality emphasis.
- Have your subject cast his or her eyes up or down according to the emotion you want to illustrate.
- Modify your style and technique to the model—fine, tight handling for poetic drama; bold, loose treatment for a light hearted or humorous subject.

There is refreshment and nourishment to be derived from studying an excellent portrait—a reflection of human nature common to all.

SECTION 7

Sketching

To ensure correct proportions, the figure is normally measured by "heads." The average figure is 8 heads high, though some artists like to lengthen the legs by another 1/2 head. Try drawing your figure 8 heads high, then 8-1/2 heads high.

The "head" measuring system will work when drawing the figure in other positions as well.

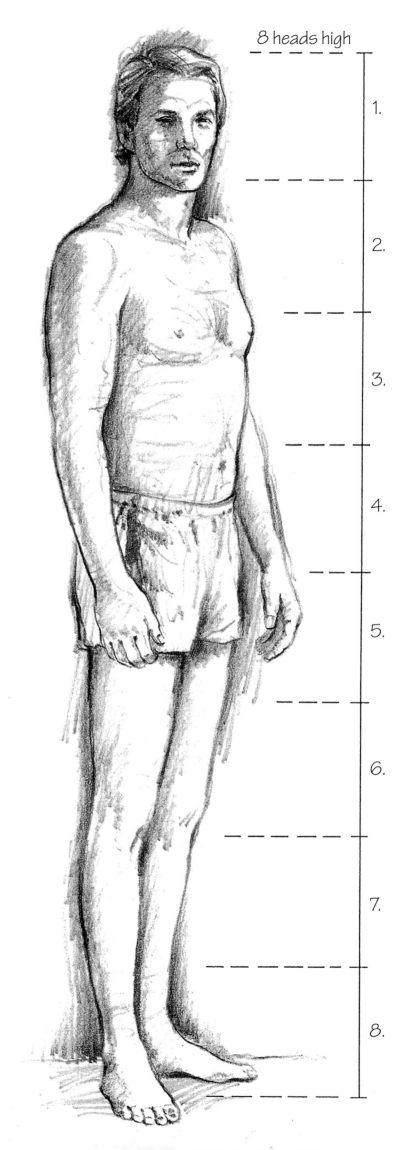

8 heads high

1.

2.

3.

4.

5.

6.

7.

8.

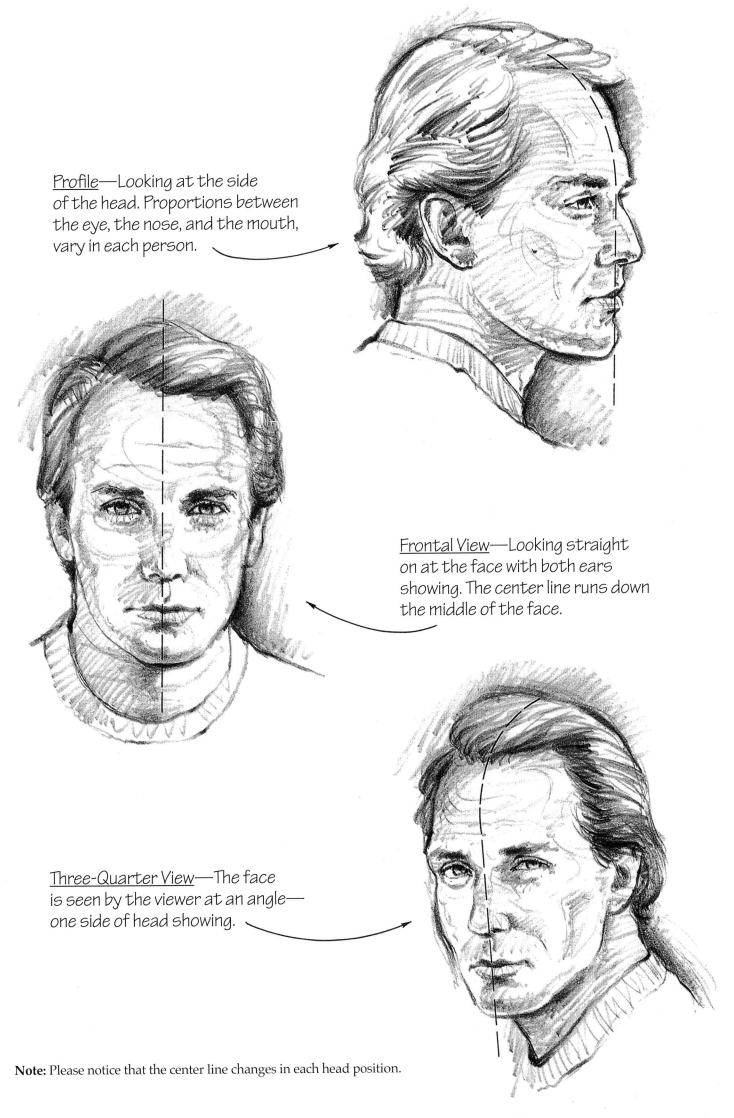

<u>Profile</u>—Looking at the side of the head. Proportions between the eye, the nose, and the mouth, vary in each person.

<u>Frontal View</u>—Looking straight on at the face with both ears showing. The center line runs down the middle of the face.

<u>Three-Quarter View</u>—The face is seen by the viewer at an angle— one side of head showing.

Note: Please notice that the center line changes in each head position.

Smiley

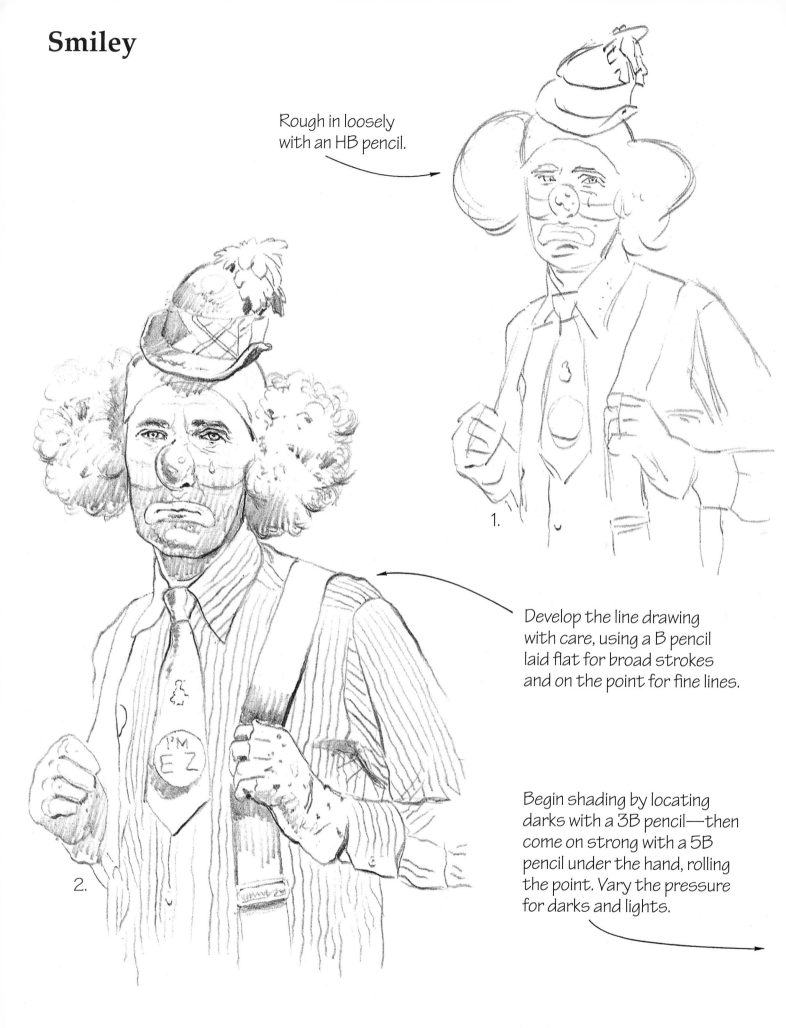

Rough in loosely with an HB pencil.

1.

Develop the line drawing with care, using a B pencil laid flat for broad strokes and on the point for fine lines.

2.

Begin shading by locating darks with a 3B pencil—then come on strong with a 5B pencil under the hand, rolling the point. Vary the pressure for darks and lights.

This whimsical subject lends itself to a looser rendering.

Use the 3B and 5B pencils on the side of slick points for lighthearted effect.

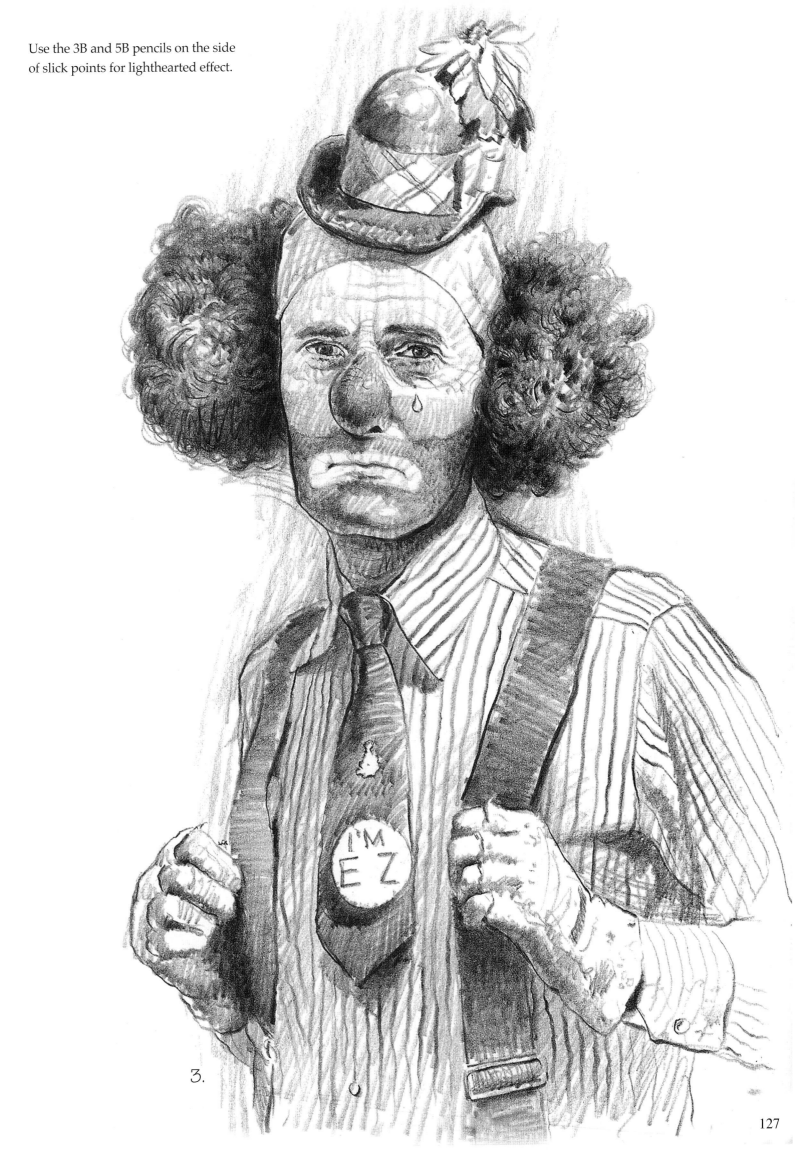

3.

Chinese Lady

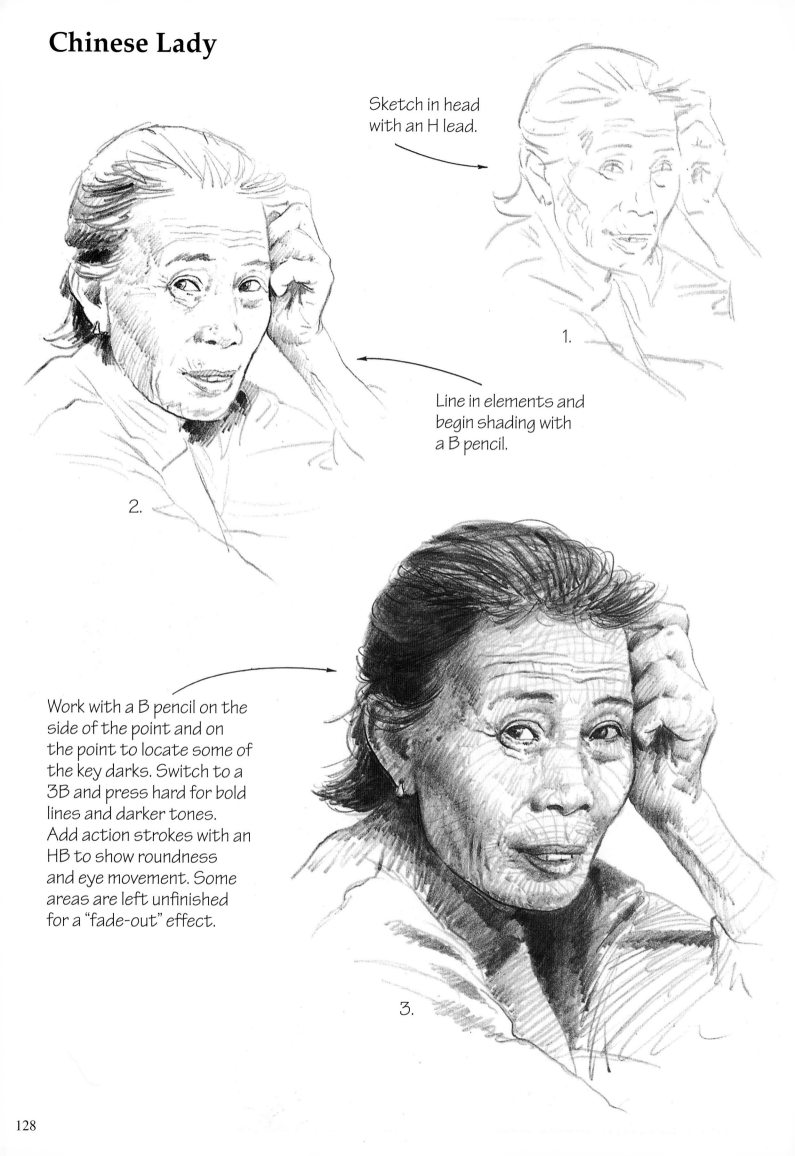

Sketch in head with an H lead.

1.

Line in elements and begin shading with a B pencil.

2.

Work with a B pencil on the side of the point and on the point to locate some of the key darks. Switch to a 3B and press hard for bold lines and darker tones. Add action strokes with an HB to show roundness and eye movement. Some areas are left unfinished for a "fade-out" effect.

3.

Nigerian Woman

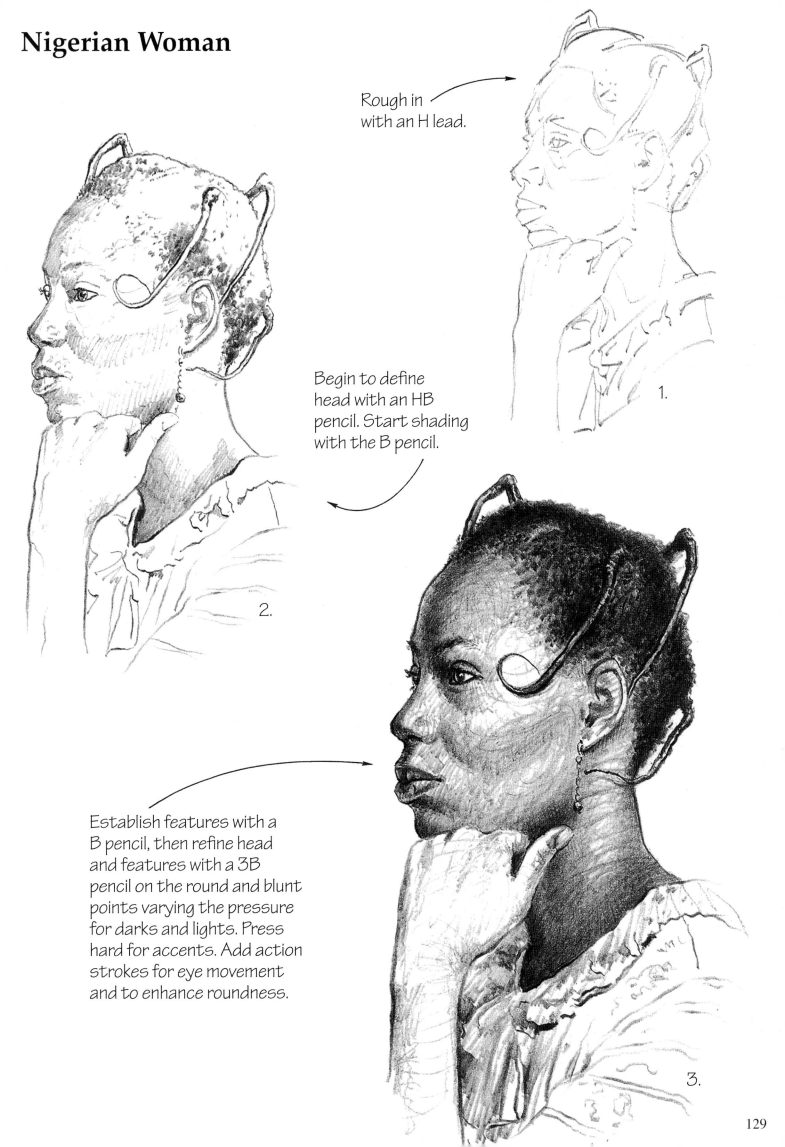

Rough in with an H lead.

Begin to define head with an HB pencil. Start shading with the B pencil.

1.

2.

Establish features with a B pencil, then refine head and features with a 3B pencil on the round and blunt points varying the pressure for darks and lights. Press hard for accents. Add action strokes for eye movement and to enhance roundness.

3.

Woman from Kenya

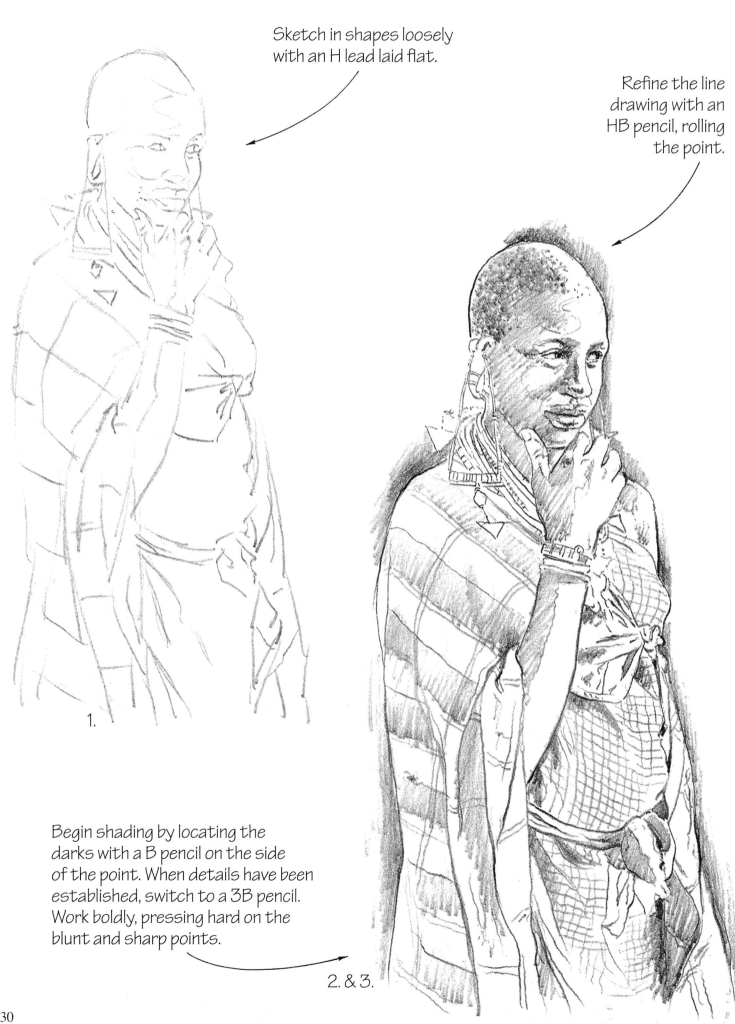

Sketch in shapes loosely with an H lead laid flat.

Refine the line drawing with an HB pencil, rolling the point.

1.

Begin shading by locating the darks with a B pencil on the side of the point. When details have been established, switch to a 3B pencil. Work boldly, pressing hard on the blunt and sharp points.

2. & 3.

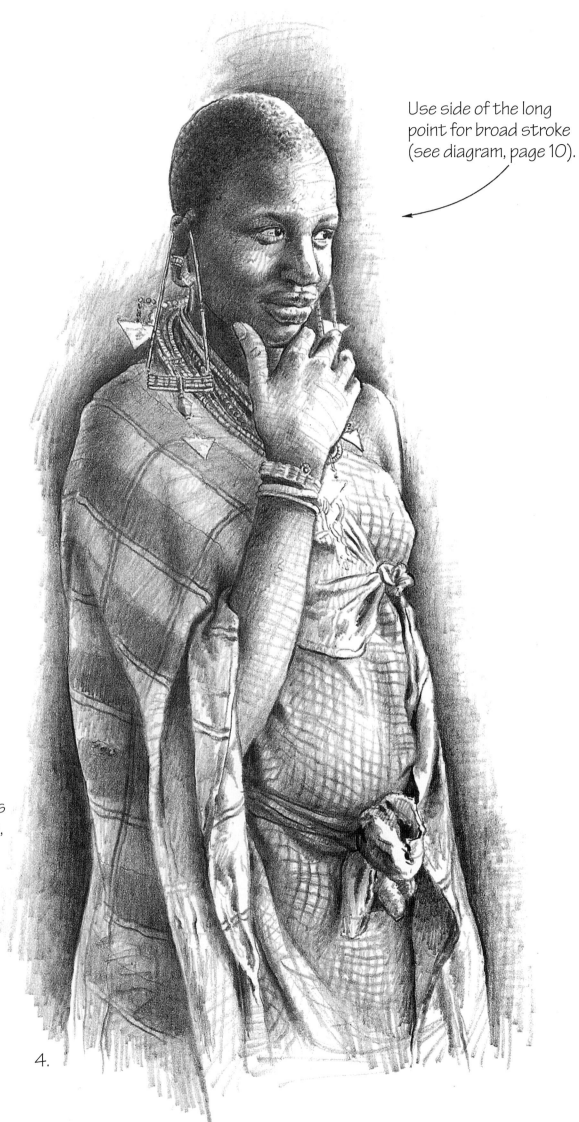

Use side of the long
point for broad stroke
(see diagram, page 10).

Build coat on
coat of tones; use
both hand positions
and all point modes,
as illustrated on
page 11.

4.

Young Man

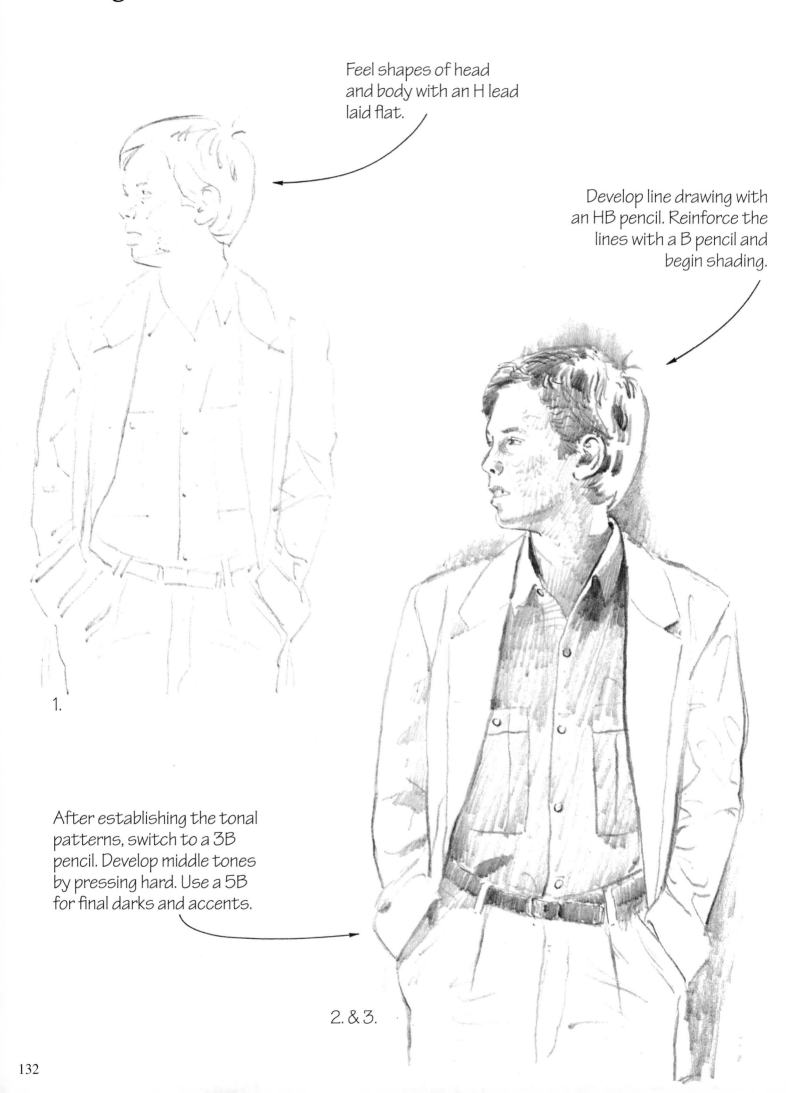

Feel shapes of head and body with an H lead laid flat.

Develop line drawing with an HB pencil. Reinforce the lines with a B pencil and begin shading.

1.

After establishing the tonal patterns, switch to a 3B pencil. Develop middle tones by pressing hard. Use a 5B for final darks and accents.

2. & 3.

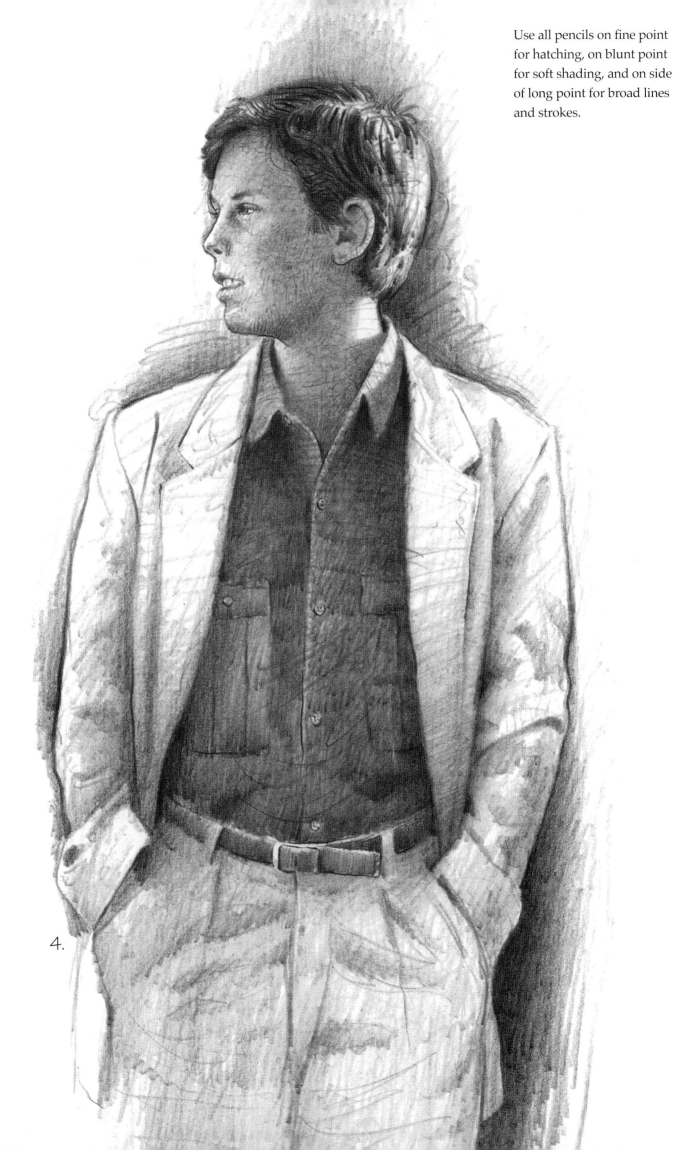

Use all pencils on fine point for hatching, on blunt point for soft shading, and on side of long point for broad lines and strokes.

4.

Ballerina

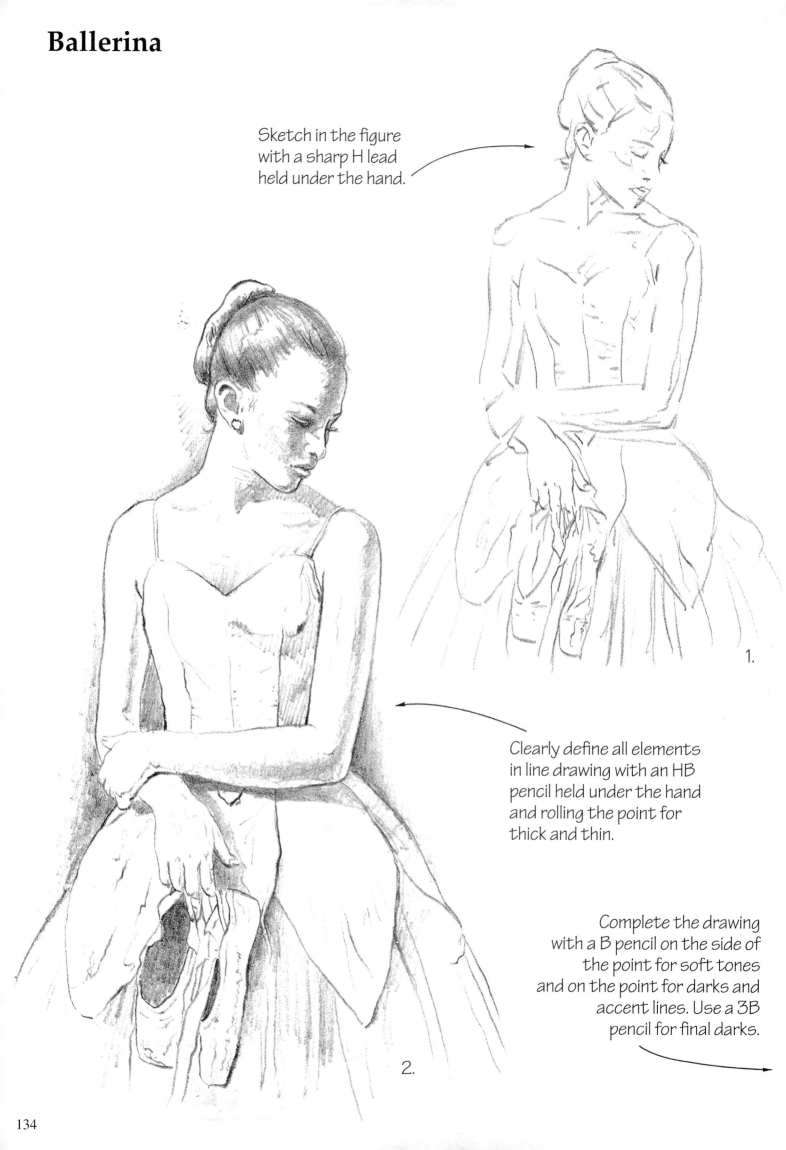

Sketch in the figure with a sharp H lead held under the hand.

Clearly define all elements in line drawing with an HB pencil held under the hand and rolling the point for thick and thin.

Complete the drawing with a B pencil on the side of the point for soft tones and on the point for darks and accent lines. Use a 3B pencil for final darks.

1.

2.

The background is executed with
broadstrokes and glazing.

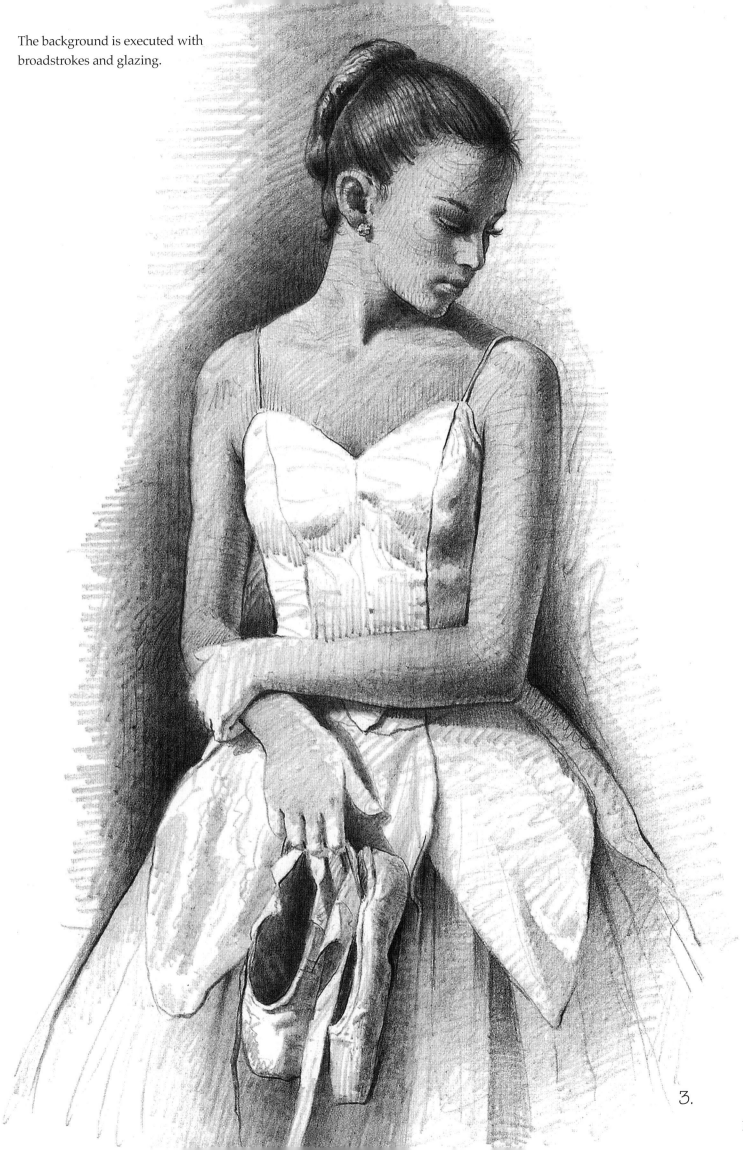

3.

Island Girl

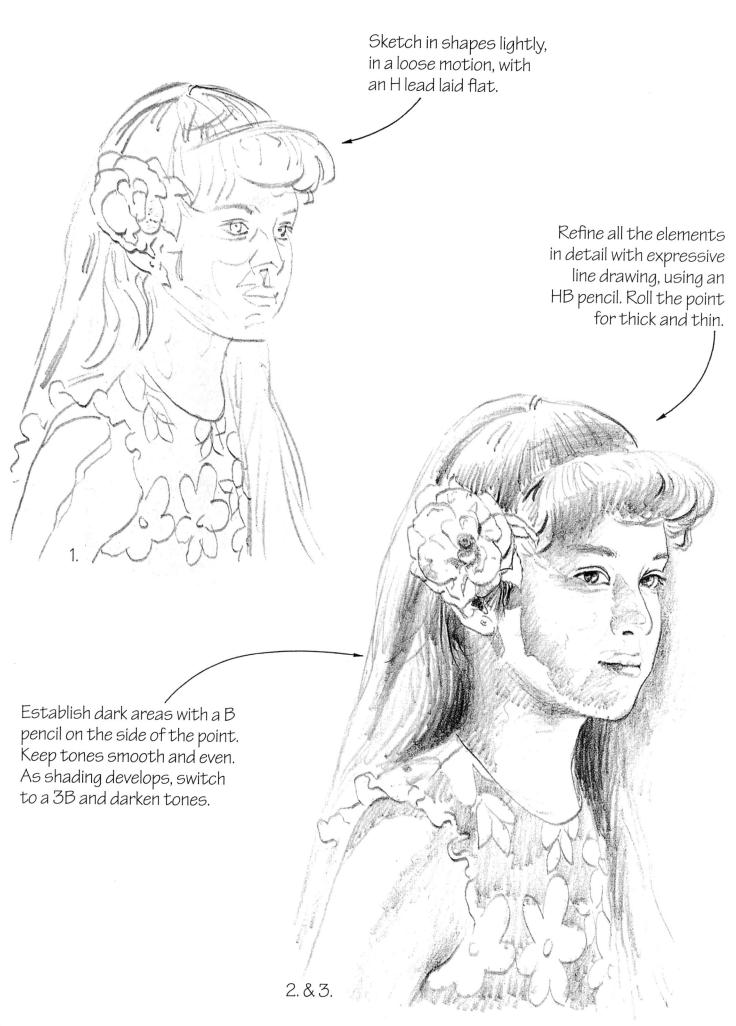

Sketch in shapes lightly, in a loose motion, with an H lead laid flat.

Refine all the elements in detail with expressive line drawing, using an HB pencil. Roll the point for thick and thin.

Establish dark areas with a B pencil on the side of the point. Keep tones smooth and even. As shading develops, switch to a 3B and darken tones.

1.

2. & 3.

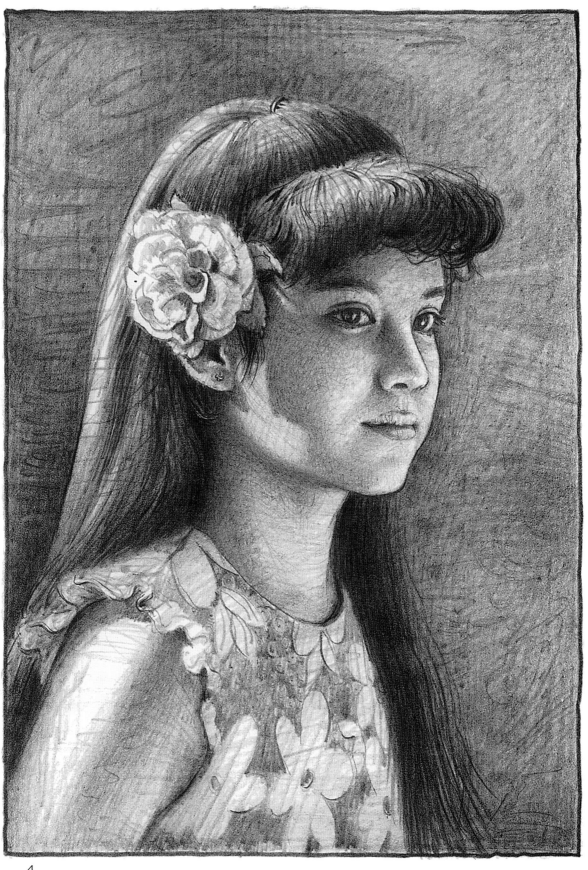

4.

This drawing is achieved with multiple coats of glazing and hatching.
Give special attention to tonal transition on the face to create a sense of
roundness. Use 5B pencil for deeper tones in hair and other dark areas.
Exexcute the background with HB pencil laid on side of pencil point for
smooth shading. Add final accents with sharp points. Apply action lines
throughout for eye movement.

Victorian Lady

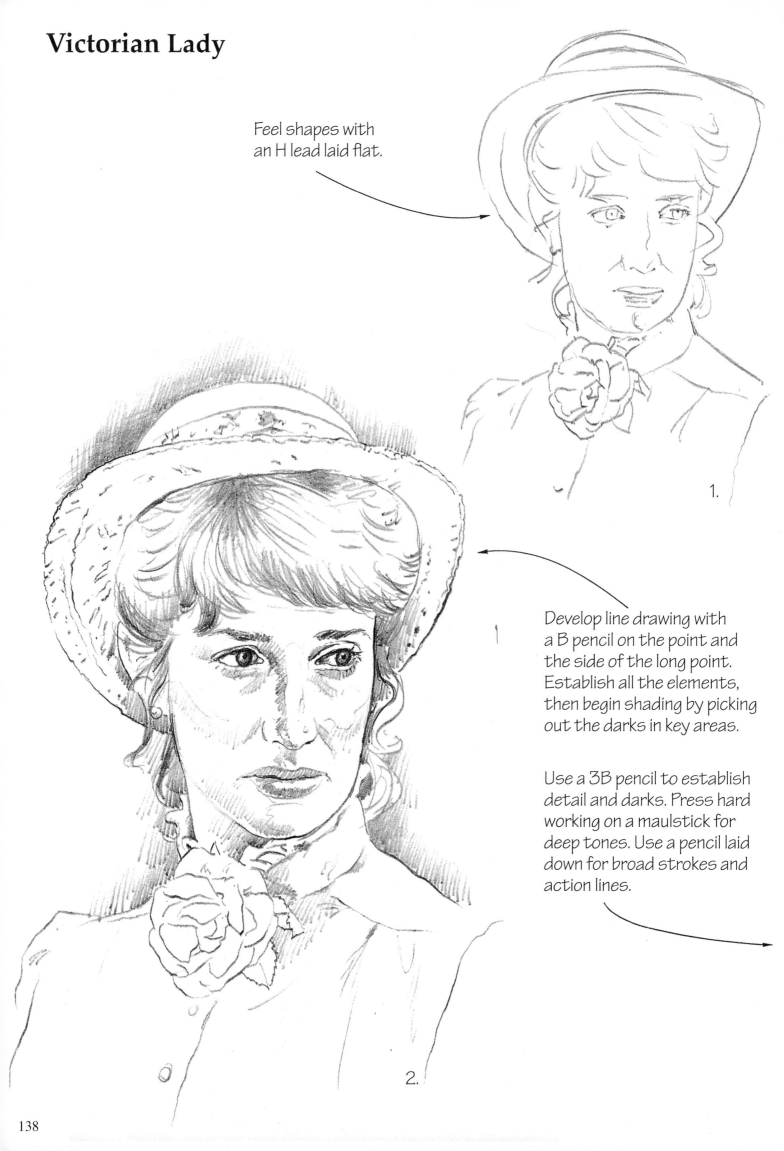

Feel shapes with an H lead laid flat.

1.

Develop line drawing with a B pencil on the point and the side of the long point. Establish all the elements, then begin shading by picking out the darks in key areas.

Use a 3B pencil to establish detail and darks. Press hard working on a maulstick for deep tones. Use a pencil laid down for broad strokes and action lines.

2.

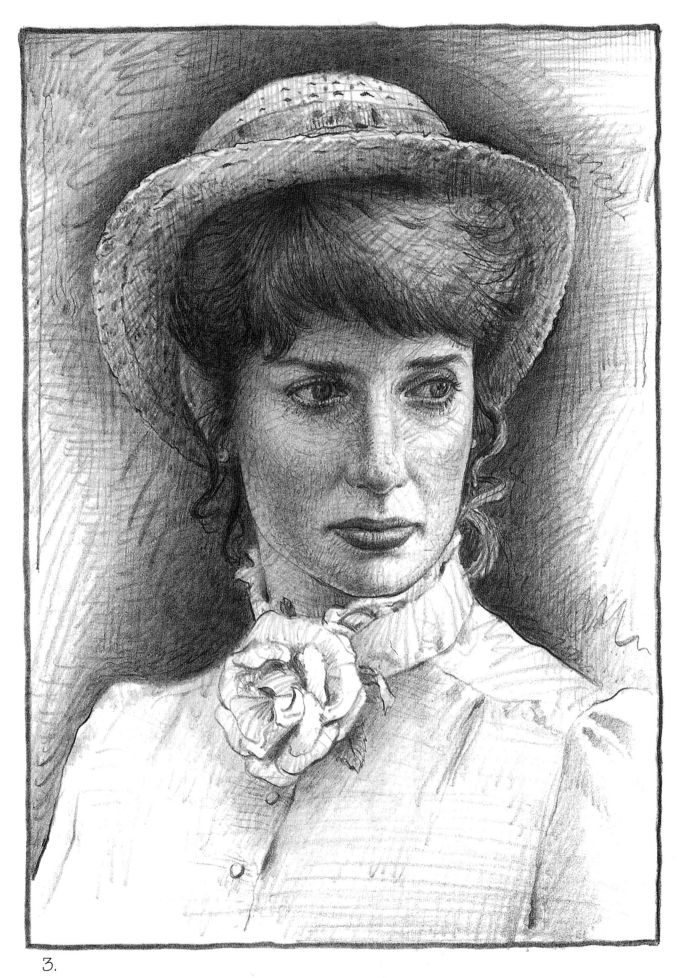

3.

To render a successful portrait in pencil you will need to pay close attention to the basic strokes shown on pages 10 and 11. Handling the pencil will become second nature after dedicated practice.

The Prospector

Feel the shapes roughly with a loose motion, using an H lead laid flat.

Line in the detail with an HB pencil, rolling the point for thick and thin.

Begin shading with a B pencil on the blunt point for soft strokes. Use a B with the sharp point for accents. Change hand positions, as needed, while you shade from light to dark.

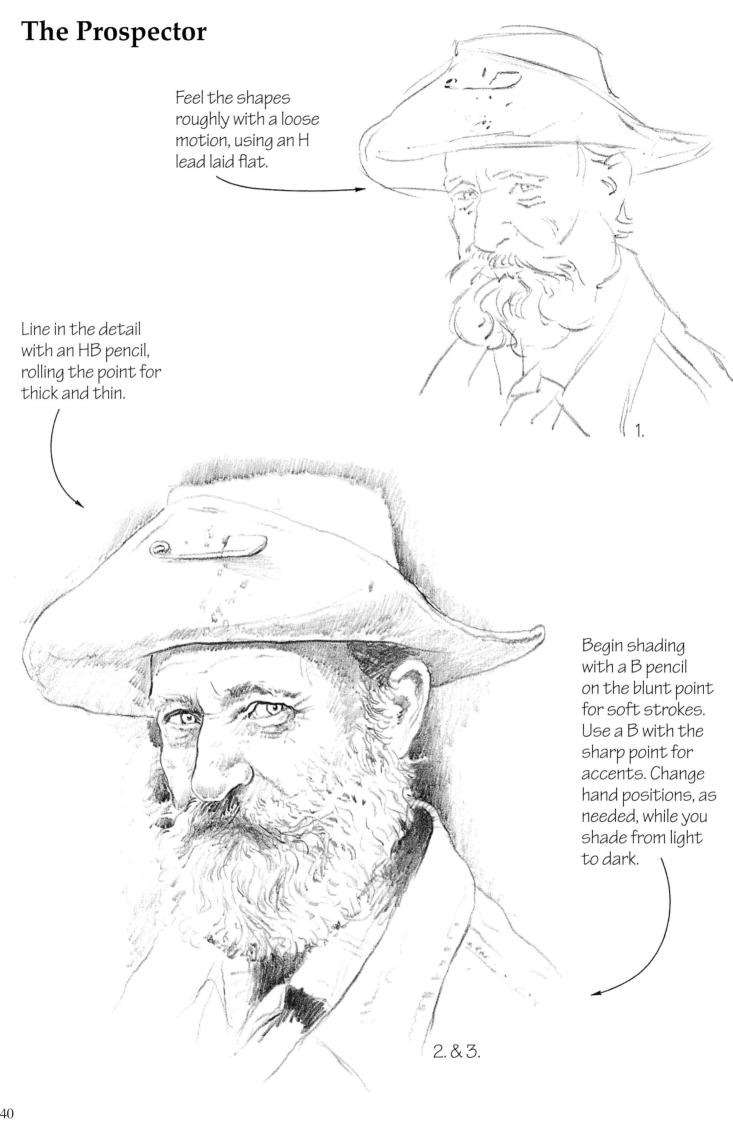

1.

2. & 3.

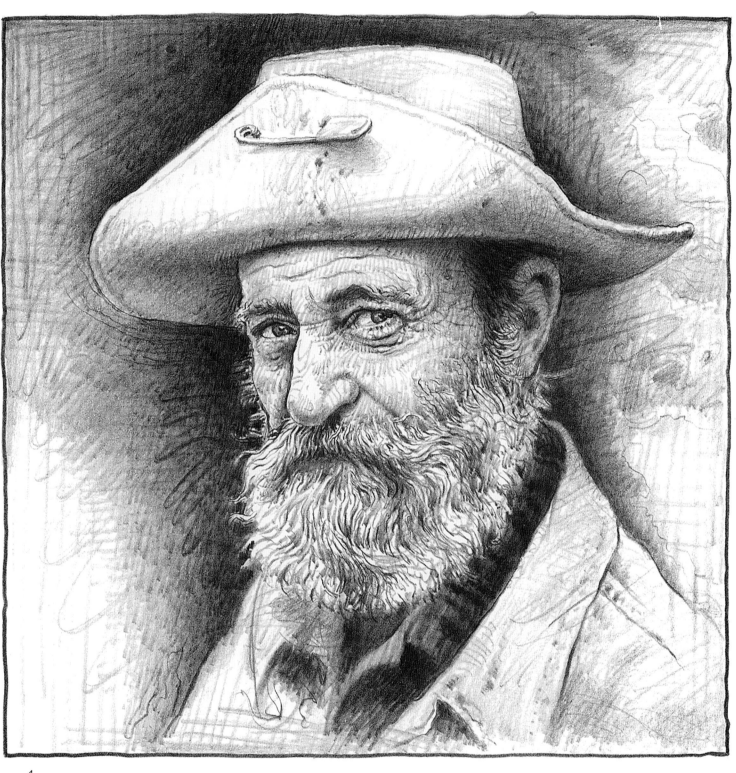

4.

Refer to step drawing to get started. Observe the finished drawing intently as you develop your own piece. Work with your 3B pencil on all point modes, pressing lightly for soft strokes, and pressing hard for darker effects. Work layer on layer as you develop the tonal density.

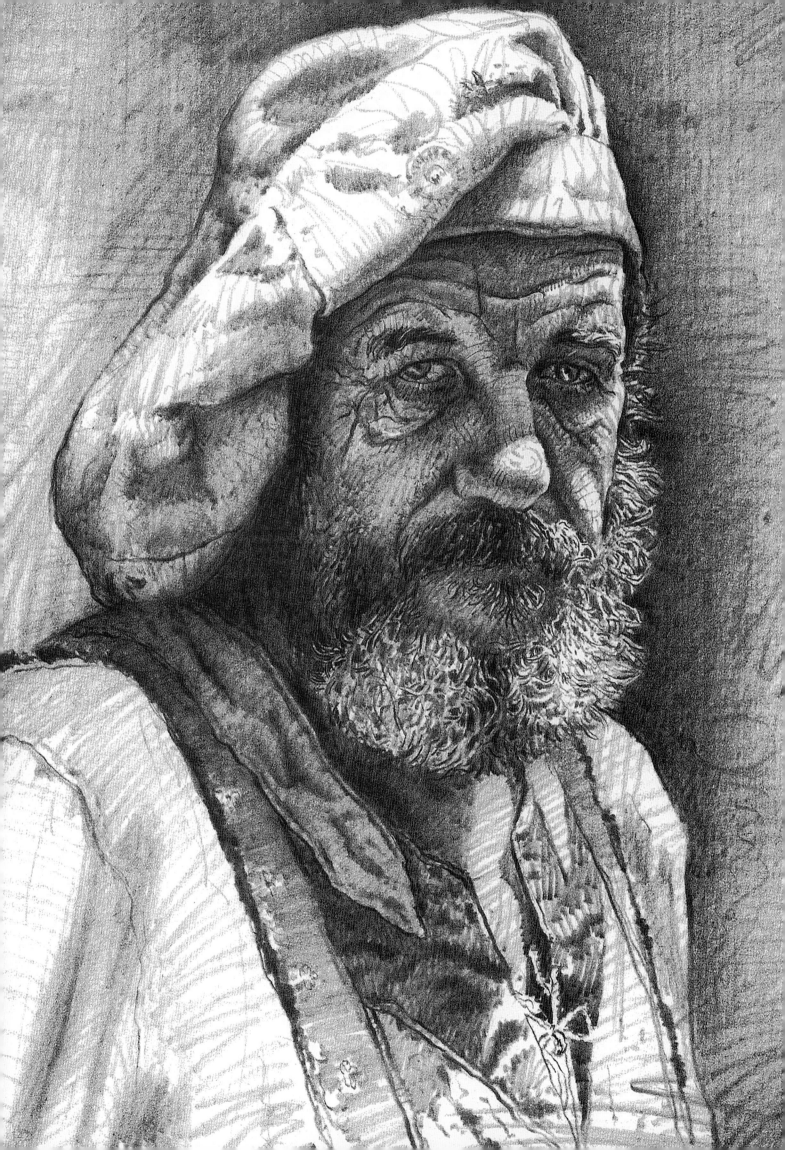

Glossary

BROADSTROKE
A stroke created by laying a long point of lead or pencil on the side.

GLAZE
A transparent film of tone laid in over other strokes; accomplished with a sharp lead or pencil laid flat or with a blunt lead on the point.

HARD EDGE
A crisp outline which makes the subject appear to come forward; produced with a sharp pencil; effective for accents and underlining.

HATCH
A stroke of the pencil on the point to produce short, fine, parallel or crisscross lines.

LINE DRAWING
Outlining the features of an object; produced by the varying pressure on a sharp point and on the side of a point.

MASS TONE
The shading of large areas in a broad back and forth motion,
achieved with a sharp lead or pencil laid flat or a blunt lead on the point.

MAULSTICK
A long, light stick used to steady the hand and prevent smudging.

PENCIL POINT MODE
Degree of sharpness.

PENCIL PRESSURE
The personalized degree of firmness in application of pencil that makes your style your own.

ROUGHING IN
Sketching shapes in their simplest forms.

SHADING
Applying multiple layers of tones with pencil stroke sand glazing.

SKETCH
A simple study of lights and darks, with little detail and accented with "line drawing" (see above).

SOFT EDGE
An indistinct outline which makes the subject appear to recede; produced with a blunt pencil or lead; effective for showing roundness and depth.

SOFT STROKES
A series of short lines made with a blunt point.

THICK & THIN LINES
Variable widths of line drawing (Step 2 of "Pencil Procedure"); executed by varying pressure on the point and/or by rolling on the side of the lead or pencil.

TONE
The application of a "value" (see below).

TRANSITION
A blending of tone from light to dark.

VALUE
The degree of lightness or darkness. There are nine values in the value scale.

WORKABLE FIXATIVE
A resin solution, available in a spray can, used to "fix" the finished drawing to the paper to prevent smudging.

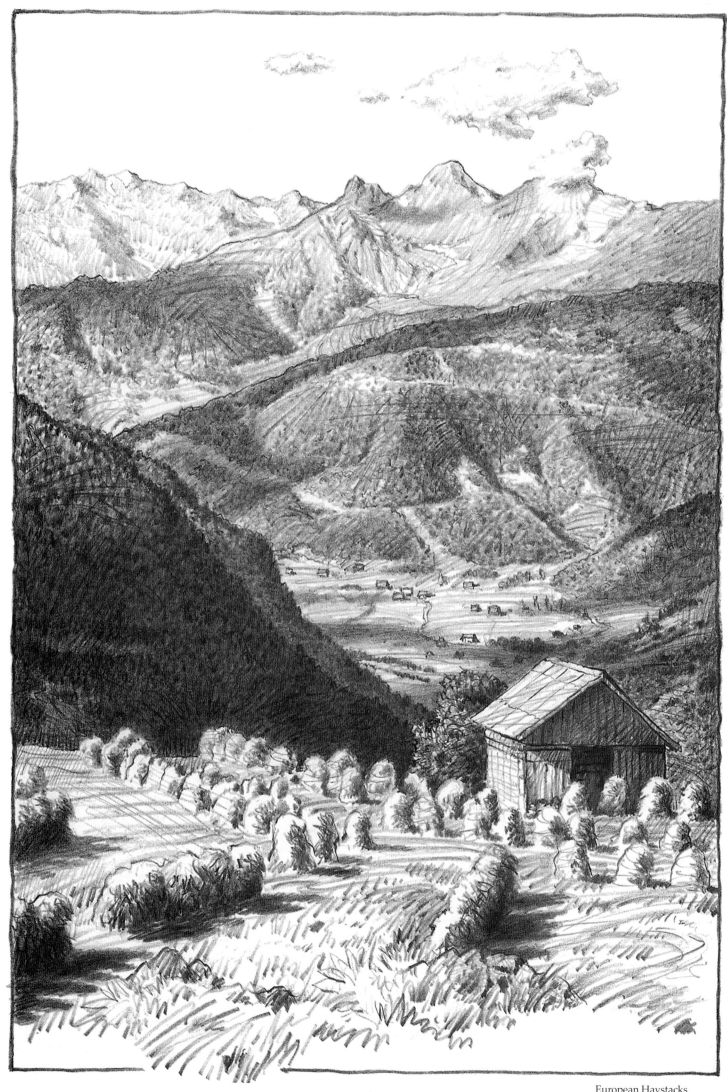

European Haystacks